D1314883

American Impressionism and Realism

THE MARGARET AND
RAYMOND HOROWITZ
COLLECTION

American Impressionism

NICOLAI CIKOVSKY, JR.

with
Nancy Anderson
Deborah Chotner
Franklin Kelly
and Lee A. Vedder

NATIONAL GALLERY OF ART, WASHINGTON

and Realism

THE MARGARET AND
RAYMOND HOROWITZ
COLLECTION

The exhibition was organized by the
National Gallery of Art, Washington.

Exhibition Dates
National Gallery of Art
24 January–9 May 1999

Copyright ©1998. Board of Trustees,
National Gallery of Art, Washington.
All rights reserved.

The book was produced by the
Editors Office, National Gallery of Art
Frances P. Smyth, *Editor-in-chief*
Susan Higman, *Editor*
Wendy Schleicher Smith, *Designer*

Typeset in Adobe Garamond and Syntax
by General Typographers, Washington, D.C.
Printed on Potlatch McCoy Silk by
Schneidereith & Sons Printing, Baltimore, Md.

The artist biographies are based in part on informa-
tion published in the National Gallery of Art's
systematic catalogue *American Paintings of the
Nineteenth Century,* Part I (Washington, New York,
and Oxford, 1996) and Part II (1998).

COVER · Childe Hassam, *Poppies* (detail), 1891,
oil on canvas, 19¾ x 24 (50.2 x 61).

Library of Congress
Cataloging-in-Publication Data

American impressionism and realism :
the Margaret and Raymond Horowitz col-
lection / Nicolai Cikovsky, Jr. ... [et al.].

p. cm.

Exhibition dates:
National Gallery of Art, 24 January–9 May 1999.
Includes bibliographical references.

ISBN 0–89468–239–3

1. Impressionism (Art)—United States—Exhibi-
tions. 2. Realism in art—Exhibitions. 3. Painting,
American—Exhibitions. 4. Painting, Modern—
19th century—United States. 5. Painting, Modern—
20th century—United States. 6. Painting—
Private collections—United States—Exhibitions.
7. Horowitz, Raymond J.—Art collections—
Exhibitions. 8. Horowitz, Margaret—Art collec-
tions—Exhibitions.

I. Cikovsky, Nicolai. II. National Gallery of Art
(U.S.)

ND210.5.I4A42 1998
759.13'074'753—dc21 98–38978

Table of Contents

7

DIRECTOR'S FOREWORD

9

LENDERS' ACKNOWLEDGMENTS

11

INTRODUCTION
Nicolai Cikovsky, Jr.

15

REMINISCENCES AND REFLECTIONS ON COLLECTING
Raymond Horowitz

24

CATALOGUE OF THE EXHIBITION
Nancy Anderson, Deborah Chotner, Nicolai Cikovsky, Jr., Franklin Kelly

154

BIOGRAPHIES OF THE ARTISTS
Lee A. Vedder

180

PROVENANCE, EXHIBITIONS, AND REFERENCES

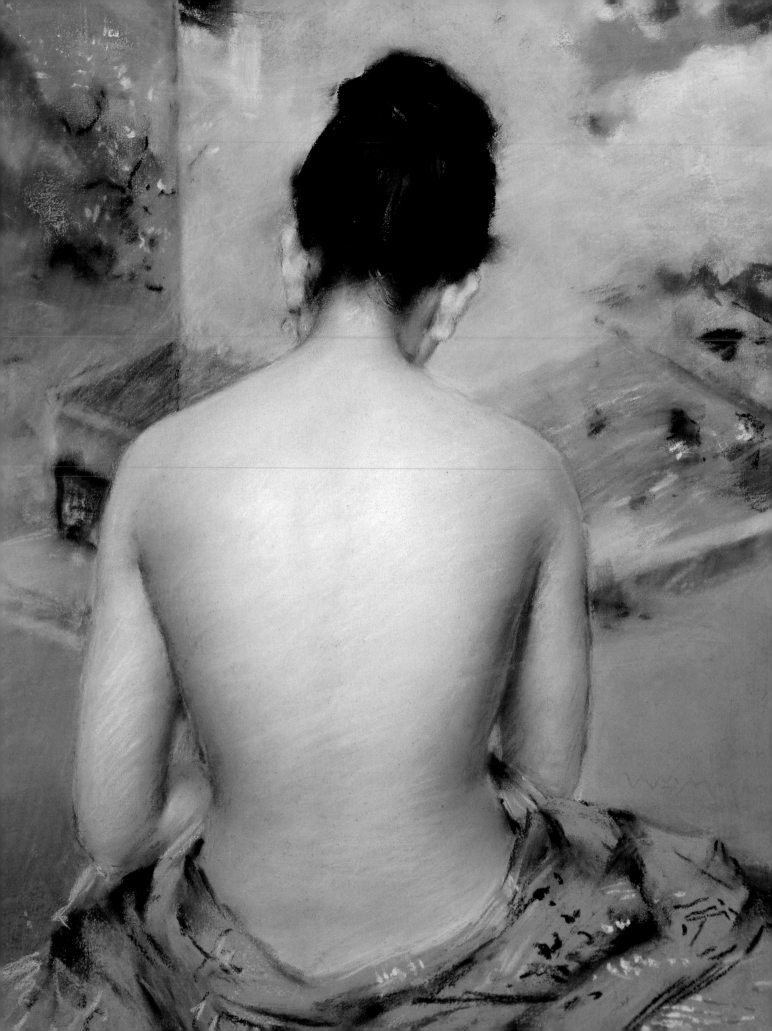

Director's Foreword

During almost forty years of collecting, Margaret and Raymond Horowitz have formed one of the finest groups of American impressionist and realist works in private hands. Among the superb oil paintings, pastels, watercolors, and drawings in the collection are works by such major figures in American art as John La Farge, William Merritt Chase, Childe Hassam, Theodore Robinson, J. Alden Weir, John Twachtman, George Bellows, Maurice Prendergast, and John Singer Sargent. Chase's radiant Shinnecock landscape *The Fairy Tale,* Theodore Robinson's *Low Tide, Riverside Yacht Club,* Hassam's exquisite *Poppies,* and Weir's *U.S. Thread Company Mills, Willimantic, Connecticut* (both partial and promised gifts to the National Gallery), are but a few of the splendid paintings in this lyrically beautiful collection.

The principal curators of this exhibition, of unerring eye and painstaking and impeccable connoisseurship, are of course the Horowitzes themselves. They worked closely with the members of the Gallery's department of American and British painting—Nicolai Cikovsky, Jr., senior curator of American and British painting; Franklin Kelly, Nancy Anderson, and Deborah Chotner, curators; and Lee A. Vedder, University of Maryland museum fellow—in the selection of the exhibition and the production of the scholarly catalogue, which the department has written, that accompanies it. Heidi Applegate, staff assistant, helped expertly with virtually every aspect of the project.

Above all I want to thank Margaret and Ray Horowitz, cherished friends and generous donors, for allowing the National Gallery of Art to exhibit their legendary collection of American impressionist and realist paintings, and by doing so to share their treasures with the nation.

EARL A. POWELL III
Director, National Gallery of Art

14 · *Back of a Nude* (detail)

Lenders' Acknowledgments

A collection is never put together by the collector alone. Although Margaret and I never had an adviser or consultant—it simply never occurred to us—we were helped immeasurably by the dealers and scholars we encountered, who were so patient and instructive, and by our fellow collectors, who were so collegial.

In the early days we shared information about paintings, painters, dealers, and prices with other collectors of American art: Daniel and Rita Fraad; Julian and Jo Ann Ganz; Vivian and Pat Potamkin; Arthur Altschul; Herbert Goldstone; Paul Magriel; and Dr. John J. McDonough; and with a collector of French and old master drawings, David Daniels. Later, we traded confidences with Richard Manoogian, Daniel Terra, and Heidi and Max Berry.

Our debt to the dealers is profound because there is no substitute for looking at and, in a sense, "feeling" paintings, and the dealers as much as our museum friends made this possible. Although we would like to mention all of them, a mere listing of their names would not do them justice, and to explain the contribution of each to our collection and to our knowledge would expand this volume to an unacceptable length. However, we cannot resist mentioning a few who supplied most of the paintings in the collection: Antoinette Kraushaar of the Kraushaar Galleries was a patient mentor who had endless time for us; Abraham M. Adler, whose Hirschl & Adler Galleries was our destination every Saturday, always enthusiastically showed us his inventory; Michael St. Clair of the Babcock Galleries, who gave us first crack at his latest acquisitions; Stuart P. Feld of Hirschl & Adler, who did us innumerable good turns; Roy Davis of Davis and Langdale, our cherished friend, who sold us many paintings and helped us select virtually all our frames, and on whose wisdom we have continued to rely; Lawrence Fleischman of Kennedy Galleries, who genuinely loved American art; Ira Spanierman, the source of some of our best paintings; and Warren Adelson, an outstanding scholar, an outstanding dealer, and, since his Boston days, a friend for whom we have enormous affection, admiration, and trust.

We would also like to acknowledge the assistance in many ways of the staffs of Christie's (particularly Andrew Schoelkopf and his colleagues, and formerly Jay E. Cantor) and Sotheby's (particularly Peter Rathbone and Dara Mitchell, and formerly John Marion).

Among the scholars, we are especially indebted to our brilliant and long-time friend, Nicolai Cikovsky, Jr., who has put on so many memorable exhibitions of American art and who had the idea for this exhibition and who, with his colleague, Franklin Kelly, is responsible for this splendid catalogue; to John K. Howat and Dianne Pilgrim, who wrote the catalogue accompanying the exhibition of our collection at the Metropolitan Museum of Art in 1973; to John Wilmerding, whose exhibition *American Light* had a profound influence on us; to Theodore E. Stebbins, Jr., whose writings, exhibitions, and even his asides have stretched our minds; and finally to Professor William H. Gerdts, with whom we have had a conversation on American art that has spanned thirty-five years and who so kindly dedicated his definitive and impressive book *American Impressionism* to us. Many other scholars, most of whom we count as friends, enriched our knowledge of, and provided important insights into, American art and, for that matter, art in general: John I. H. Baur; Annette Blaugrund; Elizabeth Broun; Helen Cooper; Cecily Langdale Davis; Linda Ferber; Lloyd Goodrich; Jonathan P. Harding; Erica Hirshler; Lisa Koenigsberg; Oliver Larkin; Barbara Novak; Richard Ormond; Ronald Pisano; Jules Prown; Edgar P. Richardson; Regina and Charles Slatkin; and H. Barbara Weinberg.

This exhibition would not have happened but for our happy encounter years ago with J. Carter Brown, who introduced us to the National Gallery family. Our thanks also to his successor, Earl Powell III, for whom we have had admiration and affection since his early days at the Los Angeles County Museum of Art, and who warmly endorsed this exhibition and its accompanying catalogue; to our more recent Gallery friends, Dodge Thompson, Mark Leithauser, Michelle Fondas, and Mervin Richard; and to all the others at the National Gallery who contributed to this exhibition and catalogue. And finally, to Robert Smith and his fellow trustees of the National Gallery of Art who made possible all this joy for us.

MARGARET HOROWITZ
RAYMOND HOROWITZ

Introduction

By the time, in the mid-1960s, when museums and scholars had barely begun to busy themselves with it, Margaret and Raymond Horowitz had been seriously at work for several years building what would soon become a fabled private collection of American impressionism. It is fabled for its exceptional quality, and also, in its way, for its definitiveness. "In its way" not because it is eccentric, and certainly not because allowances need to be made for it, but because it is deeply personal, and because it was never the Horowitzes' intention to make it a fairly—that is, a reasonably, impartially, and historically—representative collection. Certain artists attracted them more than others—William Merritt Chase, Theodore Robinson, and John Twachtman most of all—and many did not attract them at all. They felt no obligation to include an artist, no matter how important he was considered by others. They simply bought what they liked—though it was not quite so simple, for they only bought what they *both* liked, and everything they acquired had to pass that extraordinarily stringent and demanding test. (One thing that survived, in fact thrived, was a marriage of more than fifty years.)

Liking was not a whim, a momentary attraction. Liking, the application and exercise of taste, is for the two of them both a rigorously disciplined act, and a privilege earned through many years of thinking, studying, and looking widely and deeply (and, adding to the range of their knowledge and strength of their convictions, not only at American art). They engaged in a discourse, which still continues as actively as ever, with fellow collectors and the many art dealers, scholars, and curators whose company they enjoy, and who so greatly enjoy theirs. When the Horowitzes began collecting in the early sixties theirs was a pioneering enterprise. American art was out of fashion, little admired, little studied, and little collected—a situation almost impossible to imagine today when the kind of art they were among the first to collect is now—in no small part because they collected it so well—avidly sought after at staggeringly high prices.

A term the Horowitzes often use to describe what they most admire is lyrical, in the sense of a directly felt and almost palpable emotion, one that appeals to some part or property of the mind and not only the eye, and to feelings deeper and more lasting than pleasurable sensation.

Lyricism, in order to apply to the works the Horowitzes collect, must be spaciously understood. It must, that is, be able to accommodate the extroverted sensuousness of paintings like William

Merritt Chase's *The Fairy Tale* or Frank Benson's *A Summer Day,* which almost classically embody the term, while at the same time applying to Chase's more darkly complex portrait of his wife, *Reflections,* or to George Bellows' solemn, almost hieratically Byzantine portrait of his wife, Emma. And able to accommodate also the painterly and chromatic succulence of Childe Hassam's *Poppies, Isles of Shoals* and Robert Blum's epicurean pastel *The Blue Obi* (Oscar Wilde said Blum's pastels were like eating yellow satin), and, too, to the leaner, sparer, more platonic beauty of Theodore Robinson's *Low Tide, Riverside Yacht Club,* the abstract surfaces of John Twachtman, as well as the industrial subject of J. Alden Weir's *U.S. Thread Company Mills, Willimantic, Connecticut,* and Ernest Lawson's squatters' huts on the Harlem River.

Lyricism very definitely does not mean denatured aesthetic pleasure and lifeless decoration. It contains, on the contrary, a large and indispensable element of human feeling. The Horowitzes are drawn powerfully, therefore, to the intense humanity of Kenyon Cox's drawing of Theodore Robinson and of Robinson's own painted self-portrait, the intimately affectionate portraits of John Leslie Breck by his friend J. Carroll Beckwith and the drawing of Everett Shinn by his friend William Glackens, and the sheer human energy,

almost explosively expansive and barely contained, of Chase's pastel self-portrait, and the powerfully concentrated humanity of Emma Bellows. In another key are the warm and often joyous celebrations of life in Benson's *A Summer Day,* Chase's *The Fairy Tale,* and the pleasures of organized, if not always precisely orderly, society at urban parks and beaches and places of public entertainment—inevitably and irresistibly attractive to two born and bred New Yorkers—as depicted by Maurice Prendergast, Alfred Maurer, Everett Shinn, George Bellows, and Edward Potthast. If there is something that can be called a "Horowitz picture" its most significant attribute surely must be the depth, breadth, and warmth of its humanity.

Shaped though it is by a jointly shared vision and sensibility, rigorously limited in time (despite temptation) to the forty years at the turn of the century, and possessing overall and in its individual parts a special and unmistakable character of its own, the Horowitz collection is not in any respect doctrinaire. It is, like the Horowitzes themselves, embracing in its nature, not exclusive, responsive not restrictive, its limitations and restrictions often painfully exercised necessities. It contains every category of subject matter—portraits and self-portraits, figure and genre paintings, landscapes and still life—and styles that range from George Bellows' robustness to John La Farge's reticent refinement, John Singer Sargent's utter and absolute fluency to Theodore Robinson's and John Twachtman's subtle and hard-won stringencies. There are famous artists and less famous ones, male artists and female. And there are works in virtually every medium (excepting sculpture and photography):

oil paintings, watercolors, pastels, monotypes, and drawings in pencil, charcoal, and chalk. The works on paper are so numerous and so invariably strong that they could stand almost as a separate collection. And among them the breathtaking group of pastels, especially those by Chase and Blum, are absolutely and categorically the greatest of their kind. Their six Chases represent the artist's achievement at its highest level of technical and expressive power, as the four Robinsons, four Prendergasts, three Hassams, two Blums, and two Bunkers represent theirs.

Some artists are represented by single works— Benson's *A Summer Day,* Cecilia Beaux's pastel portrait of *Ethel Page,* La Farge's exquisite watercolor *Wild Roses and Water Lily,* Vonnoh's *Springtime in France,* Weir's *U.S. Thread Company Mills* — but in each case they produced nothing better.

The Horowitzes love their pictures for their beauty of form, line, and color, of course, but more deeply as almost living things. Ray Horowitz once said that the extraordinary Chase pastel self-portrait that hangs opposite the door to their apartment greets him when he comes home. Nothing better expresses the almost audible feelings and presence their pictures have for them and in which they so intimately share.

Thanks and commendations go, as they always must, to the following people and departments:

In exhibitions, to D. Dodge Thompson, chief of exhibitions; Kathleen McCleery Wagner, exhibition officer; and Jonathan Walz, assistant for exhibition administration.

In exhibition programs to Susan Arensberg, head; and Isabelle Dervaux, associate curator.

In the editors office, to Frances P. Smyth, editor-in-chief; Susan Higman, editor; and Wendy Schleicher Smith, designer.

In installation and design, to Mark Leithauser, chief of design; Gordon Anson, chief lighting designer/chief of exhibition production; John Olson, production coordinator; Donna Kwederis, design coordinator; Jane Rodgers and Debbie Kirkpatrick, maquette production; and Barbara Keyes, head of silkscreen.

In conservation to David Bull, chairman of the painting department; Mervin Richard, deputy chief of conservation and head of the department of loans and exhibitions; Judith Walsh, senior paper conservator; Hugh Phibbs, coordinator of matting and framing; Jennie Ritchie, matter/framer; and Stephan Wilcox, frame conservator.

In the registrar's office, to Sally Freitag, chief registrar; and Michelle Fondas, registrar of exhibitions.

In imaging and visual services to Ira Bartfield, head; Sara Sanders-Buell, museum specialist; and Lee Ewing and Lyle Peterzell, photographers.

In the treasurer's office to Nancy Hoffmann, assistant to the treasurer for risk management and special projects.

NICOLAI CIKOVSKY, JR.

Reminiscences and Reflections on Collecting

The following remarks, slightly revised and edited, are taken from a talk delivered at the conference "Expanding Horizons: American Painting 1865–1930," held at New York University on 25 April 1996.

A collector, when talking about his or her collection, runs the risk of appearing either immodest or falsely modest, as well as of repeating the usual tiresome clichés about art collecting. Yet by looking back and reconstructing the story of our collection, some light may be cast on the development of interest in turn-of-the-century American painting.

Our collection is—and always was—a joint venture between my wife, Margaret, and me. Both of us have the same taste, the same "eye," and the same intensity. In the truest sense we are partners. So if I use the word "I," please understand that it means "we."

How did we get started? Since our college days, both Margaret and I have had a lively interest in painting and the history of art. As an undergraduate at Columbia College, I attended courses in art history given by the late Meyer Shapiro, and after graduation I attended classes by him at the New School for Social Research in New York. Margaret and I enjoyed frequent visits to museums and art galleries. But art was only one of our interests, and I was a Depression kid and a busy, hard-working lawyer. Growing up, I had never collected anything except stamps, and then only for a few short months. If, thirty-five years ago, someone had suggested that I would become an art collector, I would have said he was out of his mind.

We did not set out in any deliberate way to assemble a collection. On the contrary, like most important decisions in one's life, it was accidental and unplanned. In the late 1950s, my close friend, Dan Fraad, who was a collector of nineteenth- and twentieth-century American representational painting, gave me a French drawing as a birthday present on several successive birthdays. I wanted to reciprocate and, because our friend then had only American oils, we decided to give him an American drawing for a Christmas present. It would have been inappropriate to spend more than a modest sum, but we discovered that we could buy a good—though not a great—American drawing for two hundred dollars or less. For two years, Margaret, almost daily, scouted the galleries specializing in American art, and I joined her on Saturday afternoons. We also read everything on American art we could get our hands on. For the first gift to our friend we came up with a sensitive drawing by William Glackens, and the next year we presented him with a fine George Bellows drawing.

Some time in 1960, having by then become so immersed in the field, we thought that it might not be a bad idea to buy ourselves some American drawings. And so, more as a lark than as anything serious, we began.

The first things we bought were about half a dozen inexpensive works on paper by Robert Henri, William Glackens, Everett Shinn, and John Twachtman.

We weren't as yet fully involved in either the fact or the idea of collecting art, but we continued to visit the galleries regularly and then, one day

in early 1961, we saw a painting that had an immediate and irresistible appeal. It was an early work by Robert Henri, *Girl Seated by the Sea,* painted in 1893 (cat. 26). The price was many times more than the cost of the drawings we had previously acquired, but we knew we had to have it, and so—as I would do many times in the future—I gulped and bought it on the spot. We already knew enough about Henri to know that he painted in an impressionist idiom for only a few years and that this painting was not characteristic of the main body of his work. But this didn't stop us.

A few weeks later, we came upon, and bought, Childe Hassam's *Nurses in the Park,* painted in Paris about 1889 (cat. 23). This is also an early work in an impressionist style. We thought it was exceptionally fresh, and we were captivated by it because of the unsentimental way Hassam painted the charming and sentimental subject.

As our interest and knowledge grew, we visited the Metropolitan Museum virtually every Sunday and roamed through all the painting galleries. One painting there attracted us particularly, a landscape by Theodore Robinson called *Bird's Eye View, Giverny.* The more we looked at the painting the more we realized that it could hold its own with the French impressionists and that Theodore Robinson was a magnificent painter.

We tried to find out as much as we could about Robinson's work and kept after the dealers for Robinsons. Toward the end of 1961 we got lucky and found the self-portrait by Robinson—said to be the only one he ever painted (cat. 36). What we found especially appealing, and of course especially revealing, is that he pictured himself reading a book and in profile rather than the usual full-face portrait.

Looking back, I believe that the character of the collection was already defined by these three early oils—the Henri, the Hassam, and the Robinson—even though in 1961 we were not yet fully committed to collecting. That would happen the following year, 1962, when we acquired more than twenty diverse works in various mediums, among which were the following pictures:

A watercolor, *Under the Willows,* by John Singer Sargent (cat. 40), painted in Calcot, England, in 1888. We liked the spontaneity of the watercolor and its translucence, almost to the point of being transparent with light, which softens the outlines of the figures.

A Maurice Prendergast monotype, *The Breezy Common,* done between about 1895 and 1897 (cat. 34). In addition to the charm of the scene, we were drawn to this monotype because of the sense of movement—the figures seem to be going in different directions within the deliberately confined space created by the dark border Prendergast used to enclose the subject. The total effect is one of contained vitality.

A pastel by Childe Hassam, painted in 1890, *Poppies, Isles of Shoals* (cat. 24), which we consider to be the freest in style of all the works in the collection. It is the one painting that always seems to be of special interest to collectors of French impressionist paintings.

An oil, *Upper Harlem River*, by Ernest Lawson (cat. 28), of about 1915. Its heavy impasto is found in only a few of our other paintings. We liked the misty luminosity of this painting, and its unconventional subject of squatters' huts in winter. (It turned out that Lawson would not be one of our favorites, but we decided to keep this one painting by him.)

It was only at this time, when we could be more analytical about our acquisitions, that we came to the realization that we were greatly attracted to lyrical, representational, but nonacademic painting; painting that expressed a definite sensibility and certain moods and feelings—warmth, tenderness, intimacy, optimism. In spite of differences in style, there was cohesion and unity in our choices. The pictures we consistently admired had more than surface appeal, they all had a strong structural and aesthetic underpinning.

These days, when "American impressionism" is a household term, it is difficult to realize how little interest there was in this field only thirty years ago, and how unfashionable it was. In fact, we were ridiculed as "square" by most of our chums who had an interest in art. Outside of museums, most turn-of-the-century American paintings one saw in auction houses and art galleries were pretty dismal and could easily discourage popular or critical interest. We had to apply ourselves constantly to find good examples.

In this sense, the difference between then and now is not as great as one might think. Today, collectors bemoan the lack of premium, high-quality pictures and yearn for the good old days. But the fact is that the good old days were not that good after all, and a premium, high-quality picture was as hard to find then as it is now. What makes it seem different today is that beginning in the 1980s the prices of American impressionist paintings began to escalate exponentially, and, despite a dip in 1990–1991, prices have remained high. High prices seem to increase the difficulty of acquiring a first-rate picture, but there are now new players who can afford these prices and they are all chasing the same few, elusive masterpieces.

What *has* changed significantly is that there is less collegiality among collectors now than in the past. Years ago, the handful of collectors of historical (in contrast to contemporary) American art knew all the other collectors and freely traded information on what pictures were available, where, and at what prices. Today, there are many more collectors and many of them know each other

through overlapping membership in various museum groups. However, there is considerably less closeness and virtually no sharing of information.

For Margaret and me, collecting and the development of connoisseurship were serious matters. We constantly talked to other collectors, art historians, museum curators, and dealers, trying to learn as much as possible. We traveled to museums, large and small, to look at works we had seen in reproduction, and we read everything that remotely bordered on our field.

After our 1962 buying spree we confronted the question of whether we should continue to concentrate on this one area of art. Here, Margaret's objectives and mine dovetailed completely. She was insistent that there was great emotional satisfaction in mastering one field and in pursuing a single vision and organizing principle. There was no chance that I would ever collect contemporary American or French impressionist art, which were fashionable even then. I might have ventured into areas that were then relatively overlooked, like German expressionism, but for a person like me, with my mind set and limited resources, it was natural for me to go along with Margaret's preference for American impressionism. And that we have continued to do.

In staying with our decision, we do not mean to exaggerate the importance of this kind of painting in terms of world, or even American, art, or, for that matter, even in terms of other American art at the turn of the century. We realized, for instance, that our sensibility did not embrace Thomas Eakins—even though we believed then,

and continue to believe, that he was America's greatest painter—or Winslow Homer—other than a few lyric exceptions like his 1869 oil *Long Branch, New Jersey,* in the Museum of Fine Arts, Boston. On the other hand, we felt that people who neglected or undervalued the turn-of-the-century American art that captivated us were simply not using their eyes and were overlooking an entire era of beautiful painting.

For a while I was not altogether comfortable with the term "collector," but I guess we began to fit that category when, in the three years from 1963 to 1965, we acquired close to fifty paintings, all in the area we had staked out:

Gondolier's Siesta, a watercolor painted in Venice in 1905 by John Singer Sargent (cat. 41). We were taken by the richness of the watercolor, its great verve, and its dramatic effect. For us, it had everything we admired in Sargent—Venice, well-drawn figures, dramatic architectural elements, and a sense of ambiguity.

Low Tide, Riverside Yacht Club, an oil by Theodore Robinson, painted in 1894 (cat. 39). Robinson, generally regarded as America's first impressionist painter, has always been a special favorite of ours. In this painting, Robinson comes as close as he, or any other American impressionist, came to using impressionist technique without sacrificing solid form and well-defined space.

Back of a Nude, a pastel by William Merritt Chase, painted about 1888 (cat. 14). It is probably the popular favorite in the collection. More than a realistic rendering of a model in an unusual setting in the artist's studio, it is highly theatrical and, in the sense that it is loaded with unanswered questions, full of mystery. From the beginning, I might say, we have been drawn to pastels, particularly those that combine bravura handling with dramatic intensity.

Frank W. Benson's *A Summer Day,* an oil of 1911, is painted with joyous spontaneity (cat. 7). The sunlight is hot and direct, and the artist is interested in the dazzling effect it produces.

At the Shore is an oil by Alfred H. Maurer, painted in 1901 (cat. 29). Long before we acquired it, I knew of this painting through Elizabeth McCausland's biography of Maurer, in which it was illustrated. I kept thinking about it, and once I even dreamt about it. Then one day the dealer who handled many of Maurer's works called me at my office and told me to come at once, that he had a surprise for me. I dropped everything and rushed to the gallery. The surprise was *At the Shore.*

Maurice Prendergast's free and brilliant watercolor, *Revere Beach,* painted in 1896 (cat. 32), full of shimmering movement, expresses the mood of most of the collection.

After 1965, I began to spend more money than I had on hand, so that in addition to accumulating paintings I accumulated debts. Consequently, I had to borrow from the banks and get time from the dealers to pay for the paintings.

But the essential fact is—and I was not fully aware of it until fairly recently—that at the time we started to collect in earnest I was an established lawyer with a good practice and a certain confidence about the future. Although we have all read about a few collectors who put together great collections spending only pennies to do so, I doubt that this has happened often. In any event, in my case it would have been inconceivable to have started to collect before I had reached a level of comfort with money.

However, I don't want to exalt the element of money because it is not really decisive in forming a collection. Although the best works of art are always expensive, and in many cases the most expensive, the converse is not true: expensive paintings are not always the best. I have seen too many people who have put fortunes into paintings and ended up only with a dealer's stock.

In 1966, a change in public and critical opinion about the paintings we were collecting became noticeable. I can pinpoint this date because of another accident. In those years, the Metropolitan Museum had a yearly summer loan show comprising paintings from private collections. Before 1966, virtually the only paintings included were blockbuster French works. But that spring we were moving to another apartment, and to accommodate us, Stuart P. Feld, then the curator of American art, arranged to have our paintings stored briefly in the museum's basement. The associate curator of *European* paintings—whom we had never met—accidently came upon our paintings and asked Stuart whether the owners might be willing to lend to the summer loan show. We readily agreed, and when the show opened we were astonished and pleased to see a room devoted entirely to fifteen of our paintings.

This, I think, marked the turning point. After this summer show, several dealers in American art reported to me that their clients had begun to ask to see "Horowitz" paintings and American impressionist pictures.

As our knowledge deepened and we became more discriminating, we realized that some of our purchases had been mistakes and that others had lost their romance. Because a collector never stops making mistakes, refinement never ends and a collection is never "finished." It is like a living organism. If you stop collecting, the collection becomes a lifeless thing, merely decoration on the walls.

Beginning in 1964 we began the process, which still continues, of weeding out and trading up, of making gifts to museums, exchanging, and, once in a while, selling. One of the first paintings we acquired in part through exchange is our Prendergast oil, *Picnic by the Inlet,* painted between about 1918 and 1923 (cat. 35). I got a crack at it only after it had been turned down as too expensive by a handful of very wealthy collectors. It immediately burned a hole in my head, but I thought it was too rich for me. (An aside about prices: Despite the recent rise in prices of works of art, the idea that everything in the good old days was dirt cheap

is simply not accurate. The works of many artists, such as Prendergast, were never cheap in either absolute or relative terms. Another aside about our buying habits: We never bargain. We ask the best price and either accept it or walk away. As it happened, this approach turned out to be quite beneficial, because as a result of it we got first crack at new paintings from several dealers.) I could not stop thinking about the Prendergast, and I finally told the dealer, "Let's have it home." Once at home I knew I could never send it back, and, after parting with five of our fine pictures and some cash, it was ours.

This is an appropriate moment to report that in our experience with the dealers in American art—and we bought from all of them over the years—they have been genuinely helpful, decent, and just plain nice.

Margaret and I were never interested in assembling a "historical" collection and we never felt a compulsion to "fill in gaps." But we did try, after 1966, to concentrate on acquiring top examples of certain artists. One of them was William Merritt Chase. His pastel *Self-Portrait* (cat. 13), made about 1884, is one of only four pictures that we bought at auction. It has tremendous panache, and, like Manet's pastels, has all the warmth and force of a painting in oil. Another of the paintings by Chase we acquired was the oil *The Fairy Tale* (cat. 16), painted in 1892. One day Margaret accidentally met the delivery man of a certain art gallery, who told her that he thought a good Chase had just come in. She practically ran to the

gallery, asked to see the painting, almost fainted when she saw it, called me at the office and told me to come at once. When I arrived we bought it. It is Margaret's personal favorite and it has become the signature painting of our collection. That a detail from it—the delicate, lovingly painted figures and balancing parasol, positioned against a portion of the directly painted landscape—was used by William Gerdts for the dust jacket of his *American Impressionism,* the standard work on the subject, did a lot to make that so.

Along with accident, surprise has been an important element in the formation of our collection. In 1971, John K. Howat, curator of American art at the Metropolitan Museum, told us that the museum wanted to hold an exhibition of our paintings. We recalled later that Stuart Feld, Howat's predecessor, had originally floated the idea of an exhibition there of our collection, but it had not really registered as far as we were concerned. The reality of Howat's announcement came as a delightful surprise. We were excited and thrilled. Howat selected fifty paintings by twenty-five artists. He and Dianne Pilgrim, now director of the Cooper-Hewitt Museum, spent the next year and a half producing a scholarly but lively and handsome catalogue. The exhibition opened in April of 1973, and, I understand, was well attended.

After the 1973 exhibition we took a breather to take stock. We have continued to keep our hand in but the pace of our collecting has slowed. Things that interest us have always been in short supply, but now, when things do turn up their prices are towering, and some paintings, sadly, have simply been beyond our reach.

That said, some of our very best acquisitions were made after 1973. One of them is William Merritt Chase's oil *Reflections,* painted in 1893 (cat. 17). Although the painting relies on the common iconography of the mirrored reflection for both its subject and its title, it is complex and full of meaning. It is quite different from our other Chases and is one of my all-time favorites.

Another of our top favorites, acquired just a few years ago, is Childe Hassam's *Poppies,* painted in 1891 on the Isle of Appledore, off the coast of New Hampshire (cat. 25). It is generally agreed that Hassam's Isles of Shoals paintings of the early 1890s are his best. With its great delicacy and strong pictorial structure, we think this is one of the very best of the best.

One of the exciting experiences in collecting is the capacity to be surprised. When we first saw *Portrait of John Leslie Breck* by J. Carroll Beckwith we could not believe it was his work (cat. 4). We had known Beckwith only as kind of beaux-arts portrait painter, and had never seen anything by him in this loose, impressionist manner. We liked the painting at once. We were even more pleased

when we learned that its subject was another artist, and that it was painted in Giverny in 1891. Not wanting to lose it, we overpaid considerably for it, in terms of typical Beckwith prices at the time. Collectors can sometimes be goofy this way when they want something badly enough, but we just could not resist this impressionist portrait done with such obvious affection and brio, portraying a young man on the edge of experience, but already showing a touch of melancholy in his eyes.

Our most recent acquisition is an oil of about 1895 by John Twachtman, a view of his house in Greenwich, Connecticut, titled *September Sunshine* (cat. 45). For us, this painting has the same lyricism—the personally felt intensity of style, emotion, and quality—that runs through the entire collection.

A final note. Collecting can sometimes bring out the worst in one—especially in an aggressive, price-tag culture—but more often it can also be, to use Bernard Berenson's famous phrase, "life-enhancing." The fact that one collects in a narrow field does not mean that one's field of vision must be narrow. Indeed, the opposite is true. The passion for discovery is heightened and concentrated and the search to see behind the curtain becomes more intense. Collecting, looking, reading become an adventure in innovation, in seeing things in new ways, in refashioning and refreshing your ideas about life—and this is what art is all about. Collecting in this manner takes on in some small way the attribute, not of creativity, to be sure, but of the high purpose of finding things that no one ever thought were there.

RAYMOND HOROWITZ

Catalogue of the Exhibition

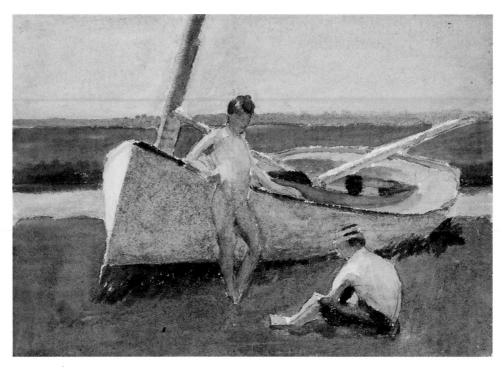

1 · *Two Boys by a Boat*

I

Two Boys by a Boat

c. 1894, watercolor and
graphite on paper, 6 x 8½
(15.2 x 21.6)

1 Anshutz to his brother Edward,
7 May 1893, Thomas Anshutz
Papers, Archives of American Art,
microfilm roll 140, as quoted
by Randall Griffin, Thomas An-
shutz: Artist and Teacher (Seattle,
1994), 60.

2 Griffin, Anshutz, 1994, 59–60.

3 Holly Beach, now known as Wild-
wood, is located on the Atlantic
shore of southern New Jersey
north of the city of Cape May.

4 Griffin, Anshutz, 1994, 54.

5 In addition to the swimming-hole
pictures, Eakins took a number
of photographs of young boys
similar to those later taken by
Anshutz. See Susan Danly and
Cheryl Leibold, Eakins and the
Photograph (Washington, 1994),
85, 110, 186, 191.

6 Anshutz to Cresson Schell,
as quoted by Griffin, Anshutz,
1994, 59.

Long considered one of the most influential
teachers of his generation, Thomas Anshutz has
been described as the critical link between the late
nineteenth-century realism of Thomas Eakins,
his mentor, and the early twentieth-century realism
of Robert Henri, John Sloan, William Glackens,
and Everett Shinn, his students.

Although revered as a teacher, Anshutz suffered
a period of doubt in the early 1890s when he felt
both his teaching and his painting had grown
stale. In 1892, after eleven years at the Pennsylvania
Academy of the Fine Arts, he resigned his position
and moved to Paris, where he enrolled in classes
taught by Lucien Doucet and Adolphe-William
Bouguereau at the Académie Julian. Although
quickly disillusioned with the academy, he none-
theless found the stimulation he sought in the
museums, galleries, and studios, where works by
the impressionists, Nabis, and other artists exper-
imenting with light and color were on view.
Shortly thereafter, he began producing the bright
and loosely painted watercolors that mark a
turning point in his career.

In the spring of 1893, while still abroad, Anshutz
wrote to his brother, "I have been working every
day of late at watercolor sketching. . . . It is very
difficult stuff to paint with for me, but I am im-
proving."[1] In the same letter he stated that if he
did not return to the Pennsylvania Academy, it
would "not be entirely a case of unmixed sorrow.
I feel very anxious to make a living outside of
teaching. And see no better scheme than to go to
Holly Beach and turn out a lot of water color
pictures of the sea shore etc."[2]

Holly Beach, a small resort community in
southern New Jersey, near Cape May, had long
been a vacation retreat for Anshutz.[3] In the spring
of 1894, following his return from Europe, he
purchased a summer residence there. A few weeks
later he began the series of watercolors that clearly
demonstrates the influence of impressionism
on his work as well as the staying power of lessons
learned from Eakins.

In 1884, a full decade before he began his Holly
Beach watercolors, Anshutz had taken students
on plein-air painting trips. The impetus for these
trips may have come from Eakins, who believed
that outdoor studies offered difficult, but essential,
lessons in the effects of natural light.[4] During this
same period Anshutz had assisted Eakins with
photographic studies, including the well-known
swimming-hole images.[5]

Years later, at Holly Beach, Anshutz followed
Eakins' lead by not only painting outdoors but
also by taking a series of photographs that he later
used to create a group of watercolors of young
boys and boats. Writing to a friend, Anshutz noted
that he had "been making some pictures of kids
lately and as they all have to start school next week
my occupation is gone."[6] Like Eakins, Anshutz
used photographs as he did sketches—as memory
aids for studio compositions. And, again like his
mentor, he produced studio paintings that were
far more distilled than the photographs on which
they were based.

7 Two other watercolors closely
 related to the same pair of photo-
 graphs are known. See Henry
 Adams et al., American Drawings
 and Watercolors in the Museum
 of Art, Carnegie Institute (Pitts-
 burgh, 1985), 127; Linda Ayres
 and Jane Myers, American Paint-
 ings, Watercolors, and Drawings
 from the Collection of Rita and
 Daniel Fraad (Fort Worth, 1985), 19.

8 Griffin, Anshutz, 1994, 64.

One of these works, *Two Boys by a Boat,* appears to be a spontaneously executed field study, but photographs suggest that the watercolor is a far more deliberate image (figs. 1, 2).[7] In this painting Anshutz stripped away most of the detail present in the photographs, and reduced every element to its skeletal essence. At such a high level of reduc-

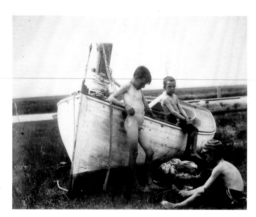

FIG. 1 · Thomas Anshutz, *Three Boys by a Boat—Maurice River,* c. 1894. Thomas Anshutz papers, Archives of American Art, Smithsonian Institution

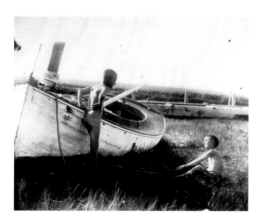

FIG. 2 · Thomas Anshutz, *Two Boys by a Boat,* c. 1894. Thomas Anshutz papers, Archives of American Art, Smithsonian Institution

tion, the painting becomes a study of form—the sensuous curves of the human body and the spare, but curvilinear architecture of the boat. Even the background landscape has been reduced to a series of horizontal bands. Narrative elements have also been excised. In the photographs the young boy on the ground is taking off his shoe; he has already removed his shirt and added it to a pile of clothing near the boat. In the painting, however, the boy's position is not explained, and there is no pile of clothing near the boat; a third figure (in the photograph most closely related to the watercolor) has been removed entirely. Even the central standing figure has been rendered with just a few lines and soft washes of color. Neither facial nor anatomical features compete with Anshutz's study of simple, sensuous forms.

In November 1893, when he was still looking for a suitable Holly Beach house, Anshutz wrote to his wife that he felt the light in the coastal town would be far better for his work than that in his studio.[8] The fresh, clear, transparent light that fills the Holly Beach watercolors was just what Anshutz was looking for—his search for such light, how-ever, was undoubtedly sparked by his experience in Paris. Eakins had encouraged Anshutz to study natural light outdoors but in Paris he saw paintings whose subject was light. The formal elements of *Two Boys by a Boat* are paramount, but they are defined by light.

The Holly Beach watercolors were produced at a critical juncture in Anshutz's career. Rejuve-nated by his trip abroad, delighted with his new summer home, and determined to strike out in a new direction, Anshutz created a group of lively, fresh watercolors with structural elements elegantly pared to the bone. N.A.

2

Woman Drawing

c. 1895, charcoal on paper,
24½ x 18¾ (62.2 x 47.6)

1 *Anshutz's teaching career is out-*
lined in Appendix C of Randall
Griffin, "Thomas Anshutz: A
Study of His Art and Teaching,"
Ph.D. diss., University of
Delaware, 1994, 273–276.

2 *Francis J. Ziegler, "An Unassum-*
ing Painter—Thomas P.
Anshutz," Brush and Pencil 4
(September 1899), 278–279.

3 *Ziegler 1899, 278–279.*

In the fall of 1893, following nine months abroad, Thomas Anshutz resumed teaching at the Pennsylvania Academy of the Fine Arts. Prior to his European trip he had served as assistant professor of painting and drawing. Upon his return he assumed responsibility for two classes: drawing from the figure and drawing from casts.[1] While in Paris Anshutz had himself attended life drawing classes at the Académie Julian. Although he found the drawing technique practiced there "mechanical," the charcoal sketches he produced served as ideal preparation for the classes he would teach when he returned to Philadelphia.

Drawing from casts had long been a staple of the curriculum at the Pennsylvania Academy, but rarely had the instructor entered as actively into the process as Anshutz often did. In 1899, after an interview with the artist, Francis Ziegler wrote that it was "his custom to spend considerable time with paper and charcoal in the midst of such of his academy students as are wrestling with the beautiful difficulties of the antique."[2] Ziegler went on to note that some of Anshutz's studies of the antique differ "considerably from conventional academic drawing." Describing the works as "sketches" often completed in less than an hour, Ziegler praised the works as "original in manner" and then continued, "the handling is with bold

masses of light and shade rather than with the point, and the introduction of a studio background, showing other casts or a group of busy students, makes these sketches resemble studies for pictures rather than the productions of the class-room."[3]

Woman Drawing, a charcoal sketch of exceptional merit, is just such a work. Briefly abandoning his role as instructor, Anshutz seated himself among his students, one of whom is sketching the cast of the figure commonly identified as Dionysus from the eastern pediment of the Parthenon. In a contemporary photograph (fig. 1), the cast is visible against the far wall. In Anshutz's sketch, however, its angular limbs have been transformed into sensuously curved arms and legs and the torso has been repositioned to echo the curves of the hat worn by the student sketching. As in the Holly Beach watercolors, Anshutz reduced the figurative elements to their essential form. No facial expressions are shown—indeed, Anshutz chose not to depict the head of Dionysus. Instead, the sketch is a study of light and shade with the opaque darkness of the chairback and the student's hat juxtaposed against the bright studio smock and the surface of the cast. Anshutz also placed in opposition the flowing curves of the smock, the sensuous anatomy of the cast, and the sharp horizontals of the chair and pedestal.

The loose and spontaneous strokes testify to a sure and unfettered hand, and the technique evident in the drawing may reflect Anshutz's rejection of the method employed at the Académie Julian, where he was advised to avoid rubbing applied charcoal. Shortly after his return from

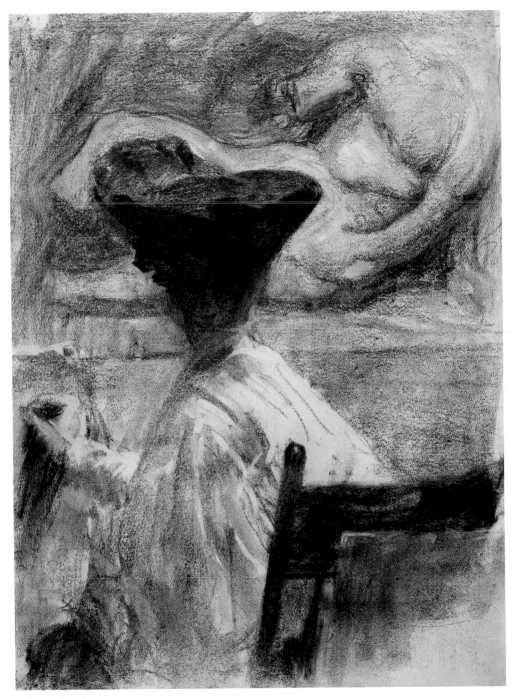

2 · *Woman Drawing*

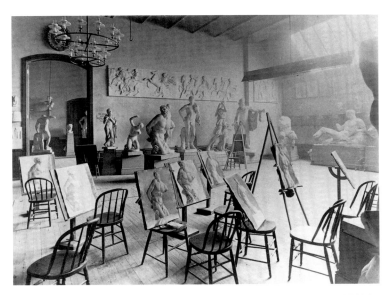

FIG. 1 · Charles Truscott, *Cast Drawing Room*, c. 1890s. Archives, Pennsylvania Academy of the Fine Arts, Philadelphia

4 Anshutz to Effie Anshutz,
11 November 1893, Archives
of American Art, microfilm
roll 140, as quoted by Griffin,
"Study," 1994, 61.

Paris, Anshutz wrote that he was "getting a corn on the end of my finger like a violinist from rubbing charcoal."[4]

Woman Drawing, a compelling work, is also historically resonant. In 1886 the board of the Pennsylvania Academy forced Thomas Eakins, Anshutz's colleague and mentor, to resign. Ostensibly the ouster came because of his insistence on using nude male models in mixed drawing classes. In fact, the move may have been prompted by a greater concern for enrollment numbers (more female students) than teaching techniques. Anshutz supported the board's decision. Thus there is no small irony in the fact that one of Anshutz's finest charcoal sketches, completed just a few years after Eakins' forced resignation, shows a female student sketching a male figure from a cast (Eakins championed sketching from the live model rather than casts) while wearing a hat that entirely obscures the genital area of the figure—Dionysus. N.A.

3
Ethel Page (Mrs. James Large)

1890, pastel on paper,
16⅛ x 12 (41 x 30.5)

1 We are grateful to Tara L. Tappert
 for providing biographical infor-
 mation on the sitter.

2 The Society of Painters in Pastel
 held their first exhibition in New
 York in 1884 and had subsequent
 shows in 1888, 1889, and 1890.
 Beaux was a contributor to the
 final exhibition. For a history of
 the Society see Dianne H. Pilgrim,
 "The Revival of Pastels in Nine-
 teenth-Century America: The
 Society of Painters in Pastel," The
 American Art Journal 10 (Novem-
 ber 1978), 43–62.

3 Tara L. Tappert, "Choices—The
 Life and Career of Cecilia Beaux:
 A Professional Biography," Ph.D.
 diss., George Washington Univer-
 sity, 1990, 258–259.

4 Cecilia Beaux, Background with
 Figures (Boston and New York,
 1930), 196.

5 Letter of 19 May 1934 from
 Cecilia Beaux to Pauline Bowie,
 courtesy of Tara L. Tappert.

Cecilia Beaux first met Ethel Page (1864–1934) in 1876, when the sitter was just eleven years old.[1] Over the years, Beaux would create at least three portraits of her: *Ethel Page (Mrs. James Large)* (1884, National Museum of Women in the Arts; fig. 1); *Ethel Page as "Undine"* (1885, private collection); and this striking image in pastel. Beaux produced this work at the height of the American revival of interest in pastels.[2] Her ability to transform the colored chalks into the textures of shimmering satin and sumptuous fur-lined velvet demonstrates extraordinary skill in this medium.

In 1890, when this work was completed, Beaux had only recently been attempting pastel portraits. While abroad in 1889 she had traveled to England, and in Cambridge she began to experiment in the medium. Having found some success with her English subjects, she turned to pastel again as she set up her studio and tried to reestablish her professional career in the United States. Pastels were "especially good for women's portraits," Beaux believed, and used the medium for several female subjects over the next few years.[3] Although she later claimed that "pastel was never a rival of oil color" and taught her "only a bit of useful strategy that was an aid toward meeting the obstinate armaments of so-called 'oils,'" *Ethel Page* is clearly an ambitious, fully realized portrait.[4]

While a lesser artist might have allowed the sitter's personality to be overshadowed by the dramatic costume that threatens to engulf her, here Beaux uses it to reinforce the subject's presence. The beauty and warmth of the twenty-five-year-

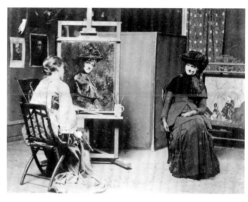

FIG. 1 · *Cecilia Beaux painting the portrait of Ethel Page (Mrs. James Large),* 1884. Henry S. Drinker Collection, Archives, Pennsylvania Academy of the Fine Arts, Philadelphia

old sitter is protected and enhanced by the golden white cloud in which she rests. Page turns slightly to one side and leans back in an armchair in a relaxed pose. The lightness and informality of this work differs noticeably from Beaux's earlier portraits of Page, and it also illustrates the artist's remarkable ability, in her most successful works, to convey the inner life of her subjects. The extraordinary sensitivity of this portrait is partly explained by the affection that Beaux had for her subject. Upon Mrs. Large's (Ethel Page) death in 1934, the elderly Beaux wrote with deepest feeling to a mutual friend: "Youth was always effulgent in her —in her voice—in her walk—in her exquisite smile . . . [and] strength of character. . . . No one can possibly imagine—who did not know her— her personality, unique, transcending ordinary humanity."[5] D.C.

3 · *Ethel Page (Mrs. James Large)*

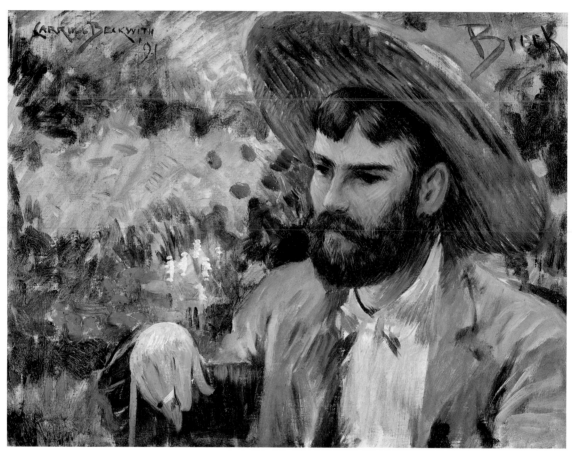

4 · *Portrait of John Leslie Breck*

4
Portrait of John Leslie Breck

1891, oil on canvas,
13¼ x 17¼ (33.7 x 43.8)

1 J. Carroll Beckwith, Diary. National
 Academy of Design, New York.

2 "I had another glimpse of Robin-
 son's charming work. I think it
 unusually attractive." Diary, 12
 August 1891.

3 The Americans admired Monet's
 art, but at least two of them,
 Breck and Butler, also admired
 Monet's stepdaughters, Blanche
 and Suzanne Monet-Hoschedé.
 Monet ended Breck's relationship
 with Blanche, but Butler success-
 fully courted Suzanne; they were
 married in 1892 and Theodore
 Robinson painted their wedding
 procession.

4 Diary, 8 August 1891.

5 Diary, 27 June 1891.

6 Diary, 19 August 1891. "Pure land-
 scape is too hard for me. I know
 too well how it should look to be
 satisfied with what I do."

7 Diary, 4 September 1891.

The mural painter and portraitist J. Carroll Beckwith (see fig. p. 59) spent the summer of 1891 in France, a visit that included, at its end, a month or so in Giverny. His particular friend there was the American painter John Leslie Breck. It was Breck who, on August 8, met Beckwith and his wife at the railroad station at Vernon and drove them to Giverny. And on September 2, as Beckwith recorded in his diary, he "began a little head of Breck."[1] It is a strikingly warm and sympathetic painting, and a token in those respects of their close friendship; it is also a very faithful likeness, as a more formal portrait photograph of Breck shows (fig. 1).

It was a memento, too, of what, for Beckwith, seems to have been a particularly heady time in the artistic community of Giverny. It included other Americans—Thomas Sargent Perry and his wife, the painter Lila Cabot Perry, and the artists Theodore Butler and Theodore Robinson, whose work Beckwith particularly admired[2]—and Claude Monet, who lived in Giverny and was the gravitational center of that constellation of admirers.[3]

Beckwith's month in Giverny was idyllic, a time of art and music, and tennis with Breck and the Perrys.[4] But it was also one that, if only temporarily, seemed to have challenged and broadened him artistically. Earlier in the summer, before going to Giverny, Beckwith had severe misgivings about the impressionist landscapes he saw in the Paris Salon; they were, he said, painted by "extremists" who "produce things bright but with no drawing and devoid of style."[5] In

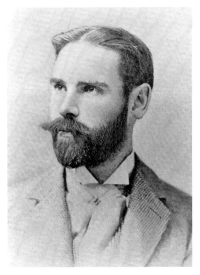

FIG. 1 · *John Leslie Breck,* published in Memorial Exhibition Catalogue, The National Arts Club, New York, 1899

Giverny, however, he tried his own hand at landscape, though he quickly gave it up as "a bad job."[6] And when Robinson took him to Monet's studio he was capable of admiring Monet's poplar series, his newest and most radically impressionist paintings: "his last things of the poplars following the Epte [River] are remarkable and profoundly interesting."[7]

And Beckwith's own style underwent a change. Though he normally painted with a certain timid breadth (fig. 2), his portrait of Breck is executed with considerably greater dash and vigor, both of brushwork and of color, as though, in response to the painterly milieu of Giverny (of which, of course, Breck's art was a part), he was bringing his style up to the level of and into line with a form of impressionism that he once considered extreme.

FIG. 2 · J. Carroll Beckwith, *Girl Reading,* oil on canvas, c. 1890. Kennedy Galleries, Inc., New York

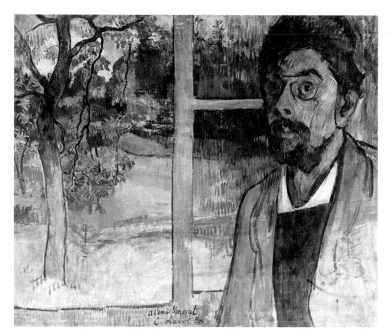

FIG. 3 · Charles Laval, *Self-Portrait,* oil on canvas, 1888. Van Gogh Museum, Amsterdam (Vincent van Gogh Foundation)

This was a matter not only of color and brushing, but of pictorial arrangement as well. By placing his friend's figure far to one side of the horizontal composition, Beckwith rejected the conventional central placement of the subject—perhaps because it *was* conventional and he was striving for something that explicitly was not, and that was, by virtue of its deliberate informality, best suited to an intimate and private portrait, and even to a degree, by the form he chose for it, expressed that intimacy and privacy. It is interesting to observe, but not possible to explain, that the form of Beckwith's portrait closely resembled one chosen a few years earlier by another group of artists at another art colony in France, the ones around Paul Gauguin in Pont-Aven in Brittany in the late 1880s. Far more radical than those of the Breck-Beckwith circle in Giverny, they—Gauguin himself, and his younger friends and admirers Emile Bernard and Charles Laval (fig. 3)—painted a group of self-portraits, which they sent to Vincent van Gogh in Arles as tokens of friendship and shared artistic purpose, that similarly placed the sitter to either side of the painting's central axis. "Japanese artists often used to exchange works among themselves," Van Gogh explained to Bernard, for "[t]he relationship between them was evidently, and quite naturally, brotherly; they didn't live a life of intrigue."[8] Perhaps the asymmetrical balance of these portraits, emulating the most distinctively non-Western element of Japanese pictorial design, was another expression of an admiration that all of these artists, and Beckwith as well, shared. N.C.

8 *Quoted in John Rewald,* Post-Impressionism from Van Gogh to Gauguin *(New York, 1962), 209.*

5

Swans in Central Park

1906, oil on canvas,
18¾ x 21¾ (47.6 x 55.3)

1 Quoted in Margaret C. S. Christ-
man, Portraits by George Bellows
(Washington, 1981), 13.

2 Quoted in Charles H. Morgan,
George Bellows: Painter of Amer-
ica (New York, 1965), 40.

3 Marianne Doezema, "The 'Real'
New York," in Michael Quick
et al., The Paintings of George
Bellows [exh. cat., Amon Carter
Museum] (Fort Worth, 1992), 98.

In the fall of 1904 George Bellows arrived in New York City, having given up his studies at Ohio State University after three years. Determined to become a painter, he enrolled in William Merritt Chase's New York School of Art, where he fell under the influence of the realist Robert Henri. Encouraged by Henri to find subjects in the world around him, Bellows discovered inspiration virtually everywhere he turned. "I am always very much amused with people who talk about the lack of subject matter for painting," he observed. "The great difficulty is that you cannot stop to sort them out enough. Wherever you go, they are waiting for you. The men of the docks, the chil-

dren at the river's edge, polo crowds, prize fights, summer evenings and romance, village folk, young people, old people, the beautiful, the ugly."[1]

During the first five or six years of his career, Bellows created a remarkable body of work drawn from his observations of the rich tapestry of New York life. Like Henri, Bellows discovered that "there is beauty in everything if it looks beautiful in your eyes. You can find it anywhere, everywhere."[2] Bellows found it on cliffs overlooking the Hudson, in city parks, in the hustle and bustle of urban streets, in the noise and chaos of construction sites, and in the smoky, crowded rooms of boxing clubs. *Swans in Central Park* is one of his earliest depictions of New York, following two pictures of the previous year, *Central Park* (Ohio State University Faculty Club, Columbus) and *Bethesda Fountain (Fountain in Central Park)* (Hirshhorn Museum and Sculpture Garden, Smithsonian Institution, Washington). With this subject, Bellows may well have had in mind the depictions by Chase, such as *A Bit of the Terrace (Early Stroll in the Park)* (c. 1890, private collection), which focused on the many pleasurable pastimes the park offered.[3] Swans were among the attractions of Central Park almost from its inception, having been introduced in 1860, and feeding them was a favorite activity for children (fig. 1). "The Park swans are very tame," observed Clarence Cook in 1869, "and will come at a call to feed from any hand, although we believe the Commissioners do not

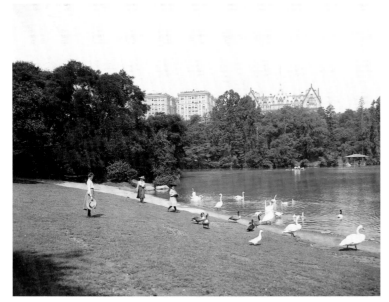

FIG. 1 · *Feeding the Swans, Central Park*, c. 1903. Library of Congress, Detroit Publishing Company Photograph Collection

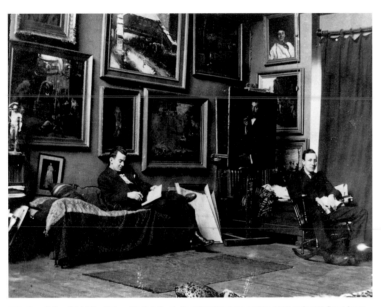

FIG. 2 · *Bellows (at right) and Edward Keefe in the studio at 1947 Broadway*, c. 1907–1908. Amherst College Library, George Bellows Papers (box 5, folder 2)

4 A Description of the New York Central Park *(New York, 1869; reprint ed., New York, 1979)*, 61.

5 *This photograph was brought to our attention by Glenn Peck.*

like to have them fed in this way."[4] Henri and others of his circle, especially William Glackens, also often painted scenes of the park.

Bellows was still very much under the influence of Henri's style at this point, but here the bold brushwork points to the emergence of his own powerful sensibility. Far more than his mentor, Bellows appreciated the expressive possibilities of thickly applied paint animating and energizing the surface of the canvas. Although he would shift his focus over the next few years to grittier and less genteel parts of the city, he would continue to employ the heavy pigment and bold forms of *Swans in Central Park* in such major works as *The Lone Tenement* (1909, National Gallery of Art) and *Pennsylvania Station Excavation* (1909, Brooklyn Museum).

Bellows apparently thought well of *Swans in Central Park,* for he gave it to his close friend and roommate Edward Keefe. A photograph (fig. 2) of c. 1907–1908 shows Bellows and Keefe in the studio they shared in the Lincoln Arcade Building on Broadway, and the right half of this painting is visible on the far wall, just behind Bellows' head.[5] F.K.

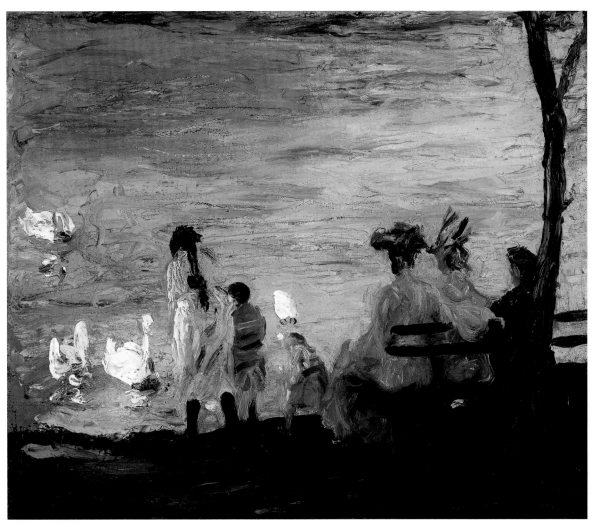

5 · *Swans in Central Park*

6

Emma in the Purple Dress

1919, oil on panel,
40 x 32 (101.6 x 81.3)

1 Charles H. Morgan, George
Bellows, Painter of America
(New York, 1965), 48.

2 Jane Myers, "'The Most Search-
ing Place in the World': Bellows
and Portraiture," in Michael
Quick et al., The Paintings of
George Bellows [exh. cat., Amon
Carter Museum] (Fort Worth,
1992), 187.

3 Philadelphia Public Ledger,
4 February 1912, 9, as quoted
in Myers 1992, 187.

Soon after arriving in New York, in 1904, Bellows met Emma Story, who studied briefly at the New York School of Art before giving up painting for music. At first he took no particular notice of her, and she preferred to keep company with Bellows' fellow students Rockwell Kent and Edward Hopper. But suddenly, in the fall of 1905, when Emma paid a visit to the school, Bellows fell deeply in love.[1] Although he made up his mind almost immediately that he would make her his wife, the courtship proceeded with agonizing slowness; but eventually Bellows worked his way into her heart. In the spring of 1910, with a growing reputation and a new appointment as life class instructor at the Art Students League, which promised a steady salary of one thousand dollars a year, he finally convinced her to marry him. They were wed that September.

Bellows had painted portraits and figure studies since the earliest days of his career, and he did not wait long before turning his artistic attentions

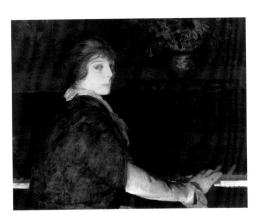

FIG. 1 · George Bellows, *Emma at the Piano*, oil on panel, 1914. The
Chrysler Museum of Art, Norfolk, Va., Gift of Walter P. Chrysler, Jr. 71.617

to his wife. In November 1910 he painted *Candle-light,* which showed Emma seated at a table, and *Girl on a Couch,* where she was depicted reclining.[2] Neither was well received, with the latter particularly disliked for its "Frenchified artificiality," and Bellows later destroyed both canvases.[3] During the early years of his marriage, Bellows, with the mounting expenses of a growing family, sought out portrait commissions, but his experiences were mixed, and after 1913 he rarely did so again. He was happiest when he could paint to please himself, rather than a particular patron. On Monhegan Island in the summer of 1914 he painted portraits of friends and relatives, including the striking *Emma at the Piano* (fig. 1). Here, one senses, her gaze is not directed at the viewer, as in a formal portrait, but at her artist/husband within the fictive space of the painting. Two summers later, while in Camden, Maine, Bellows depicted his wife outdoors in *Emma in the Orchard* (fig. 2), a brightly lit scene quite unlike the tenebrist environment of the earlier portrait.

Among Bellows' most powerfully intense and psychologically complex depictions of his wife are two painted in Middletown, Rhode Island, where he spent the summer of 1919 with his family. Indeed, *Emma in the Black Print* (fig. 3) and *Emma in the Purple Dress,* along with a portrait of his mother, *Grandma Bellows* (1919, Oklahoma City Art Museum), have been seen as the first indications of a dramatically revised approach to portraiture. With their dark background, simplified compositional geometry, allusions to the past, and mood of sober introspection, these works are

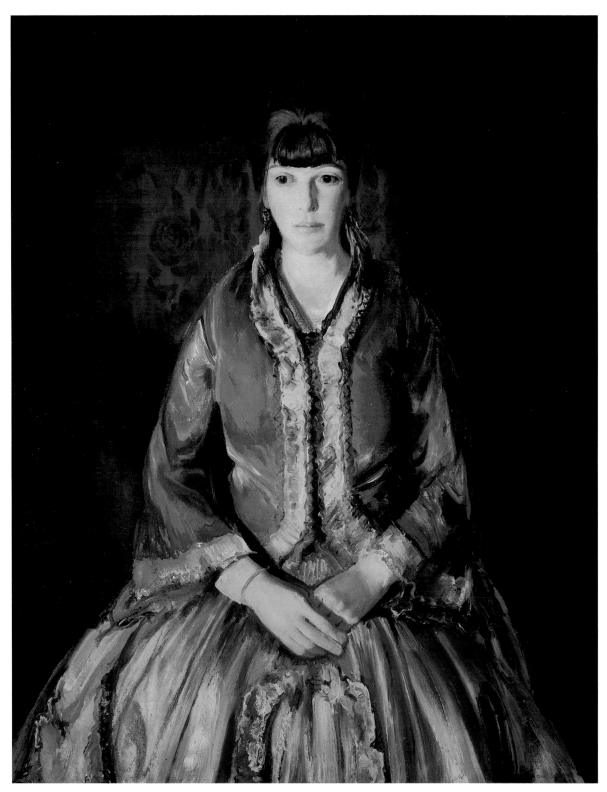

6 · *Emma in the Purple Dress*

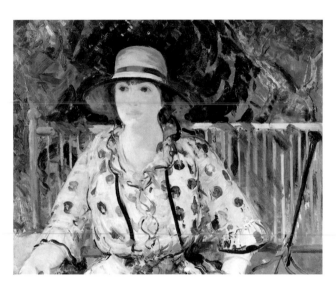

FIG. 2 · George Bellows, *Emma in the Orchard*, oil on canvas, 1916. Cummer Museum of Art and Gardens, Jacksonville, Fla.

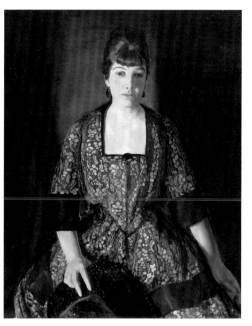

FIG. 3 · George Bellows, *Emma in the Black Print*, oil on canvas, 1919. Museum of Fine Arts, Boston, Bequest of John T. Spaulding

FIG. 4 · George Bellows, *Emma in a Purple Dress*, oil on canvas, 1920–1923. Dallas Museum of Art, Dallas Art Association Purchase

4 Michael Quick, "Technique and Theory: The Evolution of George Bellows's Painting Style," in Quick et al. 1992, 71.

as much portraits of states of mind as they are of individual appearance.[4] In the nearly monochromatic *Emma in the Black Print* she sits in a vaguely defined space, hat in hand and wearing an old-fashioned dress. Her expression is all but inscrutable, and it is not clear whether she has just been seated or is, in fact, about to rise and leave. Similar in format, *Emma in the Purple Dress* is even more rigorously geometric, with the overall pyramidal shape of Emma's body inversely rhymed by the v-neck of her blouse and her clasped hands. Though richly vibrant in its color and its brushwork, the painting's powerful stability and monumentality give the impression of an immutable stasis. Emma, as seen here, is not about to rise and leave, and any attempts by the viewer to imagine the narrative possibilities of a moment before or after that depicted are wholly thwarted. And by showing her with her eyes

slightly shifted to her right, Bellows managed to deny the possibility of any visual communication (whether with an "outside" viewer or an "inside" painter) that would establish a reference to something more than what we see. Seldom does one

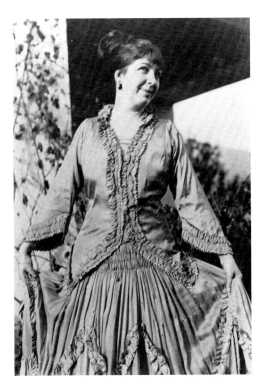

FIG. 5 · *Emma Bellows,* n.d. Amherst College Library, George Bellows Papers (box 6, album 2, no. 58)

encounter a portrait so determinedly hermetic in its totality. It may be clearly legible in what it *depicts,* but it is deeply and mysteriously indecipherable in what it *portrays.*[5] Subsequent depictions of Emma, such as *Emma in a Purple Dress* (fig. 4) and the lithograph *Lady with a Fan* (1921), showing her seated in a large chair in a clearly defined interior, are more conventionally composed and correspondingly less enigmatic.

The specific genesis of this portrait lies in a seemingly unimportant event. As Bellows' biographer Charles Morgan recounted: "One day

Emma returned in triumph from a shopping expedition with a length of purple silk that perfectly complemented one of her favorite blouses. Her quick fingers—she made all her everyday clothes —transformed it into a long, full skirt, and George immediately swept her into a chair and began work on 'Emma in the Purple Dress.'"[6] Emma posed proudly in the skirt and blouse in a photograph (fig. 5), presumably taken around the same time. The black and white image cannot corroborate it, but Bellows apparently took liberties with the colors of the fabrics. As Emma remarked some years later of the second painting of her in the outfit (fig. 4): "I know that dress by heart. I made the jacket myself. The skirt was rose-colored, the jacket blue. I don't know why he called it *Emma in a Purple Dress.*"[7] Perhaps it was because the optical blending of the colors do suggest an overall purple tonality, or because a title like "Emma in the Rose Skirt and the Blue Jacket" was simply too cumbersome. Whatever the case, Bellows was extremely pleased with the picture. As he wrote to Robert Henri: "I think I have painted my best portrait of Emma and a rare picture to boot."[8] Although never reluctant to compliment himself when he felt he had done well—he called *An Island in the Sea* (1911, Columbus Museum of Art) "a real sure enough masterpiece"—the paintings he singled out for praise were invariably among his very best, at least to modern eyes.[9] Bellows once wrote to his beloved Emma: "Can I tell you that your heart is in me and your portrait is in all my work."[10] Certainly *Emma in the Purple Dress,* more than any other work by Bellows, confirms the truth of those words, for it is, in every sense, precisely what he claimed: "a rare picture." F.K.

5 "Portray," from the Latin protrahere, *means to draw forth, reveal, expose.*

6 *Morgan 1965, 225.*

7 "Painter and Wife," Time (24 December 1951); clipping, New York Public Library Vertical Files.

8 *Quoted in Morgan 1965, 225.*

9 *Undated letter to Emma Bellows, Bellows Papers (Box I, Folder 3), Amherst College Library, as quoted in Franklin Kelly, "Bellows and the Sea," in Quick et al. 1992, 145.*

10 *Undated draft, Bellows Papers (Box I, Folder 2), Amherst College Library, as quoted in Myers 1992, 207.*

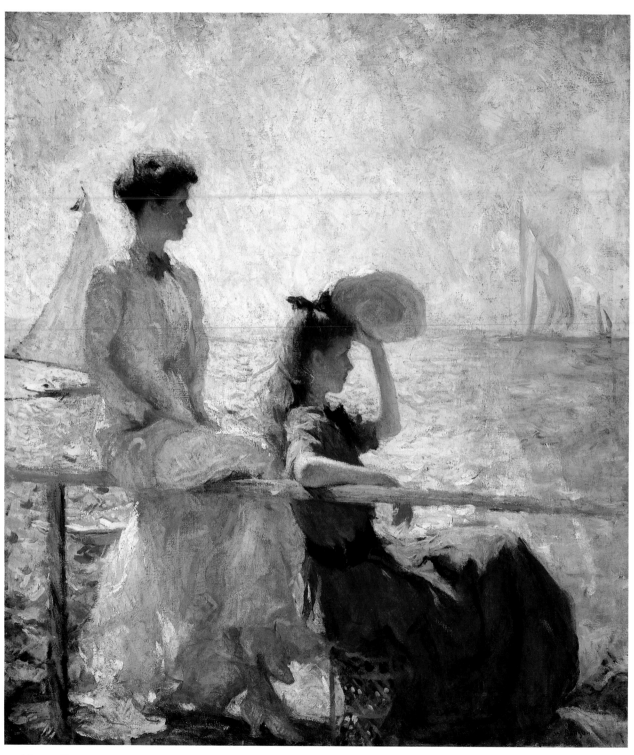

7 · *A Summer Day*

7

A Summary Day

A Summer Day

1911, oil on canvas,
36⅛ x 32⅛ (91.8 x 81.6)

1 *North Haven is the northernmost and second largest of a group known in earlier times as the Fox Islands. It is approximately eight miles long and three miles wide, with a shoreline nearly fifty miles long. See* The North Island: Early Times to Yesterday, *compiled by Norwood P. Beveridge (North Haven, Me., 1976). Among the other summer inhabitants of North Haven was the Boston sculptor Bela Pratt and his family, close friends of the Bensons.*

2 *According to Faith Andrews Bedford, "Sailboat races were a common occurrence off Bensons' point, and the family often took part in them" (in* Frank W. Benson: American Impressionist *[New York, 1994], 135). Even today, on every summer Saturday, the sails of a certain type of North Haven dinghy "can still be spotted along the Fox Islands Thoroughfare, continuing a century-long tradition of races that still start at two o'clock, when the southwest breeze picks up." Ellen MacDonald Ward, "North Haven,"* Down East *(August 1994), 46.*

3 *Quoted by Faith Andrews Bedford in* Frank W. Benson: A Retrospective *[exh. cat., Berry-Hill Galleries] (New York, 1989), 67.*

Frank Benson is most celebrated today for his depictions of his family at summer leisure in Maine. Although he was an incisive portraitist, accomplished watercolorist, and successful painter of sporting subjects and women in peaceful interiors, his impressionist scenes of figures in the out-of-doors are his most sought-after works. *A Summer Day* is one of the most beautiful of these images.

Throughout his career Benson lived in Salem, Massachusetts, while exhibiting and teaching in Boston. He also came to own a modest house at Eastham, near Cape Cod's Nauset Marsh, which he used primarily in the winter while hunting waterfowl. Beginning in 1902, however, and well into the artist's old age, the Benson family spent their summers in an old farm house, surrounded by open fields atop unspoiled North Haven Island in Maine's Penobscot Bay.[1] In 1906 they were able to purchase Wooster Farm, the property they had rented (fig. 1). Each season the artist found new inspiration in his surroundings and activities, which he depicted in works that he would exhibit in the following winters.

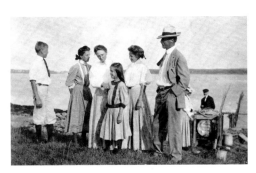

FIG. 1 · *Benson family on the lawn at Wooster Farm*, 1907. Courtesy of the Peabody Essex Museum, Salem, Mass.

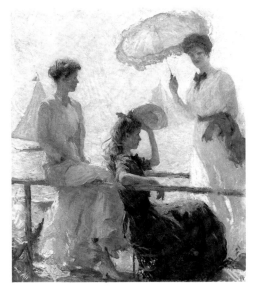

FIG. 2 · Baldwin Coolidge, photograph of the original version of *A Summer Day*, 1911. Courtesy of the Society for the Preservation of New England Antiquities

Most often the figures in these paintings were his daughters, sometimes his son, and their companions. In *A Summer Day*, Benson's daughter Elisabeth perches on a railing while her younger sister Sylvia sits beside her on a wicker stool. The two girls appear to be watching a race off the North Haven shore.[2] At one point, as seen in a photograph, the figure of another girl, their sister Eleanor, was included at the right, holding a parasol (fig. 2). A bluish shadow along the right edge of the canvas follows the contour of what was once her dress. Benson often rearranged the elements of his design, as composition was of the highest importance to him: he once wrote Eleanor that "Design makes the picture. . . . A picture is good or bad only as its composition is good or bad."[3] *A Summer Day* is composed of a grid of

4 William Howe Downes, "The Spontaneous Gaiety of Frank W. Benson's Work," Arts and Decoration 1 (March 1911), 195.

5 Downes 1911, 196.

horizontal (the railing, resting arm and thigh, horizon) and vertical (the straight backs of the sitters, the railing support, the raised arm, and the sail) arranged elements.

Even more dominant than the painting's careful disposition of figures and open space is the extraordinarily sensuous quality of the work. The fluttering wisps of hair, the filled sails of the boats, and the warm sunlight on the peachy skin of a forearm are details that suggest that the sun and fresh air are palpably and deliciously real. The figures are completely open to and engaged in their environment.

Benson had made some forays into plein-air painting as early as the 1880s, and by 1898, with the dappled light of *In the Woods* (location unknown), had shifted his emphasis to painting the figure out-of-doors. He was certainly not the only artist to do so—his close friend and colleague Edmund Tarbell, as well as other members of the Boston school, painted similar subjects. However, as the critic William Howe Downes observed in 1911, "there are few living painters whose works are better calculated to give unalloyed pleasure."[4] Benson achieves this response not only through the sheer escapism of his vibrant images of idle hours, but through his skill, sensitivity, and discipline. Of his work Downes wrote, "the suggestiveness of the style, which goes just far enough in the way of definition without impairing the pristine freshness of the first impression, is stimulating to the imagination." Downes also lauded Benson's instincts, which he felt "avoided the perils of sentimentality, banality, saccharinity."[5]

In subsequent years, other critics would be less generous in their praise. Benson must have realized that the appeal of his genteel subjects would fade for an audience becoming accustomed to the virility of the ashcan school. When he finally shifted his choice of subject, it was not to the gritty realities of urban life, but to the field and marsh. In the two decades after the 1913 Armory Show, when many American artists were responding to the modern European influences that were displayed there as well as to the new realism, Benson achieved steady commercial success with his wildfowl and sporting subjects.

In some of these, those that show white herons painted against backgrounds of blue water, the birds' shimmering feathers recall the fluttering dresses of Benson's young models. The distinctive light touch and the artist's dry, sometimes dragging brushstrokes are used to good effect in many of these later works. But the qualities that evoke the kind of world in which we might like to live are found not so much in his unpeopled landscapes, nor in his well-appointed interiors, but in his brilliant depictions of the idylls of friends and family such as *A Summer Day*. D.C.

7 · *A Summer Day* (detail)

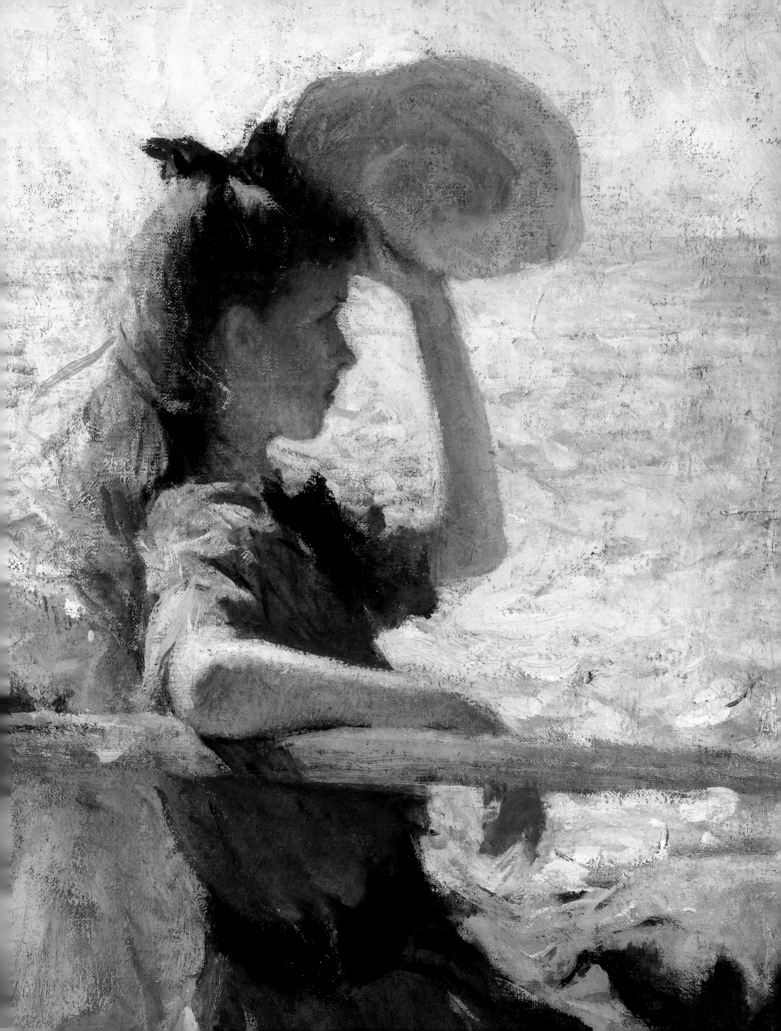

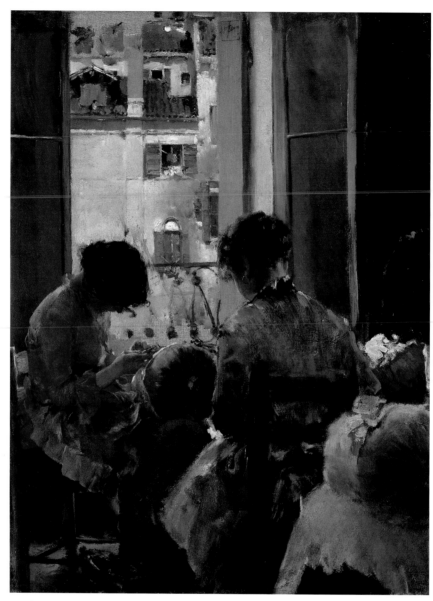

8 · *The Lace Makers*

8

The Lace Makers

c. 1885–1887, oil on canvas,
16⅛ x 12¼ (41 x 31.1)

1 *Quoted in Bruce Weber, "Robert Frederick Blum (1857–1903) and His Milieu," Ph.D. diss., City University of New York, 1985, 1: 108.*

2 *Letter quoted in Weber 1985, 1: 279.*

3 *See Margaretta M. Lovell, Venice: The American View 1860–1920 [exh. cat., Fine Arts Museums of San Francisco] (San Francisco, 1984), 27; Weber 1985, 1: 279–280; Mrs. Bury Palliser, History of Lace (New York, 1902), 59–63.*

4 *Letter to Otto Bacher, quoted in Lovell 1984, 26. The painting Blum was working on was the large version of the subject, now at Cincinnati and which he exhibited later that year. The Horowitz picture is one of two smaller versions.*

Robert Blum first visited Venice in late May 1880 after a month-long trip through Europe that included London, Paris, Genoa, Pisa, and Rome. None of those places pleased him (except Paris, where Blum saw William H. Stewart's large collection of paintings by their shared idol Mariano Fortuny). Venice, however, enchanted him, and he remained there for two and a half months. Much of that enchantment derived from the singular beauty of the place itself, of course, but a large community of American artists, which included the expatriate James McNeill Whistler, added greatly to its appeal. Whistler lived in the Casa Jankowitz, on the Riva degli Schiavoni, as did Blum; about a month after arriving in Venice Blum said of Whistler, "I know him well, he seems very much interested in me and . . . always encourages me. He is," he felt (others had a very different opinion), "a nice man."¹

FIG. 2 · Lace pillow, illustrated in Tina Frauberger, *Handbuch der Spitzenkunde*, Leipzig, 1894

Blum was in Venice several times in the 1880s, but his visit in the summer of 1885, so far as this painting is concerned, was crucial. At that time he went to the nearby island of Burano, attracted there, he wrote—following Whistler's practice, and John Singer Sargent's, too, of avoiding standard Venetian tourist subjects and places—because it is "unspoiled by the plague of foreigners, and is completely secluded."² At Burano he found the subject of this and other of his pictures of Venetian lace makers. In two respects they were thoroughly modern pictures. By the middle of the nineteenth century, the making of lace in Venice, which had been one of the world's leading suppliers since the sixteenth century, was extinct. Beginning in 1872, however, a school was founded at Burano to teach young women this lost art. The school opened with eight students; by 1882, a few years before Blum's visit, there were three hundred and twenty.³ Lace making had become an important and highly—and newly—visible part of Burano's life and culture (fig. 1). By January, Blum reported to a friend, he was at work on "a 'lace-makers' picture."⁴ (The woman at the left of the painting works on a lace pillow [fig. 2], and there are others on the table at the right.)

FIG. 1 · Carlo Naya, *Venetian Lacemakers*, 1887. Naya-Böhm Archive, Venice

5 Quoted in Weber 1985, 1: 22; Martin Birnbaum, *Catalogue of a Memorial Exhibition of the Works of Robert Frederick Blum (New York, 1913).*

6 M. G. van Rensselaer, "American Painters in Pastel," Century Magazine 29 (December 1884), 208.

One aspect of the painting's modernity, therefore, is its currency of subject. The currency of its style is another, for it is painted in the manner of one of the most admired and influential artists of the late nineteenth century, Mariano Fortuny—one of those artists, Giuseppe de Nittis and Alfred Stevens are others, who often had a greater influence on Americans than their now more admired contemporaries Edgar Degas or Claude Monet. Blum's devotion to Fortuny was formed as a student in Cincinnati in 1874 (the year of Fortuny's death). He and his fellow art students "worshipped" at Fortuny's "shrine," and a few years later, in New York, his devotion had become so great that he was "chafingly called Blumtuny."[5] What one critic described as Fortuny's "brilliancy, and gem-like sparkle," and another, less complimentarily, called "brassy and glassy," was, if not the sole influence on Blum, undeniably the greatest, and strong enough in the nervous detail and sharp contrasts of light and dark in oil paintings of the middle 1880s, like *The Lace Makers,* to survive the equally strong yet very different influence of Whistler.

FIG. 4 · Johannes Vermeer, *The Lacemaker,* oil on canvas transferred to panel, c. 1669–1670. Musée du Louvre

Blum's interest in modern subject matter did not appear for the first time in *The Lace Makers.* Two years earlier, at the exhibition of the Society of American Painters in Pastel in New York (of which Blum was president), he showed three pastels of "groups of working-girls" that were, in a description that might apply equally well to *The Lace Makers,* "actual transcripts from . . . local life. . . . They were no less truthful than novel, and were truthful in the best fashion—with a veracity touched by artistic idealization, but not transformed by it out of true verisimilitude. . . . All were unconventional and apparently unstudied in arrangement, rapid, frank, and nervous in handling. . . ."[6]

If *The Lace Makers* is in its subject and style an emphatically modern picture, its roots in tradition—though aspects of tradition that were newly available in the nineteenth century and thus in that way modern also—are equally deep. For surely resonating in Blum's *Lace Makers* is the presence of such artists, deeply admired by Blum and his friends (like William Merritt Chase), as Velázquez (fig. 3) and Vermeer (fig. 4). N.C.

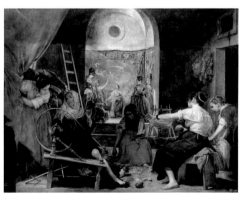

FIG. 3 · Diego Velázquez, *The Weavers,* oil on canvas, c. 1657. Museo Nacional del Prado

9

The Blue Obi

c. 1890–1893, pastel on
canvas, 18 x 13 (45.7 x 33)

1 *Martin Birnbaum,* Introductions:
Painters, Sculptors and Graphic
Artists *(New York, 1919), 97.*

2 *Robert Blum, "An Artist in
Japan,"* Scribner's Magazine
13 (April 1893), 399.

3 *Robert Blum to Otto Bacher,
Tokyo Hotel, 22 June 1890. Otto
Bacher Papers, Archives of
American Art, Smithsonian Insti-
tution. Blum arrived in Japan
on 6 June 1890.*

"It may safely be claimed that [Robert Blum's]
Japanese pastels were never excelled, if judged
purely from the technical point of view—that is
to say, from the way in which the medium is
handled," Martin Birnbaum wrote. "With his little
sticks of color he could make the flesh of a Geisha
as silken as if he were using . . . precious oils . . . ;
he could breathe, so to speak, on the tinted paper.
. . . Unexpected vivacious notes of brilliant inten-
sity sparkle like jewels which are always magically
placed, and the best of these works"—of which
this is certainly one—"can be soberly described as
delicious." "Blum," Birnbaum quoted Oscar
Wilde as saying, "your exquisite pastels give me
the sensation of eating yellow satin."[1]

Blum had a lifelong passion for Japan, con-
ceived many years before he actually went there.
In 1873, when he was sixteen and still living in
his native city of Cincinnati, some Japanese fans
being sold in the street—"the first I had ever
seen"—became "an episode that to me had the
force and suddenness of a revelation." Three
years later, in Philadelphia (where he was studying
at the Pennsylvania Academy of the Fine Arts),
the "magnificent Japanese display at the Centennial
Exhibition . . . augmented the wild desire that
had grown up in me to someday visit [Japan]."[2]
It was not until 1890, however, that he managed
actually to do so. He was not disappointed: "[I]t
is the most glorious experience I have ever had,"
he wrote his friend Otto Bacher a few weeks after
he arrived. "You know that delightful glamour
that is cast over everything when you are in love?
This is what Japan is to me just now and I am
praying to God to keep it for me. I am treading
enchanted soil. It is the one experience of my life
where the expectation was fully realized after all
the wild vague day dreams."[3]

In Japan, Blum produced oil paintings, wash
drawings and watercolors, and pastels. The subjects
of Blum's Japanese works were, of course, Japanese.
But their language of style, although he admired
Japanese art and acquired it for himself, is unmis-
takably Western—that of Mariano Fortuny in
his oils and watercolors (see figs. 1, 2), and of James
McNeill Whistler in his pastels. Blum knew
Whistler in Venice in 1880, and was one of a large

FIG. 1 · Mariano Fortuny, *The Choice of a Model,* oil on canvas, 1874. Corcoran Gallery of Art, Washington, D.C.
William A. Clark Collection 26.88

FIG. 2 · Robert Blum, *The Ameya,* oil on canvas, c. 1892. The Metropolitan Museum of Art, Gift of the Estate of Alfred Corning Clark, 1904

4 *Blum 1893, 410.*

number of artists, chiefly American, in Whistler's orbit. Whistler had come to Venice the year before, in the wake of the famous Ruskin trial and the disastrous bankruptcy that was its result, to make a series of twelve etchings of Venice for the Fine Art Society, London. He planned to stay a few months; he stayed for more than a year and produced in that time not twelve but fifty etchings, as well as more than a hundred pastels. Whistler's Venetian work in both mediums was widely and profoundly influential, and on no one as greatly as Blum, and on no part of his work more than his pastels.

Blum, with his friend William Merritt Chase, was one of the American masters of pastel, and a founding member and moving spirit of the Society of Painters in Pastel, which held its first exhibition in February 1884. Combining in one medium ("little sticks of color") the properties of drawing and painting—of line and color—pastel was perfectly suited to Blum's temperamental preference for informality, suggestiveness, and rapid notation, as well as to the extreme delicacy and refinement of his artistic sensibility. The exquisite, almost evanescent delicacy of Whistler's pastels, especially their blushes of color lightly touched ("breathed") upon tinted papers, was the perfect vehicle for the expression of Blum's temperament and sensibility.

In Japan, Blum was struck by "the overpowering mass of blue, which in all gradations and the whole gamut of broken tints," he observed, "forms the fundamental color of Japanese clothing."[4] N.C.

9 · *The Blue Obi*

10

Low Tide

c. 1880–1882, oil on canvas,
14½ x 20½ (36.8 x 52.1)

1 *See Erica Hirshler, Dennis Miller Bunker: American Impressionist (Boston, 1994), 21–23.*

Over the course of his career Dennis Bunker created a number of masterful portraits, but it is his landscapes that demonstrate the more open and experimental qualities of his work.

Low Tide is one of several images of boats Bunker painted between 1880 and 1882, before he had European training.[1] The sketches are based on scenes of Long Island and Nantucket shorelines. Despite its small size, *Low Tide* has a certain monumentality. The bow of the boat, for instance, fills the lower half of the canvas and extends beyond its edges. Brushwork varies from rough and sketchy to fairly restrained, with fully modeled elements such as the mast and draped sail. The thinly painted, vertical strokes in the foreground suggest the deck's planking, with layers of translucent varnish. Across the bow, a hilly green shoreline is described rather than defined, and the slightly peaked gray hill, barely visible in the distance, also rings true.

A curious aspect of the painting is the man in a hat at far left. He does not appear to be a member of the crew, but rather an artist at work, paintbox propped in front of him. Whether Bunker included a colleague or projected his own image there is undetermined. In the freshness and immediacy of the oil sketch, however, Bunker's presence is apparent throughout. D.C.

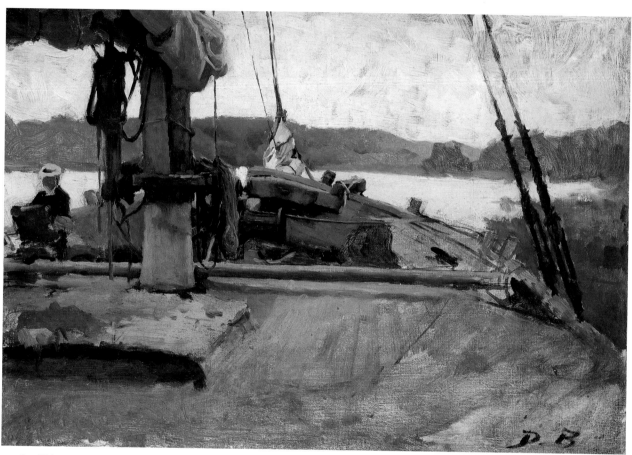

10 · *Low Tide*

11 · *Roadside Cottage*

11

Roadside Cottage

1889, oil on canvas,
25 1/16 x 30 (63.7 x 76.2)

In the summer of 1889, Dennis Bunker joined the composer Charles Martin Loeffler in the town of Medfield, Massachusetts, about fifteen miles southwest of Boston. They stayed at Miss Alice Sewell's boarding house, living and working in the caretaker's small cottage. There Bunker was inspired to paint a series of the Charles River, which meandered through the nearby meadows and marshes. The season was exceptionally productive for Bunker, not only in terms of number but also in the beauty and surety of the works.

Bunker spent the previous summer at Calcot, in England, with John Singer Sargent. He later complained that he completed few worthwhile paintings in those weeks, but his struggle with plein-air techniques bore fruit the following summer in Massachusetts. Impressionism as an avant-garde movement had been largely ignored by Bunker and his fellow Americans as they studied with academicians in Paris early in the 1880s. But the practice of painting out-of-doors in the French countryside, which the students adopted, and the direct observation of nature this encouraged, developed their sensitivity to the effects of natural light. Although Bunker and his colleagues came to impressionism late—a decade or sometimes two later than their European counterparts—they applied it to American subjects with great vigor and creativity. Bunker, in addition to absorbing the methods of observation and execution practiced in France, was greatly influenced by the fluid, energetic painting of Sargent.

Roadside Cottage is one of Bunker's most fully realized impressionist works and one of two finished images of his place in Medfield. The white-washed house provides a perfect surface for capturing the sun-dappled appearance of a landscape beneath the foliage of full summer. The modest cottage, which likely would have been clapboard, takes on the appearance of a stucco building from the European countryside. From the shadows that cast cool darkness across the house and the yard, one can sense towering trees outside of the picture, on the near side of the road. The lawn appears a lush, deep green with small, sunlit patches of chartreuse. The road is roughly and energetically laid-in with purple and gray shadows, and glimmers of pale salmon (in this work Bunker has comfortably absorbed the French impressionist idea that there are no black shadows). Bunker strikes a nice balance between dissolution of form, in the soft, short strokes, and attention to the three-dimensional quality of objects. Solidity and structure are conveyed, not only in the block of the cottage, but in the carefully delineated front steps, steep shaded bank, windows and doors, and overhanging roof. The painting not only shimmers with light and atmosphere, but suggests the gravity and weight of a place so central to the artist's memory of this moment in his life and career. D.C.

12

Portrait Study

c. 1880, watercolor
on paper, 14¾ x 10⅜
(37.5 x 26.4)

1 *"Fine Arts,"* The Nation 32
 (3 February 1881), 81.

2 *"The Water-Color Exhibition,*
 New York," American Architect
 and Building News *9 (19 March*
 1881), 135.

3 *"Fine Arts,"* New York Herald,
 22 January 1881.

4 New York Herald, *23 January 1881.*

5 *"Among the Water-colors,"* New
 York Times, *14 February 1881.*

Portrait Study, as it was called when it was exhib-
ited, is an early work by William Merritt Chase.
Although it was his only contribution to the 1881
exhibition of the American Watercolor Society,
it nevertheless commanded the notice of nearly
every critic. "Mr. Chase sends a head of a young
woman, so deftly executed as to draw admiring
attention to its execution," *The Nation*'s critic
wrote.[1] Mrs. Van Rensselaer thought it was "clever
as far as the life and modelling went and the use
of blacks in the costume. . . ."[2] "[T]he best work
of its kind in the collection," the *New York
Herald*'s reviewer said.[3] It sold for the respectable
price of seventy-five dollars.[4]

The *New York Times*' critic wrote that "it
would be unfair to regard it as especially typical
of the work of this able young painter."[5] For
despite the deft execution, skill, cleverness, and
bravura handling that critics saw in this work,
and despite the enormous popularity of watercolor
in America in the years around 1880, when it
was painted, watercolor was not Chase's favorite
medium. That was so, perhaps, because water-
color was a less forgiving medium than oil and pas-
tel, both of which Chase preferred, a medium
less permissive of alteration or amendment and
less tolerant of impulsiveness. N.C.

12 · *Portrait Study*

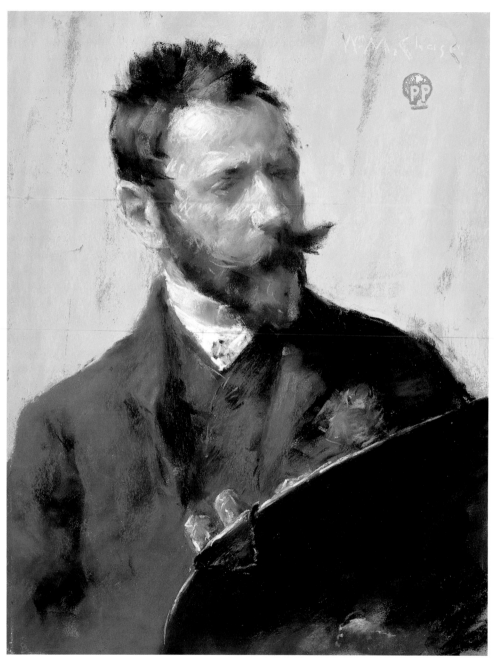

13 · *Self-Portrait*

13
Self-Portrait

14
Back of a Nude

15
Roses

c. 1884, pastel on paper,
17 ¼ x 13 ½ (43.8 x 34.3)

c. 1888, pastel on paper,
18 x 13 (45.7 x 33)

c. 1888, pastel on paper,
13 x 11 ⅜ (33 x 28.9)

1 See Dianne H. Pilgrim, "The Re-
vival of Pastels in Nineteenth-
Century America: The Society of
Painters in Pastel," American
Art Journal 10 (November 1978),
43–62.

2 Dianne Pilgrim has suggested that
it might be a portrait of Chase's
close friend Robert Blum, whom
he depicted on other occasions,
and whom he undeniably resem-
bled. Pilgrim 1973, 24.

3 "The Pastel Exhibition," Art Ama-
teur 10 (May 1884), 124; "The
First Exhibition of the American
Painters in Pastel," Art Journal
46 (1884), 157; "Fine Arts," New
York Herald, 16 March 1884.

With Robert Blum and J. Carroll Beckwith, William Merritt Chase was a founding member of the Society of American Painters in Pastel.[1] His self-portrait was one of the sixteen pastels he showed in the Society's first exhibition at W. P. Moore's Gallery in New York in 1884; it bears on its surface, proudly, almost polemically, and as a functional part of its design, the two P's that formed the Society's monogram. It is indeed a self-portrait.[2] Listed in the catalogue simply as *Portrait*, it was described in reviews as "a clever portrait of himself" and "a portrait of the gentleman himself," and a "characteristic autograph portrait."[3] What is more, the stiff brushy hair, gravity-defying moustache, goatee, and long, sharp nose all so closely resemble the same traits of appearance in J. Carroll Beckwith's nearly contemporary portrait of Chase (fig. 1), not to mention the almost palpable aura of style both images exude, that there can be no doubt that they depict the same person.

Pastel was part of the explosion of interest in new mediums—one that included watercolor, wood engraving, and etching as well—that occurred in America in the years following the Civil War. Until then pastel was particularly

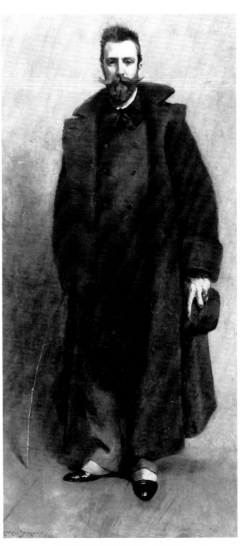

FIG. 1 · J. Carroll Beckwith, *Portrait of William Merritt Chase*, oil on canvas, 1881–1882. Indianapolis Museum of Art, Gift of the artist

4 Art Amateur 10 (May 1884), 123.

5 Art Journal 46 (1884), 157.

6 M. G. van Rensselaer, "American Painters in Pastel," The Century (December 1884), 208.

7 Quoted in Pilgrim 1973, 28.

8 Mrs. Schuyler van Rensselaer, "Fine Arts. An Exhibition of Pastels," The Independent, 24 May 1888, 647. "[H]is nude figure . . . , all things considered, is the most important work in the collection." "An Exhibition of Pastels," New York Sun, 6 May 1888.

9 "An Exhibition of Pastels," New York Sun, 6 May 1888.

little used by American artists and largely unfamiliar to the American public — "known, so far as it is known at all, as the parent of certain woolly and faded portraits haunting the deserted upper rooms of decrepit country-houses."[4] But in the hands of the Pastel Society artists, though all of them were new to the medium and largely unpracticed in it, pastel was used with astonishing vigor and originality. One critic wrote of the first American Pastel Society exhibition that traditionally, the

peculiar qualities [of pastel] were a velvety softness and delicacy of tint — qualities limiting the scope of pastel drawings to sketchy subjects and portraits. But these young American painters obtained results which made their work a revelation of what could be done with this pigment. They subjected it to the most serious of tests, that of producing striking effects by means of "broad" treatment. So admirable were some of these effects as to raise the question among artists whether either in oil or water colour they could have been equalled.[5]

"Originality, brightness, dash, coupled with a certain audacity in style and treatment" was how another described the works in the exhibition. "Mr. Chase's portrait of himself, as vehement and vigorous a piece of work, both in color and handling,"[6] specially exemplified their brilliance.

Chase was one of the supremely gifted pastelists of the nineteenth century. Instead of working in the delicate draftsmanly mode that Whistler promulgated and that strongly influenced Chase's friend Blum, however, Chase regarded pastel as a painting medium and treated it with "all the freedom and nearly all the vigor of oil," as someone wrote of many works in the Pastel Society exhibition. "It was his delight in pastel that opened our eyes to the charm of that medium," his friend and student, Irving Wiles, wrote. "Up to then no one had handled pastels in so painter-like a manner."[7] And in this, "his characteristic autograph portrait," as a critic called it, Chase, as if to express the painterliness of his pastel technique, depicts himself holding a painter's palette. Painterliness was a matter both of handling — of the oil-like solidity of form, opaqueness of pigment, and assertiveness of color — and of finish — eschewing the suggestive sketchiness of Whistler and Blum in favor of fully worked surfaces.

As his contemporaries saw, Back of a Nude is a magisterial case of Chase's painterly use of pastel: "Mr. Chase sent the most important picture, perhaps, in the [1888 Pastel Society] exhibition — a figure of a nude woman, seen from the back, seated on green cushions, which could not have been more solid in treatment or more brilliant in color had it been done in oils, while it had a delicacy and purity of texture which pastels alone, and pastels handled in the cleverest way can achieve."[8] It was "so solid, so complete, and so beautifully rich in texture that the strongest work in oil would not make it seem thin or weak by contrast."[9]

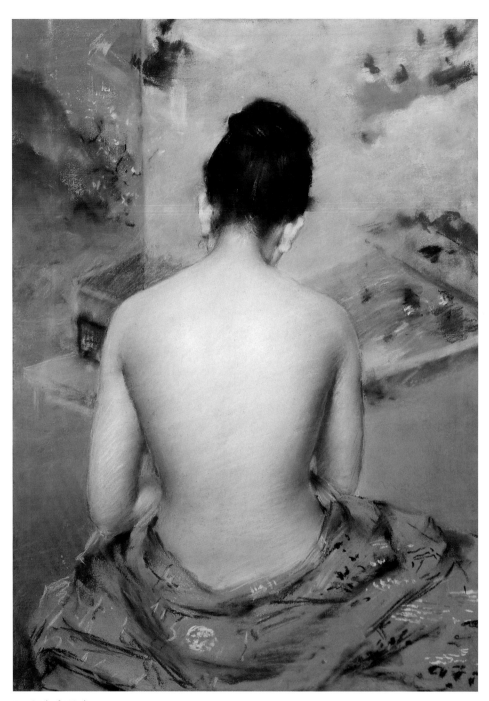

14 · *Back of a Nude*

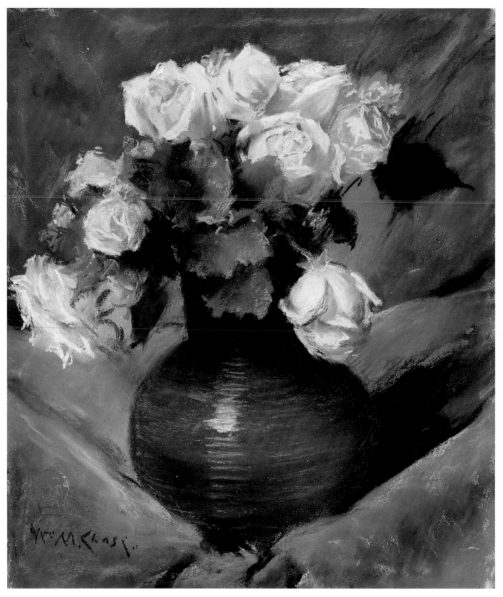

15 · *Roses*

"[F]or simple treatment of flesh," a critic wrote of another Chase nude in the 1889 exhibition, "nothing superior has ever been shown by the same artist in oils."[10]

In 1885 Chase was very close to James McNeill Whistler, until, as so often happened with Whistler, the relationship dissolved acrimoniously a year later. When *Back of a Nude* was exhibited at the Art Institute of Chicago in 1897, however, it bore the Whistlerian title *Study of Flesh Color and Gold.*

Chase was a prolific painter of still lifes, particularly the fish still lifes he produced seemingly without end later in life as demonstrations, almost performances, of his technical dexterity. However, he was seldom a painter of flowers. *Roses*, therefore, presents a comparatively rare subject in his art. "[T]here is nothing more difficult than flowers,"[11] Chase told his students, but as an artist for whom no representational problem was insurmountable ("Whatever the bodily eye can see, Mr. Chase can paint," Kenyon Cox wrote) he must have been speaking on his students' behalf, not his own. In the first Pastel Society exhibition in 1884 Chase exhibited a self-portrait, "out-of-door scenes," and three large still lifes (of which the small *Roses* cannot have been one).[12] By this range of subject matter he demonstrated his own supremely versatile talent, and the range and versatility of the pastel medium ("it is doubtless…their extraordinary versatility which has brought [pastels] into renewed prominence, abroad as well as here, in these days of intense concern for methods and mediums and processes").[13] But by painting still lifes, conventionally regarded as a less important subject than figures and landscapes, Chase also demonstrated his belief, his central artistic conviction, that it was not subject that counted most but the way it was treated: "It is never the subject of a picture which makes it great," he said; "it is the brush treatment, the color, the line."[14] Invoking his idol Velázquez, he said: "A yellow dog with a tin can tied to his tail would have been enough inspiration for a masterpiece by a consummate genius like Velasquez [sic]."[15]

Roses bears the stamp of the Painters in Pastel. It is not known in which of the Society's exhibitions it was included. N.C.

10 *"The Pastel Exhibition,"* The Art Amateur 21 (June 1889), 4.

11 Quoted in Pilgrim 1973, 26.

12 Art Journal (1884), 157.

13 *"An Exhibition of Pastels,"* New York Sun, 6 May 1888.

14 Perriton Maxwell, *"William Merritt Chase—Artist, Wit and Philosopher,"* The Saturday Evening Post 172 (4 November 1899), 347.

15 Maxwell 1899, 347.

16

The Fairy Tale

1892, oil on canvas,
16 1/2 x 24 (41.9 x 61)

1 John C. Van Dyck, American
Painting and Its Tradition *(New
York, 1919), 188. The phrase
is taken from another notoriously
conspicuous public figure,
Chase's one-time friend James
McNeill Whistler, who, in his
1888* Ten O'Clock *lecture said:
"Art is upon the Town!—to be
chucked under the chin by the
passing gallant—to be enticed
with the gates of the householder
—to be coaxed into company,
as a proof of culture and refine-
ment." In* The Gentle Art of Making
Enemies *(London, 1892), 135.*

Each summer for eleven years, beginning in 1891, William Merritt Chase taught classes in outdoor painting at Shinnecock, on the eastern end of Long Island near the village of Southampton. During those summers Chase and his family lived in a large, comfortable house designed by Chase's friend, the architect Stanford White, in the starkly beautiful Shinnecock hills (fig. 1). There Chase made many of his best and most beautiful pictures, ones that, coupled with the impressive presence of his personality, made Shinnecock, like Giverny, Argenteuil, or Barbizon, one of the canonical sites of nineteenth-century land-scape painting.

Chase, by his own design, was the most con-spicuous public artistic figure of his time. In the years following his return from Europe in 1878

FIG. 1 · William Merritt Chase, *The Bayberry Bush (Chase Homestead in Shinnecock Hills),* oil on canvas, c. 1895. The Parrish Art Museum, Southamp-ton, N.Y., Littlejohn Collection 1961.5.5

he campaigned tirelessly in the cause of art. For the instruction of his countrymen, Chase made him-self the example, the public impersonation, of his ideal of art. Performer, politician, polemicist, and publicist, he "carried the banner and announced that art had come to town."[1] And in his best paintings of the 1880s he had painted public and social spaces, Central Park in New York and Prospect Park in Brooklyn. But in the 1890s, after his marriage in 1886, and particularly during his summers at Shinnecock, his art became increas-ingly private, not obscure or excessively intro-spective, but about what he knew best and loved most, and the pleasures of his still new domestic life. Most of Chase's Shinnecock paintings were located within the house and studio, which, though not designed specifically for him bore the distinct stamp of his individuality, and in the landscape closely surrounding it. These pictures depict his wife and children enjoying the sun's warmth and cooling sea breezes, and engaged in the pastimes of summer, gathering flowers in the fields and shells on the beach, reading, strolling, exploring. The mood is inescapably idyllic, in the sense of carefree but passing contentment, but in the deeper sense, too, of its evocation of a more permanent condition of pastoral perfection and elemental natural harmony; *The Fairy Tale*'s title in particular, while it describes its subject—Chase's second daughter, Koto Robertine, listening with rapt attention as her mother tells or reads her a story—also evokes the painting's magical, enchanted ideality. Yet when John Gilmer Speed, after having described the painting in great detail, then said "No one could give any idea by mere

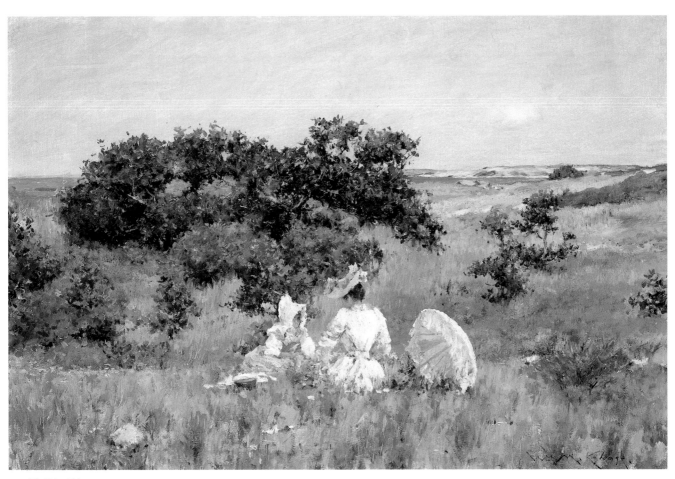

16 · *The Fairy Tale*

FIG. 2 · William Merritt Chase, *A Study*, in *Harper's Monthly* 87 (June 1893), 9

FIG. 3 · "Mr. Chase's Studio at Shinnecock, 1892," in *Demorest's Family Magazine* 33 (April 1897), 308. Library of Congress

description of the poetic beauty of this lovely picture . . . ," he sensed, despite the immense and infectious charm of its subject and the literary intimations of its title, that the painting's appeal and its principal mode of address were above all visual and painterly.

The Fairy Tale began to attract special attention soon after it was painted in 1892. In his article on Chase's first summer at Shinnecock, Speed not only described the picture (a "particularly notable" one, he thought) in great detail, but also illustrated it twice, both as a figure and as the painting on an easel in a reproduction of another Chase painting, *A Study* (fig. 2).[2] And in a photograph of Chase at work in his Shinnecock studio "taken expressly for Frank Leslie's Illustrated Weekly" and published there in September 1892, the picture is seen resting against a piece of furniture (fig. 3).[3] Since the Horowitzes acquired it in 1969 *The Fairy Tale* has become the signature painting of their collection. N.C.

2 John Gilmer Speed, "An Artist's Summer Vacation," Harper's New Monthly Magazine 87 (June, 1893), 11, 13, 9.

3 "The Shinnecock Art School," Frank Leslie's Illustrated Newspaper (29 September 1892), 224, later reproduced in Demorest's Family Magazine.

16 · *The Fairy Tale* (detail)

17
Reflections

1893, oil on canvas,
25 x 18 (63.5 x 45.7)

1 "The Exhibition of the Society of American Artists," Art Amateur 30 (April 1894), 127.

2 "William M. Chase, Painter," Harper's New Monthly Magazine 78 (March 1889), 549, 552.

Reflections is a portrait of William Merritt Chase's favorite subject at Shinnecock, his wife, Alice Gerson, seated at night in the large central hall of their house. Pictorially and psychologically, it is one of Chase's most complex and probing paintings.

Seen from the rear, Alice is reflected in the mirrored door of a large armoire. Mirrors and mirror images appear in a number of Chase's Shinnecock interiors (as in fig. 1, in which Chase himself is reflected in the same armoire). In the exploration and explanation of pictorial illusion nothing is as valuable as the mirror: without assistance or insistence, it invokes the potency, intricacy, and ambiguity of pictorial illusion, and the "mirror of nature," as the standard of perfect and complete illusion, was for centuries, archetypically and idiomatically, the emblem of art.

But in the late nineteenth century the mirror was understood less as the symbol of art's capacity to reflect outward nature than as the symbol of self-reflection and psychological insight—the

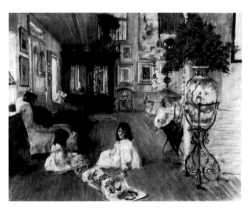

FIG. 1 · William Merritt Chase, *Hall at Shinnecock,* pastel on canvas, 1892. Terra Foundation for the Arts, Daniel J. Terra Collection, 1988.26. Terra Museum of American Art, Chicago

symbol less of seeing than of the unseen. That is the meaning and function of the mirror in *Reflections.* One critic, explaining that "The lady is reflecting about some matter; we see her face *reflected* in the glass," saw it merely as "a pun in paint,"[1] but it was more serious and subtle than that. Mirrored in *Reflections,* her expression is inflected by a wry smile and intent—even intense—gaze that are signs of meditative thought and emotion. This is deepened and tinctured by darkness, and still more by the possibility of imaginative and psychological entry into the reflective space containing the reflected image, an entry that the experience of the painting compels and that not merely reinforces but makes compellingly real the sense of inwardness and interiority that it expresses.

In 1889, the artist Kenyon Cox wrote that "His art is objective and external. . . . Whatever the bodily eye can see, Mr. Chase can paint, but with the eye of the imagination he does not see."[2] Technically brilliant but not deep or thoughtful, a mindless but exceedingly gifted painter of surfaces—this was the standard reading of Chase's artistic accomplishment. But *Reflections,* for all its painterly brilliance and complexity, shows that Chase, when dealing with a subject close to him, could do a great deal more than record externals.

Reflections hangs in the same room in the Horowitz apartment as another penetrating artist's portrait of his wife, George Bellows' meditative but disquietingly charged *Emma in a Purple Dress* of 1919 (cat. 6). In the company of Bellows' more expressively modern and frankly psychological portrait, *Reflections,* though more allusively symbolist, gives no ground. N.C.

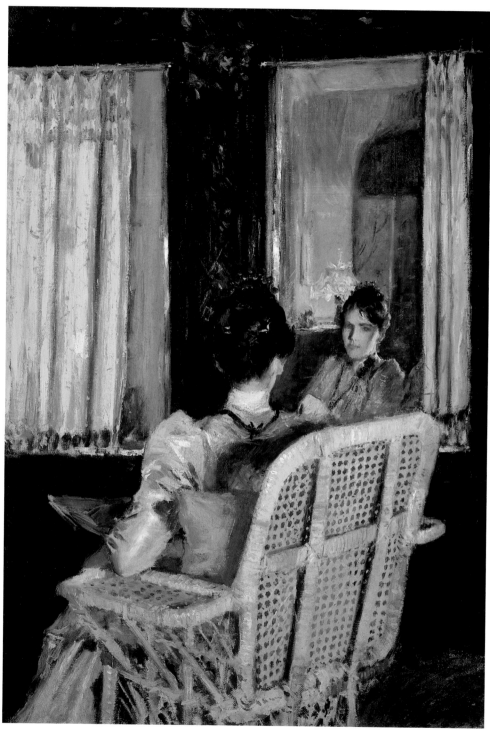

17 · *Reflections*

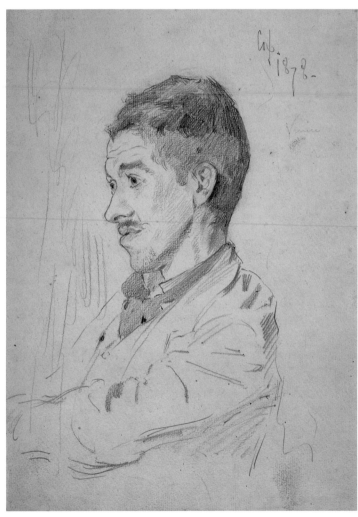

18 · *Theodore Robinson*

18

Theodore Robinson

1878, pencil on paper,
11 x 8½ (27.9 x 21.6)

1 *Letter to his mother, Paris,*
12 November 1879. An Ameri-
can Art Student in Paris: The Let-
ters of Kenyon Cox 1877–1882,
ed. H. Wayne Morgan (Kent, Ohio,
c. 1986), 182.

2 *Letter to his parents, Paris,*
15 December 1878, in Morgan
c. 1986, 141–142.

3 *Birge Harrison, "With Stevenson*
at Grez," Century Magazine 93
(December 1916), 307.

4 *A Chronicle of Friendships (New*
York, 1908), 66.

Theodore Robinson and his contemporary Kenyon Cox befriended each other in the later 1870s in New York and continued their friendship as students in Paris. In 1879, Cox described Robinson as "my best friend here." "I began his acquaintance by making a caricature of him," Cox wrote, "and when a Frenchman said that we were the two ugliest and most talented men in the atelier, we felt that we had thenceforth a tie in common."[1]

Cox, a supremely gifted draftsman, records his friend's appearance with touching and sympathetic candor. Robinson's entire life was devastated by asthma; his diary is filled with mention of it: "My asthma very bad—nights and days, a devilish nuisance" (13 July 1893); "Ill all day" (28 August); "have been horribly asthmatic and played out" (27 May). He almost ecstatically noted the periods when he slept most of the night (he took to drawing stars next to those entries): "I woke this a.m. at 5 after sleeping all night without a break—from 10 p.m.—the first time this has happened in many months. If only it could continue!" (3 June 1892); "Have slept almost all night *sans* interruption two or three times. This has not occurred for months —please God it continue" (26 July 1893); "Woke up, *mirabile dictu* from an unbroken sleep—the first for months and months—pray God it continue, and I be allowed to work untrammeled by ill health and feebleness of any sort" (15 April 1895).

"If I could only be strong," Robinson wrote pathetically on 31 August 1893. But he was not at all a pathetic person. Illness cruelly marked his appearance, to be sure—Cox's drawing is evidence of that, though possibly an extreme form of it,

perhaps having been made when, in 1878, Robinson had returned to Paris from Venice "very much used up" by a fever he caught there and, Cox wrote, "very thin and feeble"[2]—but it did not touch his spirit. The American painter Birge Harrison recalled,

. . . when one of the French comrades threw an arm around his shoulders, and casting a sidewise and puzzled glance upon him remarked, "Tu est vilain, Robinson; mais je t'aime," we all understood, for out of those goggle-eyes shone the courage of a Bayard ["The Knight without fear and without reproach"], and in their depths brooded the soul of a poet and dreamer, while his whole person radiated a delightful and ineffable sense of humor.[3]

"Frail, with a husky, asthmatic voice and a laugh that shook his meagre sides yet hardly made itself heard, timid and reticent, saying little, yet blessed with as keen a sense of humour as any one I have ever known," is how his friend Will H. Low described him.[4]

Despite their early closeness, Cox and Robinson later grew apart as Robinson became more and more involved with advanced painting while Cox became more and more conservative (his best known publication is *The Classic Point of View*); in his diary, Robinson indicated their distance, quoting Cox as saying he "had always thought I could do something good, but it wasn't necessary to become an impressionist to do it" (12 May 1892), and, of the jury for the 1894 Society of American Artists, reporting that "A gang, led by Cox & rather loud-mouthed, was rather ill-disposed to 'impressionistic' pictures" (2 March 1894). N.C.

19

Seated Woman

c. 1902, black chalk, ink,
and pastel on paper,
18 ⅝ x 14 ¾ (47.3 x 37.5)

1 Forbes Watson, "William Glack-
ens," Arts 5 (April 1923), 252.

In August 1897, *McClure's Magazine* published
a story by Rudyard Kipling, "Slaves of the Lamp."
Illustrations by William Glackens—the first by
the artist to appear in a periodical—accompanied
the text. During the following months Glackens
supplied *McClure's* with additional illustrations but
the response from readers was not entirely favor-
able. Complaints to the magazine's editors suggested
that Glackens' illustrations were perceived as not
"sweet" enough: "They were too real, too original,
too fresh and amusing to appeal to a public satu-
rated with false illustration."[1]

The "fresh," "original," and "real" qualities of
Glackens' work—disparaged by some of his con-
temporaries—were often the very characteristics
applauded by later critics. During an era of Gibson
girl gaiety, Glackens produced images, like *Seated
Woman,* that were free of the sweetness readers of
McClure's often preferred.

Comfortably at ease in a high-backed chair,
the unidentified subject of the sketch is dressed
almost entirely in black. Rapidly drawn with both
ink and chalk, the figure is as much a study in the
tonal qualities of black as it is a portrait drawing.

Against the rich dark shades of the skirt and bodice,
Glackens juxtaposed pale yellow gloves, a lavender
sash, and the ivory cast of a powdered face. In
a bravura demonstration of technical expertise, he
added a veil that falls from the sitter's hat to rest
on her shoulders, but does not obscure her face.
The active quality of line suggests that the image
was completed quickly, most likely during the
period when Glackens was still producing news-
paper illustrations on deadline.

At an unknown date Glackens gave the draw-
ing to his friend Everett Shinn, who added an
inscription on the verso speculating that the subject
may have been a model in a sketch class at the
"Philadelphia [Pennsylvania] Academy of the Fine
Arts." Though her identity remains a mystery,
Glackens' subject displays an air of self-possession
refreshing in its candor and perfectly matched
by the quick confidence of the artist's line. N.A.

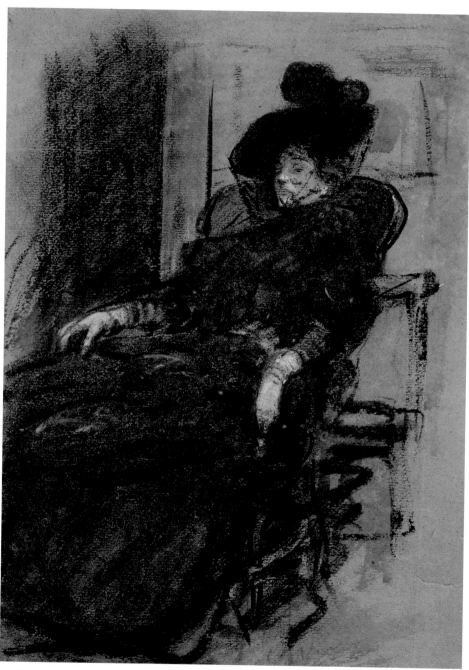

19 · *Seated Woman*

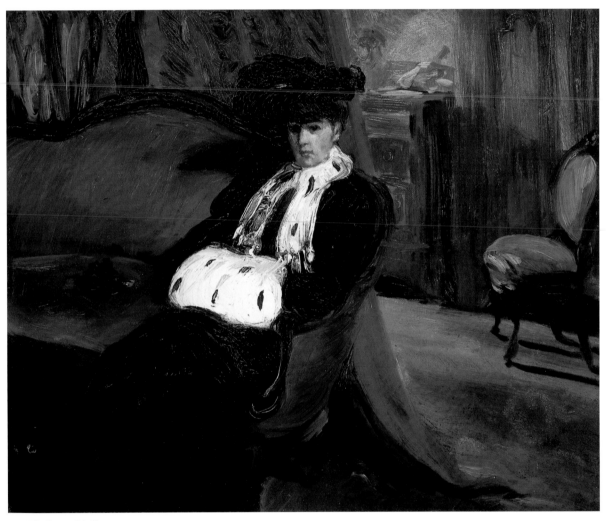

20 · *The Ermine Muff*

20

The Ermine Muff

c. 1903, oil on canvas,
15 x 18 (38.1 x 45.7)

1 Glackens, in John Sloan, Gist of
Art (New York, 1944), 25, as
quoted in William Gerdts, William
Glackens (New York, 1996), 96.

In June of 1889 William Glackens graduated from Philadelphia's Central High School as valedictorian of his class. Albert C. Barnes, who later formed one of the most important modern painting collections in America, was a classmate and fellow member of the baseball team. Although they followed very different paths after graduation, the two schoolmates renewed their friendship many years later when Barnes asked Glackens for assistance in building his collection. Perhaps only a friendship established in youth could withstand Glackens' withering assessment of the pictures Barnes had already purchased. Reportedly the artist told Barnes that the New York dealers from whom he had purchased much of his collection had charged him inflated prices for mediocre works: "I know what you have. A couple of Millets, red heads by Henner, a Diaz, and fuzzy Corots. They are just stinging you as they do everybody who has money to spend."[1]

A short time later, in 1912, Barnes sent Glackens to Paris with twenty thousand dollars to purchase high-quality modern paintings. Glackens returned with works by Edouard Manet, Edgar Degas, Pierre Auguste Renoir, Vincent van Gogh, Paul Cézanne, Henri Matisse, and Paul Gauguin, artists whose works Glackens had studied long before Barnes sent him on the buying mission.

In June 1895, seventeen years earlier, Glackens had traveled to Paris with Robert Henri and several other young Philadelphia artists. He remained abroad for more than a year bicycling to distant cities to see paintings and later working in a rented studio in Montparnasse. Unlike his companions, he did not enroll in academic classes; instead, he studied pictures. Paintings like The Ermine Muff confirm that years before he began purchasing works for Barnes, Glackens had absorbed the lessons of the impressionists, particularly the coloristic and compositional breakthroughs of Manet and Degas.

Glackens' interest in Manet may have been sparked by an exhibition at Durand-Ruel's New York gallery in the spring of 1895, which included fifteen of the artist's major works. His enthusiasm for Manet grew as he and Henri (who would later be called the "American Manet") sought out additional works abroad. In The Ermine Muff Glackens' coloristic debt to Manet is evident. As was often the case in works by the French artist, black served not only as the primary color but also as the defining element of the composition. Glackens used black to temper nearly every other color in the picture. The unusual compositional structure of The Ermine Muff — with the

2 Quoted in William Gerdts, American Impressionism (New York, 1984), 279.

strong diagonal of the curtain separating a dark foreground from an illuminated background—was likely born of Glackens' close study of works by Degas.

The European sources of Glackens' work were recognized almost immediately by his contemporaries. As early as 1910 Albert Gallatin acknowledged Glackens' debt to Manet and then counted the American among the "legions of artists" who had learned "invaluable lessons" from the "masterly pastels and paintings" of Degas.[2]

Capitalizing on lessons well learned, Glackens placed, at the center of his composition, an elegantly dressed woman whose forthright gaze engages the viewer directly. Boldly dressed in black and white, she exhibits the same confident candor as the figure in Glackens' drawing *Seated Woman* (cat. 19). Altogether different in this work, however, is the lush opacity of the oil paint. With colors rich and deep Glackens created a shadowed interior that serves as foil to the luminescent white of the ermine muff and collar.

In later years Glackens' painterly allegiance changed radically. Renoir replaced Manet and Degas as models and the dark, moody paintings of the artist's early period were superseded by bright, airy compositions heavily influenced by the work of Renoir. N.A.

21

Study of a Young Man (Portrait of Everett Shinn)

c. 1903, red chalk on tracing
paper, mounted on board,
10 x 8⅛ (25.4 x 20.6)

1 Everett Shinn, "William Glackens
as an Illustrator," American Artist
9 (November 1945), 22–27, 37.

2 Shinn 1945, 22.

3 Shinn 1945, 22.

4 Shinn 1945, 22.

5 Bennard B. Perlman, "Drawing
on Deadline," Art and Antiques
(October 1988), 116.

6 Perlman 1988, 116.

7 Shinn 1945, 22.

8 Shinn 1945, 37.

In 1945, seven years after the death of his good friend William Glackens, Everett Shinn published a thoughtful and perceptive essay on his work as an illustrator.[1] Declaring that "a pulse beats in his pen lines," Shinn noted that "throughout his distinguished career, Glackens made thousands of drawings" and "at the end of a working day, his studio floor was literally covered with them."[2] Shinn was an informed observer, for he and Glackens had forged their friendship more than fifty years earlier when both were working as artist-reporters for Philadelphia newspapers and attending classes together at the Pennsylvania Academy of the Fine Arts.

As Shinn recalled, Glackens arrived at the academy in the early 1890s "equipped with a natural ability to draw" but not in the favored academic manner—from casts and models.[3] Impatient with the measured pace of the academy, Glackens, Shinn, and their artist-reporter companions "haunted" local galleries to "study the work of current illustrators."[4]

John Sloan, another member of the group, later described the "art room" at the *Philadelphia Press* as their favorite rendezvous.[5] There the young artists challenged each other with exercises designed to promote speed and accuracy in drawing: "Between assignments they would gather outside the Press building to test their memories

and sharpen their sense of observation. They would walk behind a stranger in an effort to observe the characteristics of his or her movement: the shuffle of trousers, the swish of a skirt, the swing of an arm or the twist of a body."[6]

Employed to produce illustrations for fast-breaking news, Glackens quickly developed a sketching technique that allowed him, in the words of Shinn, to produce drawings "with lightning speed."[7] Economy of line and an ability to focus on the defining elements of a subject's character helped the aspiring artist produce images on deadline. The same skills allowed Glackens to create an elegant early portrait of his friend Shinn.

Although the two artists initially met in Philadelphia, this drawing was likely completed in New York after both young men had moved north to work as illustrators for New York newspapers and magazines. The medium also suggests that the drawing was completed after 1896, when Glackens returned from more than a year abroad where, as Shinn noted, he discovered red chalk, which soon became one of his favorite sketching materials.[8]

The speed of execution and linear economy Glackens perfected as an artist-reporter are reflected in the graceful spareness of this image. Glackens needed just a few well-placed lines to suggest his sitter's coat, hat, and walking stick, as well as the

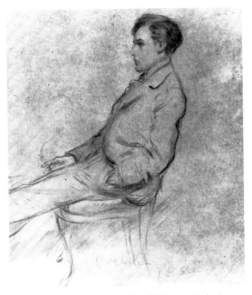

FIG. 1 · William Glackens, *Portrait of Everett Shinn*, sanguine drawing on brown paper, c. 1903. Mead Art Museum, Amherst College

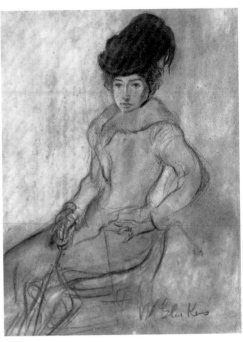

FIG. 2 · William Glackens, undated drawing of Florence Scovel Shinn. Collection of Mr. and Mrs. Arthur G. Altschul

9 *Shinn 1945, 22.*

10 *Shinn 1945, 23.*

studio chair on which he sits. The artist reserved the deepest and richest tones for his friend's features, as he did in a related drawing (fig. 1) and another of Shinn's wife, Florence (fig. 2), perhaps completed at the same time.

Described as a practiced observer who could bore "with uncanny precision into the very souls of all his characters," Glackens produced a telling portrait of a fellow artist in this early drawing.[9] Years later, Shinn spoke for several of the young Philadelphians who later became much better known as members of The Eight when he affectionately wrote: "whatever of merit the rest of us produced in subsequent years, we owe, in no small measure, to the example and informal teaching of our friend, William Glackens, who taught without uttering a word of advice."[10] N.A.

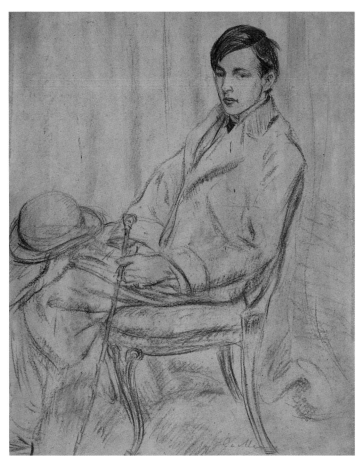

21 · *Study of a Young Man (Portrait of Everett Shinn)*

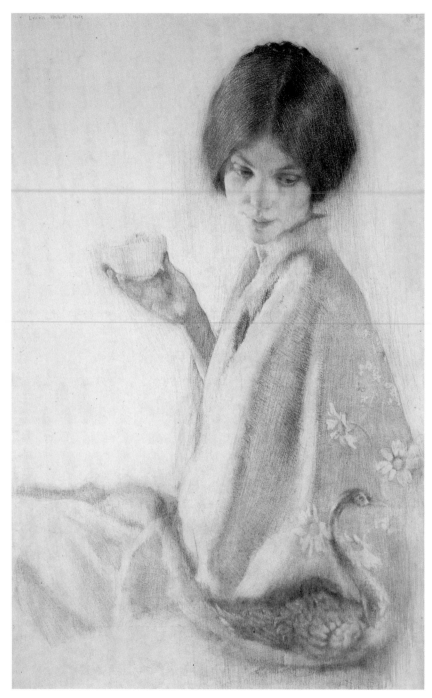

22 · *Japonoiserie*

22
Japonoiserie

c. 1907, charcoal on paper,
22¼ x 14 (56.5 x 35.6)

1 The study, unlocated but known
through a photograph, is listed
but not illustrated in Erica Eve
Hirshler, "Lilian Westcott Hale
(1880–1963), A Woman Painter
of the Boston School," Ph.D. diss.,
Boston University, 1992, 245.

2 Hirshler 1992, 69–70.

3 It is not possible to determine
whether the swan is glass, porce-
lain, or some other material, but
the artist Edmund Tarbell (who
in 1908 called Hale's "the finest
modern drawings I have ever
seen") purchased a drawing titled
The Little Silver Swan for his own
collection. Hirshler 1992, 70.

Although quite successful as an oil painter, Lilian Westcott Hale has been especially praised for her works in charcoal. In these exquisitely delicate drawings, the artist created form by a distinctive method of closely laying long, thin strokes from charcoal sharpened to a razor-fine point. Through this carefully controlled, exceedingly precise technique Hale produced beautifully modulated drawings, created not as studies for paintings, but as complete works in their own right.

There is, in fact, what appears to be a study (c. 1907, private collection) for the head of the sitter in *Japonoiserie*.[1] Hale's subject for both of these works is probably Rose Zeffler (Zeffy), her favorite model at the time. Zeffy appeared in the well-received *The Convalescent (Zeffy in Bed)* (1907, Sheldon Memorial Art Gallery) and modeled for a series of drawings that Hale exhibited at Philadelphia's Fifth Annual Watercolor Club Exhibition in 1907 and in Hale's one-woman exhibition at Rowlands Galleries in Boston in 1908.[2] Detailed descriptions for these shows do not exist, making it impossible to confirm that this drawing was on view, but it is quite likely that this is the work listed as *Japonoiserie* in the exhibition records.

The oriental element implied by the drawing's title may refer to a number of aspects of the image, such as the small, handleless teacup the model holds and the kimono she wears. Her graceful, but formal posture, too, suggests the Far East. Asian art had a tremendous influence on American and European artists at the turn of the century. This interest was particularly strong in Boston, with its history of Asian trade, its students of Asian aesthetics, and its collectors of Asian art.

The meditative quality of Hale's subject is perhaps also vaguely Far Eastern, but is characteristic of the Boston school as well, the artists of which preferred refined and contemplative rather than gritty subject matter. Often these subjects included women in tastefully appointed interiors, engaged in moments of reflection. Such is the figure in *Japonoiserie*. Her head, turned slightly sideways and dipped downward, is echoed in the curved neck of the swan in the foreground, but is yet more graceful than the decorative object upon which she gazes.[3] D.C.

23

Nurses in the Park

c. 1889, oil on panel,
9 ¾ x 13 ¼ (24.8 x 33.7)

1 *Art Amateur 15 (November 1886), 113, as quoted in Ulrich W. Hiesinger,* Childe Hassam, American Impressionist *(Munich and New York, 1994), 31.*

2 *John Kimberly Mumford, "Who's Who in New York—No. 75," New York Herald Tribune, 30 August 1925, 11, as quoted in Hiesinger 1994, 32.*

3 *Frank T. Robinson,* Living New England Artists *(Boston, 1888), 103.*

4 *Quoted in A. E. Ives, "Mr. Childe Hassam on Painting Street Scenes," The Art Amateur 27 (October 1892), 116–117.*

In the autumn of 1886, Childe Hassam, "the audacious and brilliant watercolorist and landscapist," set off with his wife for Paris.[1] His intention was to study figure drawing, so he enrolled in the Académie Julian, where the course of study followed the French academic system. Outside of the academy, Hassam worked on his own and, as he said, "in my own manner."[2] What drew his attention was "modern life in the gay streets of Paris. The parks and the gardens give him many suggestions and material wherein his figures can move or loiter in shadow or sunlight. . . ."[3] Hassam himself was unequivocal in declaring himself a painter of contemporary life:

I believe the man who will go down in posterity is the man who paints his own time and the scenes of everyday life around him. . . . There is nothing so interesting to me as people. I am never tired of observing them in every-day life, as they hurry through the streets on business or saunter down the promenade on pleasure. Humanity in motion is a continual study to me. . . . it takes an artist to catch the spirit, life, I might say poetry, of figures in motion.[4]

In *Nurses in the Park* and a related painting, *Parc Monceau* (fig. 1), Hassam depicted one of the many urban parks created during Baron Haussmann's sweeping redesign of Paris in the 1860s and 1870s. Parc Monceau, originally a large private garden, is on the edge of the Europe district, not far from the Gare Saint-Lazare. Adolphe Alphand, Haussmann's chief of parks, divided the land, half of which was sold as lots, and built streets, including five named after famous artists (Velázquez, Ruysdael, Murillo, Rembrandt, and Van Dyck).[5] He transformed the remaining land into a pleasant oasis of lawns, plantings, and curving sidewalks, with a small lake at one end. Claude Monet painted the park in 1876 and again in 1878; one of his paintings from the latter year, *The Parc*

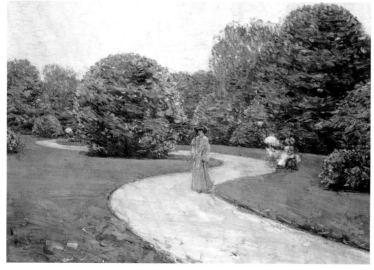

FIG. 1 · Childe Hassam, *Parc Monceau*, oil on canvas, 1889. Private collection, courtesy of Vance Jordan Fine Art, Inc.

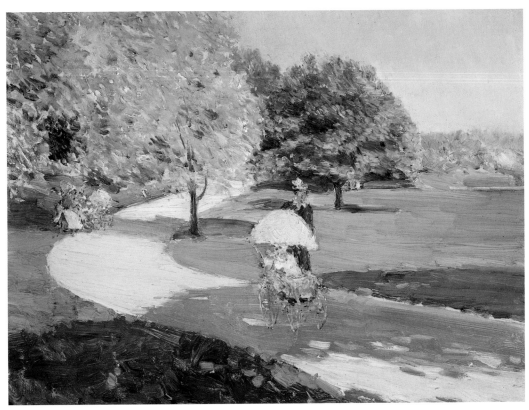

23 · *Nurses in the Park*

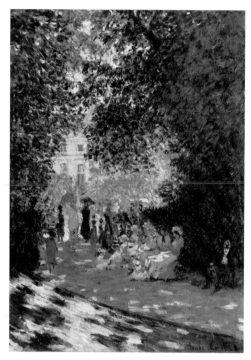

FIG. 2 · Claude Monet, *The Parc Monceau*, oil on canvas, 1878. The Metropolitan Museum of Art, The Mr. and Mrs. Henry Ittleson, Jr. Purchase Fund, 1959

5 Robert L. Herbert, Impressionism: Art, Leisure, and Parisian Society *(New Haven and London, 1988), 142.*

6 *Monet's six views of the park are reproduced and discussed in Daniel Wildenstein,* Monet: Catalogue Raisonné *(Cologne, 1996), nos. 398–400 and 466–488; see also Herbert 1988, 142.*

7 *"Even Claude Monet, Sisley, Pissaro [sic] and the school of extreme impressionists do some things that are charming and that will live...."; letter to William Howe Downes, 28 May 1889, as quoted in Hiesinger 1994, 179. Hassam's use of the word "extreme" was in contrast to what he considered the "poetic" style of painters such as Jean Charles Cazin. Pilgrim 1973, 82, identifies The Metropolitan Museum of Art's The Parc Monceau (fig. 2) as having been shown in Paris in 1889, but according to Wildenstein (1996, 187), that was another work,* Le Parc Monceau *(1878, private collection, Switzerland).*

8 *Robinson 1888, 101.*

9 *"Exhibition of Mr. Hassam's Paintings at Noyes, Cobb & Co.'s Gallery"; undated clipping from the* Boston Transcript, *as quoted in Hiesinger 1994, 56.*

Monceau (fig. 2), is similar to the present painting not only in subject, but also in the handling of green and yellow paint in the triangular area of grass that anchors the lower left corner of the composition.[6] Hassam, of course, knew the work of Monet and others of those he referred to in 1889 as "the extreme impressionists," but whether or not he saw any of Monet's Park Monceau paintings is unknown.[7] Whatever the case, Hassam's style was very much his own, "quite unlike any other artist's," as one of his contemporaries observed.[8] *Nurses in the Park,* with its vibrant brushwork, bright colors, and striking contrasts of light and shade is small in size, but powerful in effect. When a group of Hassam's Parisian oils was shown in Boston in 1889, some were described as "thoroughly enjoyable and artistic," with "delightful effects of sunlight. . . ."[9] Perhaps *Nurses in the Park,* which was first owned by a Bostonian, was one of those "thoroughly enjoyable" pictures. F.K.

23 · *Nurses in the Park* (detail)

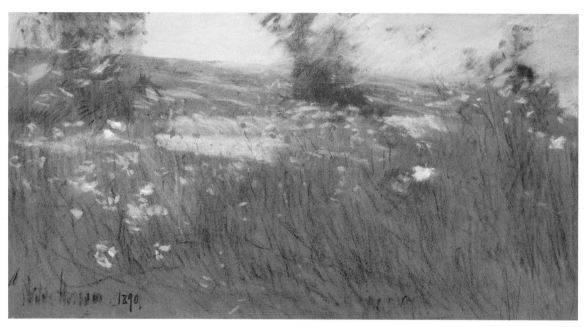

24 · *Poppies, Isles of Shoals*

24
Poppies, Isles of Shoals
25
Poppies

1890, pastel on brown paper,
7 ¼ x 13 ¾ (18.4 x 34.9)

1891, oil on canvas,
19 ¾ x 24 (50.2 x 61)

National Gallery of Art,
Washington, Gift (Partial
and Promised) of Margaret
and Raymond Horowitz,
1997.135.1

1 J. Dennis Rodman, "Isles of
Shoals: A Capsule History," Sea-
coastNH.com (1997), http://
www.seacoastnh.com/shoals/
history.html (24 March 1998).

2 Olive Tardiff, "Seacoast Women:
Celia Laighton Thaxter (1835–
1894), SeacoastNH.com 1997
(24 March 1998).

In the Atlantic, about ten miles out from the harbor of Portsmouth, New Hampshire, lie the Isles of Shoals, nine small, rocky and treeless islands. Surrounded by deep water with abundant fish, the Isles have been known to fishermen and voyagers for centuries. It was most likely from the great shoals of fish associated with these waters, rather than from the presence of shallow shoals, that the islands got their name. The first English settlements were in the early seventeenth century, with the most substantial community located on Hog Island, which was later renamed Appledore, after a village in Devonshire. During the seventeenth and eighteenth centuries the Isles supported a vigorous economy based on fishing and shipping, but in the post-Revolutionary period those activities steadily declined.[1]

The fortunes, and character, of the Isles changed dramatically after a hotel was built on Appledore in 1847 by Thomas Laighton and his Harvard-educated partner Levi Thaxter. Laighton had come to the Isles eight years earlier to serve as lighthouse keeper on White Island, bringing with him his family, including a four-year-old daughter, Celia.[2] When she was sixteen Celia married Levi Thaxter and moved with him to the mainland. The marriage was not an especially harmonious one, and Celia deeply missed life on the islands and tried to spend as much time there as she could. She began to write poetry, publishing her first poem, "Landlocked," which expressed her longing

for the Isles of Shoals, in *The Atlantic Monthly* in 1871. The poem brought her immediate success and more verse and prose followed, including the book *Among the Isles of Shoals,* published in 1874. Her fame, together with her husband's wide-ranging connections in Boston, soon ensured her a place in the city's elite literary and artistic circles. Her father's hotel had already been attracting distinguished guests to Appledore, but Celia's presence there in summer made the island a veritable mecca. Her parlor became a salon of ever-changing guests: writers, painters, illustrators, musicians, and other visitors could always be found there. Flowers were ever present, whether in arrangements indoors or growing in Thaxter's much-admired garden (fig. 1).

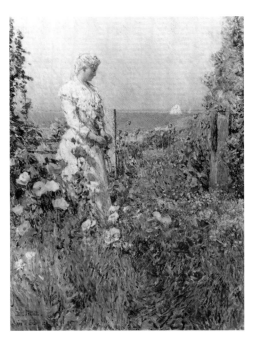

FIG. 1 · Childe Hassam, *In the Garden (Celia Thaxter in Her Garden),* oil on canvas, 1892. National Museum of American Art, Smithsonian Institution, Gift of John Gellatly

3 David Park Curry, in Childe Hassam:
 An Island Garden Revisited [exh.
 cat., Denver Art Museum] (Denver,
 New York, and London, 1990),
 provides an eloquent discussion
 of Hassam's visits, his relationship
 with Celia Thaxter, and the works
 of art he created on Appledore.

4 Curry 1990, 33.

Childe Hassam was one of the regulars in Celia Thaxter's summer circle.[3] The two met around 1880, probably in Boston, where Thaxter studied art. At one point, around 1883–1885, Hassam served as a substitute teacher for one of her classes, and not long after that he began providing illustrations for some of her publications.[4] Hassam may have begun visiting the Isles of Shoals as early as 1884, and he is known to have painted in watercolor there in 1886 (a view of the lighthouse on White Island is dated that year; Mead Art Museum, Amherst College). But virtually all of his images of the island fall into two distinct groups: those executed between 1890 and 1894 (the year of Thaxter's death) and those from 1899 to 1916, when he made numerous visits to the

FIG. 2 · *Bathing pool at Appledore, Isles of Shoals, N.H.*, 1901. Library of Congress, Detroit Publishing Company Photograph Collection

island. Some of the watercolors and oils from the first group depict the interior of Thaxter's cottage, but the majority are outdoor scenes set in her flower garden or nearby, as in these two splendid examples.

Hassam only rarely worked in pastel, preferring throughout his career to paint in watercolor or oil. But when he did use pastel, as in *At the Grand Prix (Aux Grand Prix de Paris)* (1887, Corcoran Gallery of Art, Washington), he showed himself to be a master of the medium. Of the several pastels known of Appledore subjects, *Poppies, Isles of Shoals* is the most freely executed. Leaving much of the paper blank, Hassam used quick strokes to suggest the poppies and other plants. In contrast, the blue of the sky is more thoroughly worked, which helps establish spatial divisions. The flowers seem to sway in a gentle breeze, vividly evoking for us the feel of being present in the garden. Yet Hassam's image is so delicately ethereal that we also sense the transience of the moment, as if all might vanish in the blink of an eye, changing immediate experience into treasured memory.

The oil *Poppies* presents a broader vista, moving from a dense foreground of flowers to a background of rocks, water, and sky. This view, centered on the outcropping called Babb's Rock, was one of Hassam's favorites, for he painted it many times (see fig. 5). Although one could see ample signs of man's presence from Celia Thaxter's garden (figs. 2, 3), Hassam usually excluded them from his paintings. Here, only a sailboat passing in the distance hints that we are not in a pristine, wild environment. The composition is arranged with three distinct and equal bands of space. In

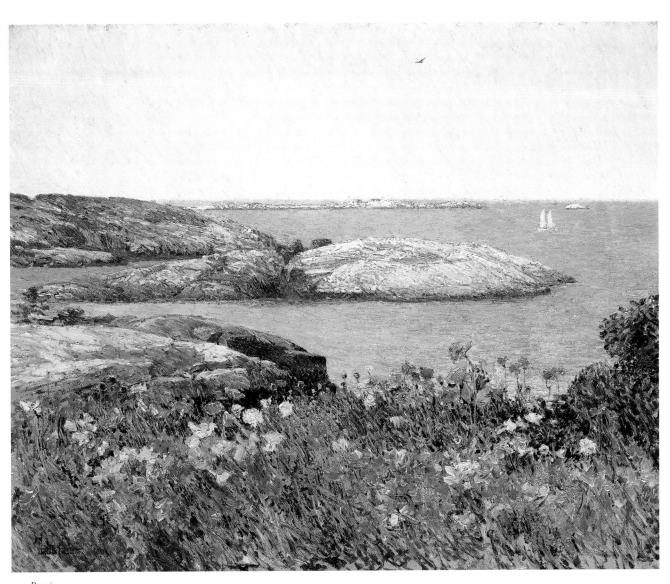

25 · *Poppies*

5 From a review of Hassam's exhibition at the Doll and Richards Gallery, Boston, c. 1891; undated clipping, probably from the Boston Transcript, *Childe Hassam Papers*, American Academy of Arts and Letters, New York, as quoted in Ulrich W. Hiesinger, Childe Hassam: American Impressionist (Munich and New York, 1994), 86.

6 See Curry 1990, passim, for a discussion of Hassam's style.

7 Hiesinger 1994, 86. See also William H. Gerdts, American Impressionism (New York, 1984), 91, which quotes Albert E. Gallatin: "Childe Hassam is beyond any doubt the greatest exponent of Impressionism in America"; "Childe Hassam: A Note," Collector and Art Critic 5 (January 1907), 102. That in the nineteenth and early twentieth centuries the term "impressionism" was used with considerable imprecision does not mean that we should continue to do so today.

FIG. 3 · Karl Thaxter, *Celia Thaxter's Garden*, c. 1892. Courtesy of Star Island Corporation

each zone different colors predominate: green and red for the flowers; blue, purple, and white for the rocks and water; and pale blue for the sky. Hassam's brushwork is equally varied, ranging from lush red and white strokes defining the flowers to long drags of pigment to suggest the multihued surfaces of the rocks. At the bottom he left areas of canvas bare, adding yet another color and texture. For those accustomed to academic landscape painting, seeing one of Hassam's Isles of Shoals paintings was, as one reviewer wrote, "like taking off a pair of black spectacles that one has been compelled to wear out of doors, and letting the full glory of nature's sunlight color pour in upon the retina."[5]

Many of Hassam's contemporaries considered the works of Claude Monet to be his prime inspiration. Irritated by how frequently this comparison was made, Hassam tended to downplay Monet's influence and stressed his debt to other painters such as John Constable and Joseph Mallord William Turner. Subsequent historians have reasonably invoked other influences, including the writings of John Ruskin, the paintings of the English Pre-Raphaelites, the art and aesthetic theory of James McNeill Whistler, and the paintings of other American impressionists such as Robert Vonnoh, who was at the Académie Julian with Hassam in 1886 (fig. 4).[6] Still, whatever the mix of influences at work, and no matter how much he changed his handling of paint at various points in his career, Hassam's work was always strongly individual. Yet he is routinely identified as America's most completely impressionist painter, with the Isles of Shoals paintings ranked among his "finest Impressionist performances in pure color and form...."[7] Paintings such as *Poppies* may have the bright colors and broken brushwork found in paintings by Monet, Camille Pissarro, and others from the late 1860s to the mid-1880s (generally considered the prime years of French

FIG. 4 · Robert Vonnoh, *Poppies*, oil on canvas, 1888. Indianapolis Museum of Art, James E. Roberts Fund

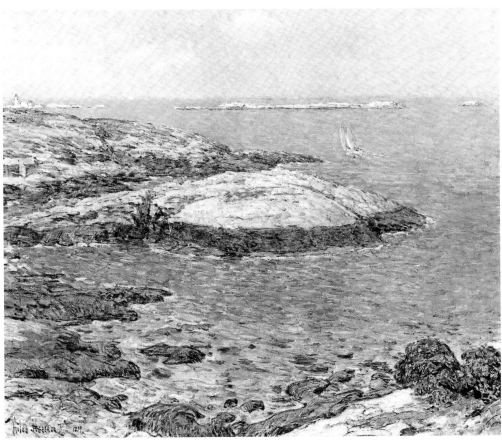

FIG. 5 · Childe Hassam, *Isles of Shoals,* oil on canvas, 1899. The Minneapolis Institute of Arts

impressionism), but beyond that there is little resemblance. As has been noted by many observers, Hassam did not use broken color to dissolve his subjects (as Monet often did in his works from 1880 onward), preferring instead a structural clarity and solidity of form that keeps objects intact and space clearly legible. The question then is why, when he knew perfectly well what actual French impressionist paintings looked like from seeing them in Paris, Boston, or New York, did Hassam fashion his paintings so differently?

One strategy used in accounting for the dissimilarity between Hassam's paintings (and those of other "American impressionists") and their supposed French models has been to suggest that he simply did not, or did not care to, understand the theoretical basis of French impressionism. As early as 1907 a critic could declare: "for the scientific aspect of Impressionism, for the theories of pure Impressionism, and for the employment of only the colors of the spectrum, Hassam seldom gives a thought."[8] In this guise, the artist seems implicitly inferior, an imitator of, literally, surface, not substance. Other observers, arguing for the existence of a fundamental American artistic vision that is linear and conceptual and favors fact over artifice, have seen the retention of structure and clarity as a conscious rejection of the most radical aspects of French impressionism.[9] In this scenario, a distinctly American pragmatism triumphs over seductive foreign influences, so that

8 Gallatin, "Hassam," quoted in Gerdts 1984, 91.

9 This view of American painting is most famously expressed in Barbara Novak, American Painting of the Nineteenth Century: Realism, Idealism, and the American Experience (New York, Washington, and London, 1969), which, in turn, proved highly influential on the work of a number of scholars of American art. For Novak, "the respect for form and the dominance of the conceptual mode" evident in works by painters such as Hassam and Mary Cassatt was part of "the continuing American tradition . . ." (p. 244).

FIG. 6 · Karl Thaxter, *Celia Thaxter's Garden Fence,* c. 1892. Courtesy of Star Island Corporation

10 As John Wilmerding wrote shortly
 before the celebration of America's
 Bicentennial: "the mature later
 work of the American impression-
 ists tended to be the weakest and
 least original, primarily because
 it adhered (despite disclaimers to
 the contrary) most closely to Eu-
 ropean precedents. This was espe-
 cially so with Robinson, Hassam,
 and Twachtman. But American
 artists generally were too deeply
 ingrained with a national aesthetic
 tradition of realism and narrative
 to be able to perceive or accept
 fully the intellectual and formal
 implications of the French theo-
 ries"; American Art (New York,
 1976), 157.

11 Kathleen M. Burnside, "Hassam,
 (Frederick) Childe," in Jane Turner,
 ed., The Dictionary of Art 14 (Lon-
 don, 1996), 219.

12 Roger Fry, "The Post Impression-
 ists," in Manet and the Post Im-
 pressionists [exh. cat., Grafton
 Galleries] (London 1910), 7–13;
 reprinted in Christopher Reed,
 A Roger Fry Reader (Chicago and
 London, 1996), 81–85.

13 The exhibition closed on 15 June
 1886, and Hassam did not arrive
 until the fall.

14 Novak (1969, 244) linked Cassatt's
 works to the "Post-Impressionist
 attitudes of the late 1880s and
 1890s." Two works by Hassam,
 Crystal Palace, Chicago (1893,
 Terra Museum of American Art,
 Chicago) and an Appledore inte-
 rior, The Room of Flowers (1894,
 private collection) were included
 in the rather diverse American
 section of the exhibition Post-
 Impressionism: Cross-Currents in
 European and American Painting,
 1880–1906 [exh. cat., National
 Gallery of Art] (Washington, 1980),
 238. Wanda Corn and John Wil-
 merding, who selected the works
 and provided catalogue commen-
 tary, noted that Hassam occasion-
 ally "went beyond or even rejected
 traditional aspects of pure impres-
 sionism," but nevertheless stress
 his "American instincts for solid
 realism." Curry (1990, 84–101)
 relates Hassam's Isles of Shoals
 paintings to contemporary works
 by Monet.

15 See Curry 1990, 115–189.

the good (color and brushwork) is taken and the bad (corruption of the integrity of objects) left behind. In other words, it is not that American artists weren't as smart as their French counterparts, or as handy with a brush, but rather that they—as Americans—saw and did things differently.[10] The "hybrid" of impressionist brushstroke and solid form practiced by Hassam and others has, in fact, been seen as the hallmark of American impressionism.[11]

But, the rejection of the impressionists' dissolution of form and the assertion of artistic individuality over shared artistic theory were not, of course, limited to the works of the Americans. These very beliefs were among those that Roger Fry felt were central concerns of the artists he included in his landmark 1910 exhibition, "Manet and The Post Impressionists."[12] By the time Hassam arrived in Paris in 1886, the eighth and final group exhibition of the impressionists, which included postimpressionist works by Gauguin, Pissarro, Seurat, Signac, and others, had come and gone.[13] But it is hard to imagine that he would have been unaware that a reaction to impressionism was already in progress. Nor does it seem conceivable he could not have known that Monet and others of the original impressionists were no longer painting works like those of the 1870s and were, in fact, experimenting with various approaches to reuniting color and form. Paintings like *Poppies,* then, are perhaps better understood not as "impressionist performances" some twenty years out of date, but as allied to the revisions and reactions to impressionism being pursued by other artists at the same time.[14]

FIG. 7 · Peter Randall, *Celia Thaxter's Garden, Appledore Island, Isles of Shoals*, 1989.

The artistic and intellectual Eden centered on Celia Thaxter's home and garden on Appledore was not destined to last long. When Thaxter died in the summer of 1894, Hassam was there, and it would be five years before he returned. His later Appledore paintings (fig. 5) are primarily depictions of water and rocks; flowers, like Thaxter and her garden, are no longer present. Hassam's style is different in these later works, more insistently concerned with formal issues of composition and surface effects.[15] By the time he painted his last images of the Isles in 1916, the hotel and most of Appledore's other buildings, including Celia Thaxter's house, were gone, destroyed by a fire that swept the island. Her garden has been recently restored (figs. 6, 7), a poignant reminder of a place and a time that proved so richly inspirational to her, to Childe Hassam, and to so many others. F.K.

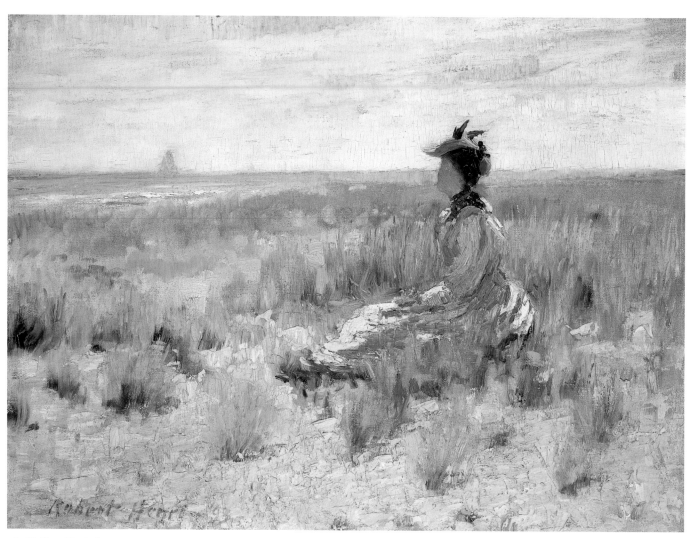

26 · *Girl Seated by the Sea*

26

Girl Seated by the Sea

1893, oil on canvas,
18 x 24 (45.7 x 61)

1 [Clark S. Marlor], "The Avalon
Summer Assembly," newspaper
clipping, [1895], provided by
the Cape May County Museum.

2 Henri, letter to his parents, Oct.–
Dec. 1887, quoted in Bennard B.
Perlman, Robert Henri: His Life
and Art (New York, 1991), 10.

3 Henri diary, 1 April 1891, quoted
in Perlman 1991, 20.

4 Henri letter, 21 March 1891,
quoted in Perlman 1991, 21.

In the summer of 1893, Robert Henri served as instructor in oil painting at the Avalon Summer Assembly in Avalon, New Jersey. The "Assembly," a Chautauqua-like educational program, had been organized "to afford teachers and others practical means for training themselves to a broader understanding of those subjects commonly taught, or which should be taught, in primary, grammar, and secondary schools."[1] As befitted such an earnest improvement initiative, the course offerings included biology, zoology, botany, geology, literature, languages, hygiene and sanitation, as well as sketching and drawing. Henri's invitation to participate came shortly after he had returned from an extended period of study abroad. The paintings he produced in Avalon, including *Girl Seated by the Sea,* clearly reflect his brief but intense enthusiasm for European impressionism.

As early as 1887, Henri confessed in a letter to his parents that he had contracted "Paris fever" and that he hoped to visit the French capital within the year.[2] A few months later he set sail and shortly thereafter enrolled at the Académie Julian in Paris. Although he continued to study at the academy for some time, Henri became disenchanted with the conservative approach promoted by the artists who critiqued his work. Following the example of the impressionists, whose work he had seen in galleries and exhibitions,

Henri began experimenting with strokes of pure color juxtaposed in the impressionist manner. Adolphe-William Bouguereau, one of the "master artists" who advised students at the academy, found fault with Henri's efforts: "All those purples! There is nothing true in the study. A fashion that will not endure long."[3] Despite such criticism, Henri continued to explore impressionist color and light. In a letter home he described a series of haystack paintings by Claude Monet that he had seen on exhibition at Durand-Ruel Gallery:

They all seem made to demonstrate light effect—some were made in spring—others in summer, fall and winter. Each effect is most strikingly lucid, the peculiar quality of light at such times strikingly rendered. On close examination the work is but masses of rough, pure color layed on as if with no method—but stand back from it and what realism and sentiment.[4]

In the fall of 1891 Henri returned to Philadelphia, enrolled at the Pennsylvania Academy of the Fine Arts, and began studying with Robert Vonnoh, another American artist who had traveled to Paris and become intrigued with the technical experiments of the impressionists. In Vonnoh Henri found a supportive friend who described himself

5 National Cyclopedia of American
 Biography 7 (1897), 462, cited in
 William H. Gerdts, American Im-
 pressionism (New York, 1984), 121.

6 In June 1893, for example, one
 month before Henri began teaching
 in Avalon, an illustrated article
 by John Gilmer Speed on Chase
 and the art school at Shinnecock
 was published in Harper's New
 Monthly Magazine.

as a "devoted disciple of the new movement in painting."[5] Vonnoh's allegiance to impressionism lasted far longer than Henri's, but during the early 1890s both artists worked to convey the "peculiar quality of light" Henri had admired in Monet and both spent considerable time painting in the open air.

Well before he journeyed abroad, Henri had begun painting outdoors. During the summers of 1887 and 1888, while visiting his parents in Atlantic City, he had completed a number of beach scenes. While living in Europe he pursued plein-air painting more deliberately—again following the example of the impressionists—first on the beaches of Brittany and later in the south of France.

In America, plein-air painting had become increasingly popular during the years Henri was abroad. In 1891, the year he returned, the practice drew increased attention when William Merritt Chase began teaching at the Shinnecock Summer Art School on Long Island. By the time Henri began teaching at Avalon, the Shinnecock school had attracted many students and considerable notice in the press.[6] Chase, who spent a decade of summers on Long Island, completed some of his finest paintings, including The Fairy Tale (cat. 16), at Shinnecock.

Nearly contemporary, and much alike in subject, Girl Seated by the Sea and The Fairy Tale are, however, works by artists at quite different stages of their careers. In 1893 Chase was an established, successful, and influential artist at the height of his creative powers. Henri, still a student, had yet to find his artistic vocabulary.

Girl Seated by the Sea is an experimental work —one that reflects Henri's brief fascination with the palette and painting technique of the impressionists. The figure at the center of the composition (perhaps one of his students at Avalon) sits in isolation looking at the sea and the ship on the horizon. Almost generic in her anonymity, she is less the focus of the composition than the warm, bright light Henri uses to define figure, shore, and sea. Adopting the "rough" strokes of color he admired in Monet's haystack paintings, Henri created a surface that conveys the "lucid" light he sought. Ironically, within a short period of time Henri would emerge as the leader of the so-called ashcan school—a group of painters whose urban realism was often expressed with colors so dark they were sometimes called the "black gang." N.A.

27

Wild Roses and Water Lily — Study of Sunlight

c. 1883, watercolor
on paper, 10 ⅝ x 8 ⅞
(27 x 22.5)

1 *Royal Cortissoz,* John La Farge:
 A Memoir and a Study *(Boston
 and New York, 1911), 15.*

2 *Henry Adams,* The Education of
 Henry Adams *(Boston and New
 York, 1946), 371.*

3 *Cortissoz 1911, 135.*

John La Farge's contemporaries thought he was one of and maybe even the most cultivated, learned, and literate artists of his age, as well as one of the most versatile. He was among the first anywhere to be influenced by (and to write about) Japanese art, and the first to anticipate the impressionist study of light and color. He touched, often as a pioneer, nearly every mode and medium of artistic expression—easel painting, mural decoration, book and magazine illustration, stained glass—and nearly every subject—landscape, still life, and the human figure. La Farge's large-scale public mural and decorative schemes are impressive and often very beautiful. But his smaller, more intimate works are consistently his most ingratiating, and consistently among the loveliest are his watercolors.

La Farge's contemporaries used terms such as complexity, ambiguity, and incipience, refinement, delicacy, and restraint, to describe the subtleties, obliquities, and allusiveness of his sensibility and mentality. He was, his biographer Royal Cortissoz wrote, "a past master of the parenthesis."[1] "La Farge's mind," his close friend Henry Adams said, "was opaline with infinite shades and refractions of light, and with color toned down to the finest gradations."[2]

The medium suited more than any other to express that opal-like iridescence—delicately changeable and mysteriously opaque—was watercolor. The subject that best expressed it was flowers; La Farge's *Muse of Painting* of 1870 rapturously paints a hanging vine of flowers (fig. 1).

FIG. 1 · John La Farge, *The Muse of Painting,* oil on canvas, 1870. The Metropolitan Museum of Art, Gift of J. Pierpont Morgan and Henry Walters, 1909

La Farge said he painted flowers as "a study[,] . . . a means of teaching myself many of the difficulties of painting," of color and light.[3] But others saw that there was something to it vastly more subtle and profound than technical exercise. "We are all . . . aware of something more than sensuous beauty in a flower, something that seems really among the things of the spirit," Cortissoz wrote. "So La Farge painted his flowers, with an indescribable tenderness. His vision pierced deeper than that of the artist who would deal in forthright, domineering fashion with 'things seen.' . . . Like that veil on which Flaubert is so magnificent

4 Cortissoz 1911, 134.

5 Cortissoz 1911, 136.

6 James Jackson Jarves, The Art
 Idea (Boston and New York, 1864),
 225, 226.

7 As in the hundreds of English and
 American books with such titles
 as Flora's Lexicon, The Garland
 of Flora, and Flowers, Their Lan-
 guage, Poetry, and Sentiment.

[he refers to Tanit's veil in *Salammbô*] there was always a beauty just beyond his reach."[4] La Farge's favorite flower was the water lily precisely because of its infinitely elusive subtlety, because, as he said, it "appealed to the sense of something of a meaning—a mysterious appeal such as comes to us from certain arrangements of notes of music."[5]

"He evokes the essences of things, draws out their soul-life, endowing them with an almost superhuman consciousness," one of La Farge's earliest and most perceptive critics, James Jackson Jarves, wrote in 1864, even before La Farge had painted most of his flower pictures, of which the Horowitz watercolor is one of the finest. "The solemn splendor and interpretive power of his free, unconventional manner, with its spiritual suggestiveness of hues," Jarves went on, "seize upon the imagination and bind it firmly to his art, through sentiments that act more directly upon the heart than the head." For "Out of the depths and completeness of his art-thought, by a few daring, luminous sweeps of his brush he creates the universal flower, the type of its highest possibilities of beauty and meaning, using color not as fact, but as moods of feelings and imagination, having the force of passion without its taint."[6] With its penetration into the meaning of flowers, which the Victorian age cultivated with special power and refinement (and which excuses Jarves' Victorian excesses of language),[7] it is hard to improve upon this interpretation of La Farge's flower paintings. N.C.

27 · *Wild Roses and Water Lily — Study of Sunlight*

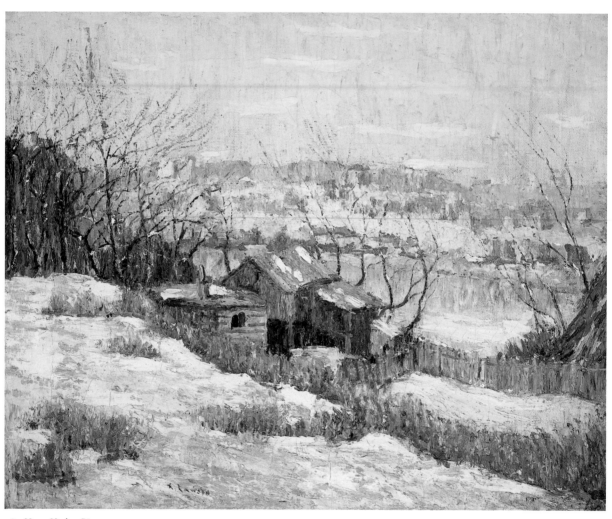

28 · *Upper Harlem River*

28

Upper Harlem River

c. 1915, oil on canvas,
16 x 20 (40.6 x 50.8)

1 *"The region depicted in* Upper
Harlem River *is in the area of
Spuyten Duyvil, on the northern
tip of Manhattan." This location
was confirmed by Lee Karpiscak,
associate director, The University
of Arizona Museum of Art, in a
memo of 20 July 1998.*

Ernest Lawson is often compared to his teacher John Twachtman, with whom he shared a love of the muted tones of winter subjects. Yet Twachtman's technique usually consists of veils of color and delicate calligraphic strokes, while Lawson's colors are thickly interwoven webs, his brushstrokes more muscular, his pigments more opaque. Lawson's works have the bright palette and broken brushwork of the impressionists, but also a strength and vigor that are postimpressionist. His works are painted without the benefit of preliminary sketches, and constructed of a thick impasto applied variously with brush, knife, and sometimes even finger.

Of all of the members of The Eight, only Lawson painted landscapes exclusively. Yet, like his colleagues, he often turned to the less obviously picturesque elements of the city. From 1898 to 1906 he lived in the then largely rural area of Washington Heights and captured the common beauty of upper Manhattan and the banks of the Hudson and Harlem rivers. Often he would paint a graceful bridge spanning the water, but he also depicted squatters' huts, pigeon coops, and such unassuming buildings as are seen in *Upper Harlem River*.[1] At least three other works by Lawson depict the same site: *Hut in Winter* (private collection) and *Upper Harlem River — Winter* (c. 1910–1915, private collection), which share a similarly wintry palette, and *The Further Heights* (c. 1915, University of Arizona Museum of Art), which seems to depict dusk, or perhaps dawn, in early spring when the almost-bare branches are tipped with tiny red buds.

Even after he had moved to Greenwich Village, Lawson continued to paint the scenes along the riverfront in upper Manhattan. For the 1913 Armory Show, Lawson entered three works, among them *Harlem River — Winter* (c. 1913, Chrysler Museum). Along with its delicate coloration and suggestion of atmosphere, *Upper Harlem River* has a solidity and weightiness to the buildings at the center of the composition. Around them, the spikey, veiny elements of the winter trees pulsate with life. The viewer is drawn into this quiet corner of the universe where the peace of nature prevails over the slightly forlorn elements of human habitation. D.C.

29
At the Shore

30
Cafe Scene

1901, oil on cardboard,
23½ x 19¼ (59.7 x 48.9)

c. 1904, oil on canvas,
36 x 34 (91.4 x 86.4)

1 *Elizabeth McCausland, A. H.
Maurer (New York, 1951), 69:
"a bathing beach close to New
York, perhaps Far Rockaway."
Ronald G. Pisano, in* Long Island
Landscape Painting: 1820–1920
*(Boston, 1985), 150 (where the
reproduction of* At the Shore *on
the following page is reversed),
asserts without qualification that
"Maurer painted at Far Rock-
away," citing McCausland as his
source. That assumption appar-
ently lies behind Pisano's use (153)
of the title Far Rockaway Beach
for a painting very similar in sub-
ject and style to* At the Shore
*(*The Beach, *c. 1901; ex. coll.
Antonette and Isaac Arnold, Jr.;
sold at Sotheby's, New York, 1
December 1994, lot 32). Thus,
the site shown in these two
paintings is plausibly, but not
certainly, Far Rockaway.*

2 *See John F. Kasson,* Amusing the
Million: Coney Island at the Turn
of the Century *(New York, 1978).*

3 *James Huneker,* New Cosmopolis:
A Book of Images *(New York,
1915), 155.*

Very few of Alfred Maurer's early works depicted American scenes; most, like *Cafe Scene,* were of Parisian subjects. In 1897 he had settled in Paris, but he returned to the United States for a visit in 1901–1902. *At the Shore* likely represents one of the many popular bathing beaches near New York, perhaps Far Rockaway.[1] By the late nineteenth century the Long Island beaches that were convenient for day trips or short stays had become ever more crowded with people, hotels, bathing sheds, and various amusements. Coney Island, the best known and most extravagant (and ultimately the most derided for its vulgarity), could attract, and amuse, tens of thousands of visitors on a good summer day (fig. 1).[2] In *At the Shore* the focus is on the beach itself and the people enjoying it. The low buildings in the background

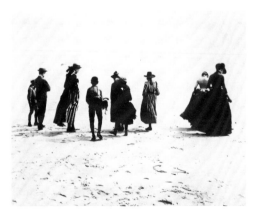

FIG. 1 · Breading G. Way, *Coney Island, Brooklyn,* gelatin silver print, c. 1888. Brooklyn Museum of Art

and the telephone pole intrude only minimally. At the lower right a boy and girl play in the sand, a red and blue pail nearby. At the left a slightly older girl stands with her right arm raised toward her mouth, holding what appears to be a hotdog with mustard. The "smell of the frankfurter 'dog' as it sizzles over the fire" was so common at the near Long Island beaches that it became indelibly associated with them, especially Coney Island.[3] But what most forcibly draws the viewer into the composition and reveals why the adults are gathering there is the flash of red and brown paint at the very center of the canvas. It is a monkey, sporting a red jacket and hat (to be passed later, of course), and performing for the crowd. The darkly clad man with his back to us is the organ grinder; upon close inspection one can make out a strap over his right shoulder and the single wooden leg supporting the organ. Grinders with their monkeys, many of which were highly skilled pickpockets, were familiar sights not only in the poorer neighborhoods of the city, but also at the beaches.

The work of James McNeill Whistler was an important early influence on Maurer, but like Robert Henri and others, he also admired the powerful brushwork and dark colors of early works by Edouard Manet. The large areas of varying tones of white in *At the Shore* are reminiscent of early Whistler, but the brushwork and use of dark black suggest Manet. Following his return to Paris in the spring of 1902, Maurer resumed

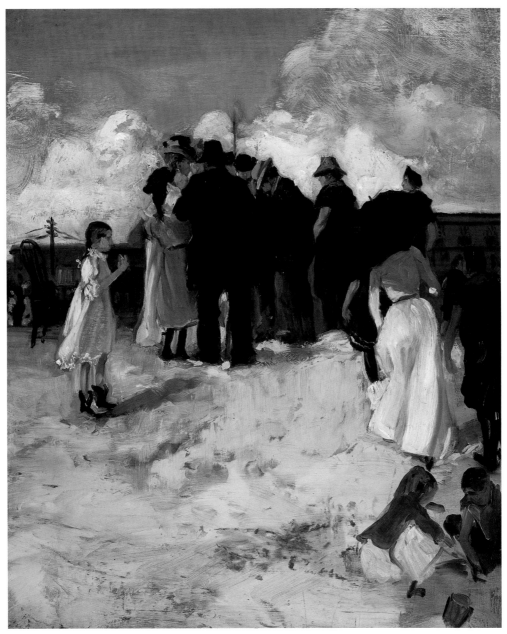

29 · *At the Shore*

4 See Nick Madormo, "The Early Career of Alfred Maurer: Paintings of Popular Entertainments," American Art Journal 15 (Winter 1983), 4–34.

5 Madormo (1983, 6, 30) dates the painting "c. 1903," but notes that dating Maurer's work to specific years between 1901 and 1904 is very difficult.

6 Madormo 1983, 27.

7 Robert L. Herbert, Impressionism: Art, Leisure, and Parisian Society (New Haven and London, 1988), 132.

painting scenes of Paris nightlife, and the influence of Whistler waned. He knew the works of many other artists who painted the café-concerts and dance halls of Montmartre, whether older artists such as Edgar Degas, Henri Toulouse-Lautrec, and Manet, or younger ones like Pierre Bonnard, Pablo Picasso, and Henri Matisse.[4] Hints of influence from all of these, and from others, have been discerned in Maurer's works, but the same could be said of many other artists who were finding their way in those years.

Cafe Scene, executed around 1904, is among the last of its type, for Maurer soon turned to brightly colored landscapes inspired by the work of Matisse and other fauve painters.[5] It has been interpreted as "an image of intensity and pathos. . . . This is not a generalized picture of big-city evening entertainment but a sensitive portrayal of social behavior."[6] It is a glimpse of a world where dancing girls spend their evenings either with partners or waiting for partners, hoping for some little recompense. Given the presence of soldiers, this hall may have been one near the barrières, the old city gates, which were frequented by the military.[7] In the foreground, a woman in a black dress looks out, her eyes seeming to lock with ours, as if to size up our intentions. Through this means Maurer establishes an emotional connection between the woman and the viewer, but the nature of that connection is indeterminate, depending on who the viewer is or presumes to be. This engagement between viewer and painted figure sets Cafe Scene apart from Maurer's other depictions of similar subjects. In works such as Le Bal Bulier (c. 1904, Smith College Museum of Art), the figures are seen from behind, or from the side and from a greater distance. In those works the viewer observes, rather than participates. Here, however, Maurer opted for a psychological intensity that made such emotional detachment all but impossible. F.K.

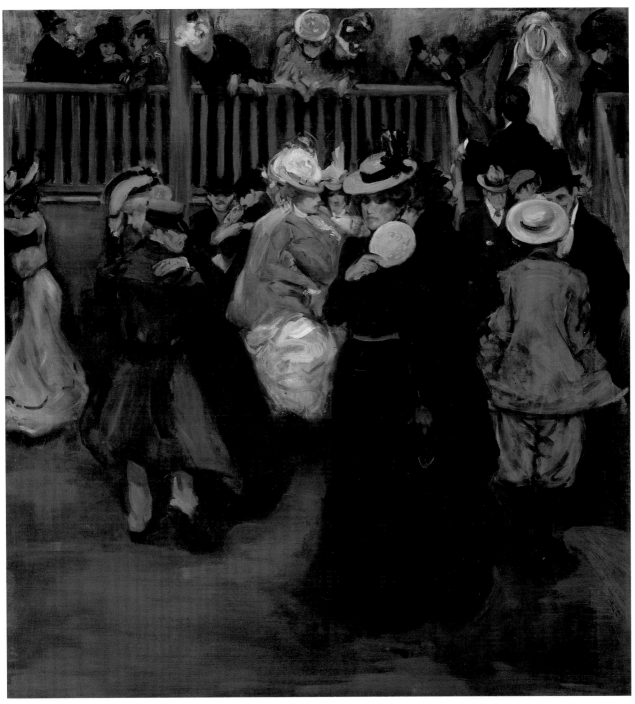

30 · *Cafe Scene*

31
Beach Scene

c. 1915, oil on panel,
11 x 15 ⅞ (27.9 x 40.3)

1 *"The catalogue of Potthast's one-man show at the J.W. S. Young Gallery in Chicago in March 1920 noted that the artist had begun a series of beach scenes only recently." William H. Gerdts, American Impressionism (New York, 1984), 244.*

Edward Potthast was nearly forty years old when he settled in New York City in 1896. Although modest and conservative, he had already made a name for himself in his hometown of Cincinnati. Once in New York, he joined numerous artists' societies, exhibited his work regularly, and expanded the range of his essentially academic style.

He did not immediately discover the subject for which he is now best known: it appears that he began to concentrate on beach scenes sometime after 1910.[1] Thus inspired, he painted image after image of happy excursionists relaxing at the water's edge at such places as Rockaway and Coney Island, close to his home, and Gloucester, Provincetown, and Monhegan, where he spent the summer. The images were immediately popular and have so remained because they capture the buoyant spirit of people at play in the sand, sun, and surf. Most of the works are modest in scale, but they partake of Potthast's innate sense of composition and his deceptively simplified command of the figure. With a few incisive strokes, he comfortably poses participants in their environment. The seashore's warmth is made palpable by the almost glaring light that envelops each scene. (Painted two decades after impressionism first made its mark on American art, the works have a brilliance that surpasses the more diffuse sunlight usually found in American impressionist paintings.)

The freshness and immediacy of Potthast's scenes at first glance recall Eugène Boudin's images of the French seaside. Although arrayed in a similarly casual fashion, Boudin's figures represent a more formally attired, upper middle-class social stratum. Potthast's commoner models, broad, free brushwork, and atmosphere full of heat and light suggest another European painter, Joaquin Sorolla, as a possible inspiration. Potthast could have seen Sorolla's paintings in a popular exhibition of 356 of his works at the New York City's Hispanic Society in 1909.

Beach Scene demonstrates Potthast's skilled and effusive shorthand in the two figures at left, whose turned heads observe an occurrence on the distant waves, and in the fluttering skirt of the standing girl dressed in white. His observation of light and shadow is particularly astute: for instance, the shirt of the woman seated under the umbrella appears blue in its shade. An especially nicely observed effect is seen in the foreground beach where the purple and blue mottling of the channels and depressions against the soft yellow sand take on an almost abstract quality. D.C.

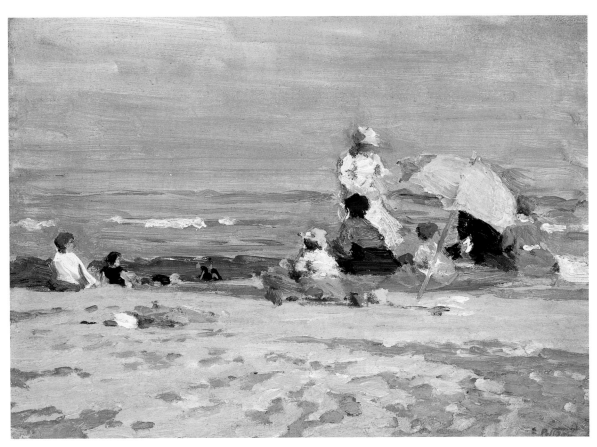

31 · *Beach Scene*

32 · *Revere Beach*

32
Revere Beach

33
Picnicking Children — Central Park

1896, watercolor on paper,
14 x 10 (35.6 x 25.4)

c. 1900–1903, watercolor
and pencil on paper,
8 ¾ x 16 ⅝ (22.2 x 42.2)

1 Milton W. Brown, "Maurice B.
Prendergast," in Carol Clark,
Nancy Mowll Matthews, and
Gwendolyn Owens, Maurice
Brazil Prendergast and Charles
Prendergast: A Catalogue
Raisonné (Munich, 1990), 19,
considers the artist's works
of 1896 to be the foundation
of his early watercolor style.

2 Brown 1990, 19.

3 I am grateful to Bob Upton and
his internet Web site, Revere-
beach.com, for information about
the history of the beach and
for his help in obtaining period
photographs of the site.

4 Eliot's words, from November
1896, are quoted in "History,"
in Reverebeach.com, http://www.
reverebeach.com/history.htm
(29 July 1998).

During his three years of study in Paris, in 1891–1894, Maurice Prendergast made many small oils, watercolors, and monotypes of outdoor life in the city. He painted the cafés and parks, the boulevards and streets, sometimes in rain, other times in sunshine. These same subjects, whether found in Boston, New York, Italy, France, or elsewhere, would be central to his art for the rest of his career. After returning to Boston in the fall of 1894, he turned his attentions to scenes of daily life. Working along Charles Street, the harbor, Franklin Park, and other sites, he occasionally made pastels, but most often he used watercolor. During the summer of 1896 he visited Revere Beach, on Massachusetts Bay, five miles north of Boston. There Prendergast executed a series of watercolors in which his handling of the medium took on a new lightness and assurance.[1] In works such as

FIG. 1 · *Revere Beach Reservation,* photogravure, c. 1902.
Reverebeach.com

Revere Beach, Prendergast employed an almost shorthand drawing style and a very loose handling of watercolor to achieve a vibrant and seemingly spontaneous effect. Throughout the sheet there are obvious traces of artistic process in the quick pencil notations, the overlapping washes of color, and the area where the bare paper is allowed to show through. The use of an empty foreground and the placement of a group of figures in the middleground, which is also found in other Revere Beach watercolors, is unique to Prendergast's early period; later he would arrange his figures in friezelike rows parallel to the picture plane (as in *Picnicking Children—Central Park* and *Picnic by the Inlet*), sometimes in the foreground only, other times in the middleground, too.[2]

The public bathing beach at Revere was created in 1895, when the Massachusetts legislature acquired a private shoreline.[3] In 1896 the Revere Beach Reservation was adapted for public use by Charles Eliot, a landscape architect who had studied with Frederick Law Olmstead, designer of Central Park in New York and the grounds of the U.S. Capitol in Washington. Bathing sheds, the structures visible in Prendergast's watercolor, were added and other improvements made, but Eliot's principal goal was not to obstruct views of "the long sweep of open beach that is the finest thing about the reservation."[4] Stretching almost three miles, Revere Beach was immediately popular with day visitors from the Boston area (see fig. 1). Prendergast clearly found the beach an appealing

33 · *Picnicking Children — Central Park*

subject, for it can be identified as the site depicted in at least two dozen watercolors of 1896–1897.

In September 1899 William MacBeth wrote to Prendergast, inviting him to join the group of artists represented by his new gallery in New York.[5] Prendergast agreed and MacBeth honored him with a one-man show of watercolors and monotypes in March 1900. The exhibition was well received, and the artist began making regular trips to New York and started a series of watercolors of scenes in Central Park. It seems likely that he was looking for a subject that would appeal to New York patrons, for he did not change his style from that he had used in the Boston park scenes that were so admired at MacBeth's.[6] Many of his New York watercolors show children enjoying the park; the festivities of May Day were of particular interest to him and form the subject of many of the Central Park series. On that day, the park "fairly bristled with youngsters," and "the grass was so strewn with white frocks that at a little distance it looked as if household linen laid out to bleach had suddenly taken to skipping about."[7] The central activity of the day was, of course, the dance around the maypole, and Prendergast depicted that subject in several watercolors. But in others he chose quieter moments, as in *Picnicking Children—Central Park*.[8] It has been suggested

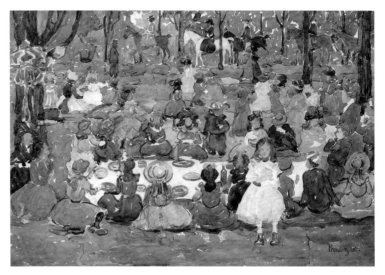

FIG. 2 · Maurice Prendergast, *The Picnic*, graphite and watercolor on paper, 1901. The Carnegie Museum of Art, Pittsburgh; Gift of Mr. and Mrs. James H. Beal, 73.4

that this watercolor may have been a study for a monotype, a medium that greatly interested Prendergast at this time (see cat. 34).[9] However, of the relatively few Central Park monotypes none resembles this scene, so this sheet could well have been an independent work. The areas of bare white paper and the prominent pencil lines might suggest that the work is unfinished, but Prendergast frequently used precisely this method to record the whites of the picnic cloth and the girls' frocks. *Picnicking Children—Central Park* is related to a larger watercolor (fig. 2) that shows a very similar scene, but with many more figures. F.K.

5 Prendergast was abroad at the time, but his brother Charles responded positively for him. It would be at MacBeth's gallery in 1908 that Prendergast joined Robert Henri, John Sloan, Arthur B. Davies, William Glackens, Everett Shinn, George Luks, and Ernest Lawson to exhibit as a group known as The Eight.

6 Gwendolyn Owens, "Maurice Prendergast among His Patrons," in Clark, Matthews, and Owens 1990, 51.

7 "Happy Youngsters Celebrate May Day," The World, 2 May 1903, as quoted in Sally Mills, "William Glackens: Little May Day Procession," in American Paintings from the Manoogian Collection [exh. cat., National Gallery of Art and Detroit Institute of Arts] (Washington, 1989), 180.

8 At one time this watercolor was believed to depict a scene in Boston Garden, but it is clearly related to other securely identified Central Park scenes; the present title is the one given in Clark, Matthews, and Owens 1990, 15.

9 Pilgrim 1973, 102.

34
The Breezy Common

c. 1895–1897, monotype
on paper, 10⅜ x 8¼
(26.4 x 21)

1 *See The Painterly Print: Monotypes
from the Seventeenth to the
Twentieth Century [exh. cat., The
Metropolitan Museum of Art
and Museum of Fine Arts, Boston],
(New York and Boston, 1980).*

2 *See Carol Clark, Nancy Mowll
Matthews, and Gwendolyn Owens,
Maurice Brazil Prendergast and
Charles Prendergast: A Cata-
logue Raisonné (Munich, 1990),
nos. 1563–1764, 574–635.*

3 *Cecily Langdale, Monotypes by
Maurice Prendergast in the Terra
Museum of American Art [exh.
cat., Terra Museum of American
Art] (Chicago, 1984), 22.*

4 *Prendergast's words were recorded
by his friend and student Esther
Williams in 1905 and are quoted
in Hedley Howell Rhys, "Maurice
Prendergast: The Sources and
Development of His Style,"
Ph.D. diss., Harvard University,
1952, 75.*

5 *See Langdale 1984, 23.*

Monotypes are considered a kind of print, but the process used to create them, and the aesthetic results of that process, are wholly unlike those found in any other form of printmaking. They are made by painting in oil, ink, or some other medium, on a smooth and nonabsorbing surface such as glass or metal. Then, before the medium dries, the artist places a sheet of paper on the painted plate and applies pressure with a press, roller, or other implement. More than one "impression" (which, of course, will be reversed from the image on the plate) can be pulled, depending on the thickness of the paint, the amount of pressure applied, and other variables, thus making the term "monotype" technically incorrect. But at most only a few "pulls" are possible, and they can vary considerably in appearance. Compared to other types of prints like etchings, engravings, or even lithographs, which are more labor intensive but permit many virtually identical impressions to be made, monotypes allow the artist far more freedom and spontaneity. Making a monotype has, in fact, much in common with making a painting, whether in oil, watercolor, or any other medium. Not surprisingly, many of the greatest masters of the medium were first and foremost painters, not printmakers.[1]

For more than a decade, from about 1891 to 1902, Maurice Prendergast, in addition to creating watercolors and oils, regularly worked in monotype. Some two hundred examples by him have been documented, making him one of the medium's major practitioners.[2] Prendergast's monotypes are much admired, and have been called "one of the supreme artistic accomplishments in that medium; both qualitatively and quantitatively."[3] Prendergast began making monotypes while he was studying in Paris, so it seems likely he was introduced to the process there. The simplicity of making monotypes is evident in his own instructions to a student: "Paint on copper in oils, wiping parts to be white. When picture suits you, place on it Japanese paper and either press in a press or rub with a spoon till it pleases you. Sometimes the second or third plate [sic] is the best."[4] The evidence offered by Prendergast's known monotypes confirms his preference for oil paint and for Japanese paper (as is the case here), a support considered ideal for the medium due to its malleability, its receptiveness, and its surface sheen, which adds luminosity to the image.[5] Moreover, the monotypes rarely show signs suggesting they were made in a press, which would apply pressure evenly and generally leave distinct plate marks on the paper. Prendergast probably did use a spoon or similar implement, which would allow greater control and flexibility in applying pressure.

34 · *The Breezy Common*

FIG. 1 · Page from Prendergast's sketchbook ("The Boston Watercolor Sketchbook"), watercolor over graphite on paper, 1897–1898. Museum of Fine Arts, Boston, Gift of Mrs. Charles Prendergast in Honor of Perry T. Rathbone

FIG. 2 · Maurice Prendergast, *Lady in Pink Skirt,* monotype on paper, c. 1895–1897. Williams College Museum of Art, Gift of Mrs. Charles Prendergast, 86.18.78

The Breezy Common is one of five closely related works that derive from a watercolor in one of Prendergast's Boston sketchbooks (fig. 1). Of these, four were inscribed with the title as part of the composition (as here); the fifth (fig. 2) has no inscription. Two of the monotypes are horizontal in format and of identical size and were clearly pulled from the same plate. The other three are vertical compositions and differ in size considerably. The Horowitz example is most closely related to *Lady in Pink Skirt* (fig. 2), where the foreground woman is similarly attired and posed, but does not have a child next to her on her left. As in his Boston and New York watercolors (see cats. 32–33), Prendergast drew his subject from the world of the urban park, where elegantly dressed ladies take leisurely strolls and children run happily through the grass. F.K.

35

Picnic by the Inlet

c. 1918–1923, oil on canvas,
28 ¼ x 24 ⅝ (71.8 x 62.6).

Partial and Promised Gift
of Margaret and Raymond
J. Horowitz to the Metro-
politan Museum of Art

1 See Nancy Mowll Matthews,
"Maurice Prendergast and the In-
fluence of European Modernism,"
in Carol Clark, Nancy Mowll
Matthews, and Gwendolyn Owens,
Maurice Brazil Prendergast and
Charles Prendergast: A Cata-
logue Raisonné (Munich, 1990),
35–45.

2 Pilgrim (1973, 106) dates Prender-
gast's exposure to Signac to a
trip to France of 1909–1910, but
he was not abroad that year.

3 Maurice Prendergast to Mrs. Oliver
Williams, 10 October 1907, Archives
of American Art, Williams Papers,
as quoted in Matthews 1990, 36.

4 Arthur Hoeber, "Art and Artists,"
Globe and Commercial Advertiser,
5 February 1908, 8, as quoted in
Nancy Mowll Matthews, Maurice
Prendergast [exh. cat., Williams
College Museum of Art] (Munich,
1990), 26.

Although he had worked with oil paint since the earliest days of his career, after the turn of the century Maurice Prendergast turned his attention to the medium with new enthusiasm and ambi- tion. The subjects of his oils paralleled those of his watercolors: adults and children promenading and playing in parks, along harbors, and at sea- shores. During the first decade of the twentieth century he tended to paint small-to-medium sized panels that were only rarely bigger than his largest watercolors. Around 1910 he began work- ing on canvas and on a greater scale. His subject matter became more and more reductive, gradu- ally crystallizing into compositions that consisted of figures in the foreground, trees in the middle- ground, and a body of water (perhaps flanked by hills) in the distance. Incidental details were greatly simplified or omitted altogether. For Pren- dergast, subject had now become merely the template upon which he could construct paintings of formal sophistication.

During the early years of the twentieth century a fertile and challenging mix of artistic influences was available to any artist with an open mind and discerning eyes, particularly if they could see at firsthand what was happening in Paris. Pren- dergast visited Paris in 1907 and in 1914, and his drawn and written observations indicate that he saw and pondered a great deal.[1] He studied the works of Cézanne, especially his watercolors; the neoimpressionist paintings of Paul Signac, Henri Edmond Cross, and others; and the controversial canvases of Matisse and other fauve painters he saw at the 1907 Salon d'Automne.[2] He saw so much, in fact, that he was uncertain what the result would be: "All those exhibitions worked me up so much that I had to run up and down the boulevards to work off steam. . . . I don't know what influence it will have after I am once more home."[3] His response is hardly surprising. In Paris Pren- dergast witnessed the extraordinary aesthetic fermentation that would, in the work of Picasso, Braque, Matisse, and others, lead to a wholesale revision of the very nature of painting. As Pren- dergast sensed, he would need to take stock of all this after he had returned home.

While he was abroad in 1907 Prendergast had been invited to join Robert Henri, William Glackens, John Sloan, Arthur B. Davies, Everett Shinn, George Luks, and Ernest Lawson in a group exhibition at William MacBeth's New York gallery. Prendergast's work was far more advanced stylistically than that of any of the others, but he agreed, contributing seventeen paintings to what became known as the exhibition of The Eight. Critics noticed the difference immediately, some negatively, others at least moderately posi- tively. One critic provided a back-handed compli- ment to Prendergast's modernity by using the kind of language that was fast becoming the *sine qua non* of aesthetic conservatism: "these canvases of Maurice Prendergast look for all the world like an explosion in a color factory."[4] Undeterred, Prendergast continued his formal experiments and was, in fact, one of the most radical painters working in America at the time. He was an enthusiastic contributor and visitor to the Armory Show of 1913 and his own work began to be acquired by the leading avant-garde collectors Albert C. Barnes and John Quinn.

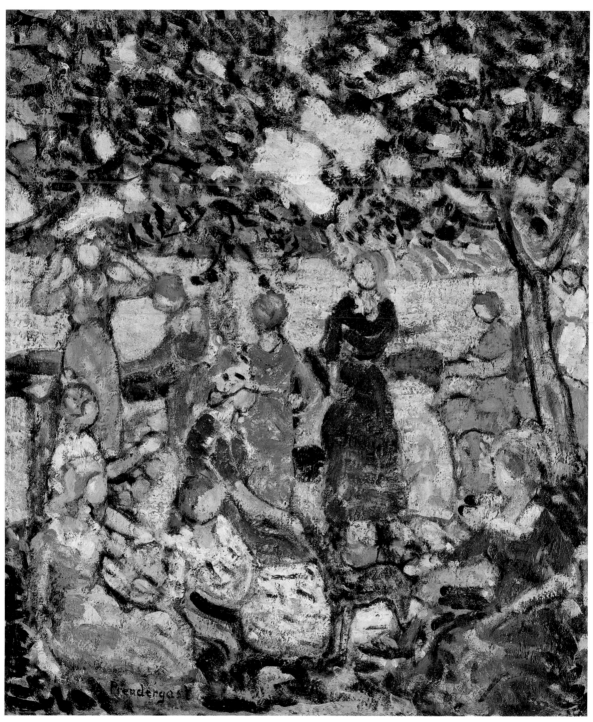

35 · *Picnic by the Inlet*

In 1914 Prendergast and his brother Charles moved from Boston to New York, doubtless because they found artistic circles there more stimulating and receptive. Over the last decade of his life Maurice created his most formally complex and ambitious oils. He rarely dated his works, making it difficult to establish a certain chronology, but his efforts culminated in a series of monumental, almost totemic, paintings from about 1918 onward, of which *Picnic by the Inlet* is a prime example. Though in many ways similar to works of just a few years earlier (see fig. 1), it more obviously asserts its reality as paint on a flat surface. The figures loom larger than they did earlier, filling more of the composition and rising higher in it, so that they overlap the background sky. Spatial recession is forcibly denied by brushwork that is unmodulated and equally vigorous all over the surface of the canvas. Forms overlap unpredictably, blurring the distinctions between near and far space. Prendergast's interlocking and overlapping mosaic of richly textured pigment creates a vibrant and shimmering surface, but the tightly controlled composition locks forms securely in space and prevents their disintegration. *Picnic by the Inlet,* like Matisse's great essay on a similar theme, *Luxe, calme et volupté* (fig. 2), is at once wonderfully animated and yet solemnly still, fusing the immediacy of perception with the permanence of rigorously controlled structure. F.K.

FIG. 1 · Maurice Prendergast, *The Promenade,* oil on canvas, 1913. Whitney Museum of American Art, Alexander M. Bing Bequest 60.10

FIG. 2 · Henri Matisse, *Luxe, calme et volupté,* oil on canvas, 1904. Musée National d'Art Moderne, Centre Georges Pompidou, Paris

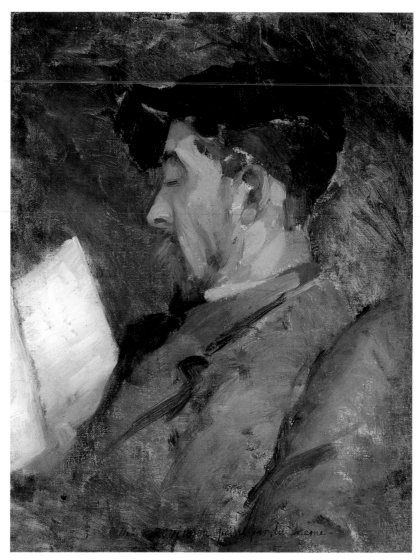

36 · *Self-Portrait*

36
Self-Portrait

c. 1884–1887, oil on canvas,
13 ¼ x 10 ¼ (33.7 x 26)

Theodore Robinson was the most thoughtful and intelligent of those American artists it is now customary to call impressionist, and also the most literate (the diaries he kept during the last four years of his life are felicitously written and sprinkled with references to and quotations of such writers as Tobias Smollett, Gustave Flaubert, Walt Whitman, and Henry James). He suffered, too, from persistently debilitating ill health, the chronic asthma that ended his life at the early age of forty-four.

This self-portrait was painted in France—he wears a beret (an undated photograph of Robinson at work shows him wearing the same beret [fig. 1], and it is inscribed "Robinson peint par lui même") —when he was in his early thirties. In its concentrated, focused intensity and emaciated features (which Kenyon Cox had recorded so affectingly several years earlier, cat. 18), Robinson's painting captures the salient characteristics of both his mind and body. In showing himself in profile, rather than in the usual frontal mirror view, it is also a representational tour de force. N.C.

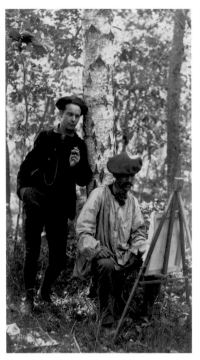

FIG. 1 · *Theodore Robinson (seated) with Kenyon Cox,* albumen print, n.d. Terra Museum of American Art, Gift of Mr. Ira Spanierman, C1985.1.25

37
Young Woman Reading

1887, watercolor on paper,
19 ⅜ x 13 ¾ (49.2 x 34.9)

1 *Diary, 14 February 1893.*

2 *Diary, 1 October 1894.*

3 *Diary, 30 March 1894.*

Although painted in Paris in 1887, this picture recalls nothing so much as Winslow Homer's American watercolors made about a decade earlier. Robinson had a lifelong admiration for Homer. He paid a call on him in New York early in his career; in 1894 he bought one of Homer's English watercolors; and in his diary he commented again and again on Homers he saw in dealers' show-rooms and at auction houses. He liked both Homer's artistic achievement—his powers of invention, his "delightful frankness," and his painting of detail[1]—and his independent character: he quoted, with implicit approval, a remark from one of Homer's letters from Prout's Neck, Maine, in which he protested, "I am not a recluse, & I am now probably the only man in New England who minds his own business."[2] Above all, Robin-son admired Homer's watercolors. He often commented on them, and of the one he bought, he said, "It has the same charm his work, and especially his watercolors and drawings, have always had for me"—adding, however, that he was "surprised at my wanting it—as I 'paint so different.'"[3]

One can understand Robinson's liking for Homer's painting of details, for he took special pains to paint the chair in which the reading woman sits, so attentive to its structural details that it almost becomes the principal motif. In this sense, it prefigures Robinson's interest in pic-torial structure that became of special importance to him several years later. N.C.

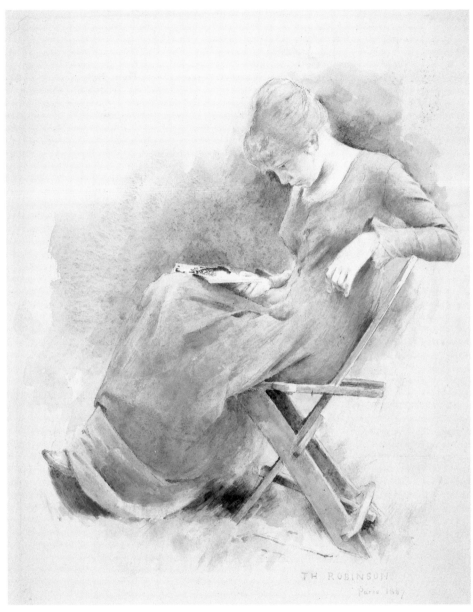

37 · *Young Woman Reading*

38 · *A Normandy Mill*

38
A Normandy Mill

1892, watercolor on gray
academy board, 9 ⅞ x 15
(25.1 x 38.1)

1 See William H. Gerdts, *Monet's
Giverny: An Impressionist Colony*
(New York, 1993), fig. 84.

2 See Sona Johnston, *Theodore
Robinson, 1852–1896 [exh. cat.,
Baltimore Museum of Art]* (Balti-
more, 1973), xix–xx. The label
on the back of the Whistler sketch
reads: "Souvenir de Venice [sic]
to Theodore Robinson from James
McNeill Whistler."

3 "At Johnston's small atelier, rue
Vaugirard. . . . Whistler called,
has just taken a studio in Paris."
Diary, 20 June 1892.

4 Gerdts 1993, 90.

The mill was a feature of Giverny important
enough to merit a photographic postcard.[1] In the
summer of 1892, his last in Giverny, Theodore
Robinson painted the mill several times from dif-
ferent points of view, in different mediums, and
—following accepted impressionist practice—at
different times of day and night. While Robinson
was in Giverny in the early 1890s Monet made the
serial paintings of grain stacks, poplars, and Rouen
Cathedral, in which he rigorously explored the
changing effects of light. But the painting of night
scenes in the late nineteenth century was inspired
most of all by James McNeill Whistler. Whistler's
Nocturnes, as he called them—borrowing from
the musical terminology he regularly used to
stress the abstract, nonimitative quality of his art
—were perhaps his most difficult, and hence his
most notorious, paintings. Robinson met Whistler
in 1879, probably in Venice, when they were close
enough to buy a painting together and for Whistler
to give Robinson an oil sketch.[2] He met Whistler
at least once again in Paris in June of 1892 and
referred to him more than once in his diary.[3] It is,
of course, tempting to think that meeting Whistler

in 1892 inspired Robinson, later in that summer,
to paint his version of a Whistler nocturne. Earlier,
however, in 1889, Robinson had painted a *Harvest
Moon, Giverny* (unlocated). Also, another Ameri-
can artist in Giverny in the early 1890s, Thomas
Buford Meteyard, painted nocturnal, moonlit
scenes of the village.[4] Whatever his inspiration,
it was potent enough to cause Robinson to paint
two virtually identical moonlit views of the mill,
a version in oil (fig. 1) and the smaller Horowitz
watercolor. N.C.

FIG. 1 · Theodore Robinson, *Moonlight, Giverny,* oil on canvas, c. 1892.
The Parrish Art Museum, Southampton, N.Y., Littlejohn Collection

39
Low Tide, Riverside Yacht Club

1894, oil on canvas,
18 x 24 (45.7 x 61)

1 *Diary. For Robinson at Cos Cob,
see Susan G. Larkin, "Light, Time,
and Tide: Theodore Robinson at
Cos Cob," American Art Journal
23 (1991), 74–108.*

Theodore Robinson was perhaps the most noticed artist in the early years of impressionist activity in America: one of his landscapes received the important Webb Prize in the Society of American Artists exhibition in 1890, marking in something like an official way the acceptance of impressionism in America. He also, as few others did, consciously and conscientiously, with rigor and clarity of purpose, came to grips with the issues that French impressionism, which he knew intimately from one of its inventors, Claude Monet, posed for him and other American artists of his generation.

However, hesitancy and irresolution were mixed with Robinson's purposiveness. They were caused by persistent illness that prevented sustained physical effort and the uninterrupted pursuit of his artistic aims, and by what he himself described as an "undecided character" that stemmed from his tendency to "see two sides to a question too much," and simply from the very newness and complexity of his artistic situation. He made his situation more difficult by a determination not to fall into easy habits and pictorial formulas, to which American impressionists seemed particularly liable: "'Woe to them that are at ease in Zion,'" he wrote on 19 February 1894 of the "clever" work in that year's watercolor society exhibition. "[O]ur only safety is in constant research." Earlier, he said damningly of the American painter Louis Paul Dessar, whom he knew in Giverny, that "He has no fear of the *banal,* of doing the already done."

"Am getting well and strong," Robinson wrote in his diary on 19 June 1894, in reference to his bouts with asthma, "and work with interest." He was working in late afternoon on the railroad bridge over the Mianus River, at Cos Cob, Connecticut (drawn there by his nearby friends Twachtman and Weir), painting "the club-house [fig. 1] and little yachts at anchor, low tide, patches of sea grass. It is particularly brilliant at about 5 p.m."[1]

In the year or two before painting *Low Tide, Riverside Yacht Club* Robinson referred in his diary to issues that had started to shape his thinking and his work. With Twachtman, Weir, and many others, Robinson greatly admired Japanese art. "Tw. and W. are rabid just now on the J.," he noted on 10 December 1893. "I have too much ignored old art," he wrote on 30 November 1893, "except such as *immediately* touches what I may be trying for at the moment [but] the best men have been influenced for the better by Japanese art, not only in arrangements, but in their extraordinary delicacy of tone and color. . . ." Like Weir and Twachtman, Robinson owned Japanese prints. Of the first he acquired—in 1894, the year of *Low Tide, Riverside Yacht Club*—he wrote, it "points

FIG. 1 · *Riverside Yacht Club*, 1913. Archives, Riverside Yacht Club

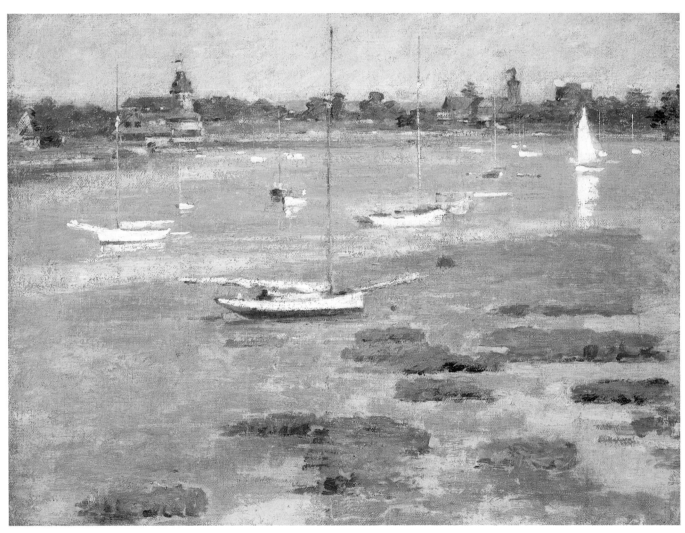

39 · *Low Tide, Riverside Yacht Club*

FIG. 2 · Claude Monet, *The Bridge at Argenteuil*, oil on canvas, 1874. National Gallery of Art, Collection of Mr. and Mrs. Paul Mellon

FIG. 3 · Georges Seurat, *The Channel of Gravelines, Petit Fort Philippe*, oil on canvas, 1890. Indianapolis Museum of Art, Gift of Mrs. James W. Fesler in memory of Daniel W. and Elizabeth C. Marmon

2 *Diary, 17 February 1894.*

3 *Diary, 29 November 1893.*

4 *Diary, 2 September 1895.*

5 *Diary, 1 January 1895.*

6 *Diary, 17 December 1894
 and 23 February 1895.*

in a direction I must try & take, an aim for refinement and a kind of precision. . . ."[2]

Following his return from France in 1893, after many years abroad, one of Robinson's chief concerns, and generally speaking the chief concern of his artistic maturity, which can be said to have properly begun that year, was American subject matter and style. "[E]mancipation from old formulae and ideas of what is interesting and beautiful, from the European standpoint, will work wonders," he wrote, and he thought of doing American subjects, like "little square, box-shaped white houses."[3] "We should paint them [New England barns] as in the old world one paints cathedrals or castles," he said later.[4] And he thought, too, of an American style consisting of "severer design."[5]

The paintings of sailboats at anchor that Robinson made in the summer of 1894—he made four —are some of his most beautiful and perfectly realized paintings. They derive from Robinson's interests and concerns at the time he made them, and in them those concerns yielded their most certain and successful results. In the pictorial architecture of the anchored sailboats he found the "arrangements," the tonal and coloristic delicacy, and the refinement and precision, of Japanese art, but also the firmness and severity that were, he sensed, the elements of an American vision and language of style.

Robinson's yacht club paintings recall those that Monet and Renoir painted at Argenteuil in the 1870s. But in style they are less like such high impressionist paintings (fig. 2) than later postimpressionist ones, which are closer in date, and closer in the spirit, to Robinson's. Robinson criticized the impressionist opticality and insubstantiality of one of his own paintings by saying it has "'sunlight' but little else" and for being "too floating, shimmery—and not firmly done."[6] The correctives to that, clearly apparent in the yacht club paintings, were the firmly plotted spatial structure and explicit pictorial design that bear far less resemblance to impressionist opticality and informality than to the disciplined formal organization of postimpressionism; less resemblance to Monet, despite Robinson's closeness to him, than, for example, to Georges Seurat's landscapes of about 1890 (fig. 3), with which they have in essence a greater and truer kinship of purpose. N.C.

39 · Low Tide, Riverside Yacht Club (detail)

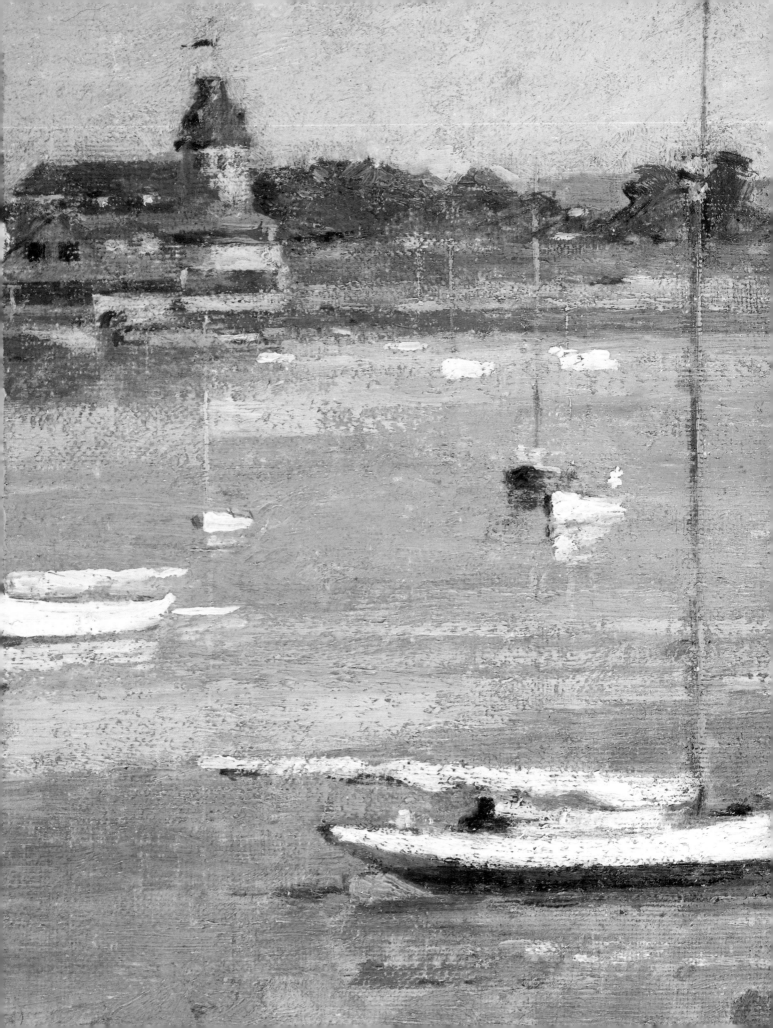

40 · *Under the Willows*

40
Under the Willows

41
Gondoliers' Siesta

1888, watercolor and pencil
on paper, 14 x 9⅜
(35.6 x 23.8)

1905, watercolor on paper,
14 x 20 (35.6 x 50.8)

1 *"From the time of his first suc-
cesses at the Salon he was hailed,
I believe," his friend Henry James
wrote in 1887, "as a recruit of
high value to the camp of the Im-
pressionists, and today he is for
many people most conveniently
pigeon-holed under that head."
"John S. Sargent," Harper's
Monthly 75 (October 1887), 681.*

These two watercolors bracket the period in John
Singer Sargent's career when he was probably the
greatest and surely the most sought after portrait
painter in the Anglo-American world: Max Beer-
bohm's 1908 caricature of sitters (and page boys
holding places for ones not there) lined up in front
of Sargent's London studio at 31, Tite Street,
Chelsea, awaited by the scowling artist seen in
the window (fig. 1), is only a slight and quite
allowable exaggeration of the fame and station
Sargent had achieved by the turn of the century.

Under the Willows was painted earlier, in 1888,
on the eve of Sargent's life as a public figure—
certified as such, as other public figures were, by
Beerbohm's attention—and as the painter of
public figures. In the years immediately following
his settlement in England in 1886, where he would
live for the rest of his life, Sargent, though working
to establish his place in English art and society,
had not yet done so. He had a studio in London
but spent a good deal of his time with a close circle
of family and friends—like the two he depicted
in *Under the Willows*—and fellow artists away
from London, in places like Broadway, Fladbury,
and Calcot—where *Under the Willows* was painted.
In these years, too, Sargent's artistic allegiances
were still shifting. He had not as yet settled into
portraiture as his principal subject, or fixed upon
his artistic position and language of form—that
is, the location on a scale from conservative to

FIG. 1 · Max Beerbohm, "The Queue Outside Mr. Sargent's," 1908, pub-
lished as "31 Tite Street," in Evan Charteris, *John Sargent*, 1927, opposite p. 160

radical of his affiliations of belief and style. He
painted major subject pictures (*El Jaleo* of 1882,
in the Isabella Stewart Gardner Museum, Boston,
being the greatest and most ambitious of them)
as well as portraits, and he was generally regarded
as an impressionist when being so, particularly
in England, the land of "finish," was daringly and
disturbingly unconventional.[1] Just what kind of
impressionist Sargent was—how devoted or how
extreme—may be a matter of discussion, but
there is little doubt that the late 1880s marked the
highpoint of his attraction to impressionism, the
closest that he came in subject, style, and method
to orthodox French impressionism. At Broadway
in 1885 he painted like an impressionist, rapidly
and randomly, "whatever met his vision without
the slightest previous 'arrangement' of detail, the
painter's business being, not to pick and choose,
but to render the effect before him." He spoke
like an impressionist, too, saying, Sir Edmund Gosse
reported, "the artist ought to know nothing
whatever about the nature of the object before

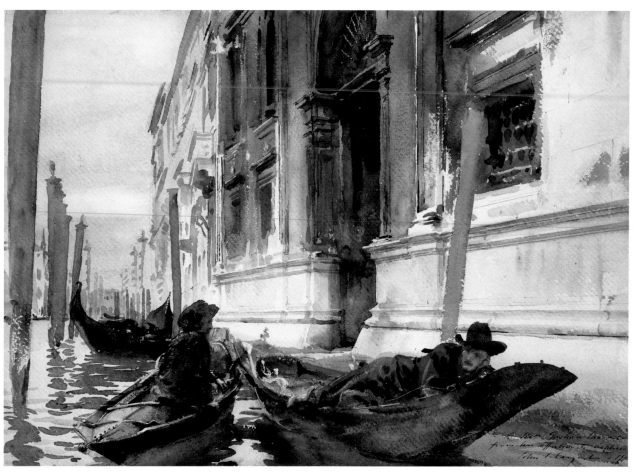

41 · *Gondoliers' Siesta*

him . . . but should concentrate all his powers on a representation of its appearance."[2] In 1887 he visited his lifelong friend Claude Monet at Giverny, where, in a major pictorial document of impressionist practice (Tate Gallery) he painted him at work out-of-doors. He also bought one of Monet's paintings, which he looked at, he said, "in a state of voluptuous stupefaction, or enchantment. . . ." And in these years he painted what are clearly his most impressionist works. One of them, executed with impressionist rapidity, arranged with impressionist informality, and filled with bright impressionist light and color, is *Under the Willows*. On the back it is inscribed to its sitters, two of his favorite models at this time and later, his sister Violet and his (and her) close friend Flora Priestly (fig. 2).

Sargent painted watercolors most of his life (his mother was an accomplished watercolor painter), but until about 1900 he did so only fitfully and, as he said, to "make the best of an emergency."[3] By about 1900 Sargent had tired of formal portraiture. "No more paughtraits," he wrote his friend Ralph Curtis. "I abhor and abjure them and hope never to do another especially of the Upper Classes."[4] He could never give up portraiture entirely, despite his hope, but he did, as Richard Ormond has nicely put, go "off duty"[5]

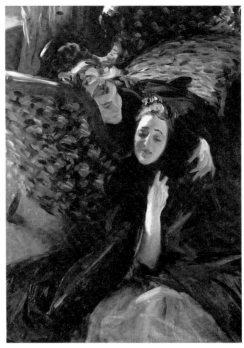

FIG. 2 · John Singer Sargent, *Violet Sargent and Flora Priestly,* oil on canvas, 1889. Private collection

to paint other subjects and work in other mediums.

Of those subjects, Venice was his favorite, and watercolor was the medium he favored to paint it. Sargent had visited Venice before 1900, of course; some twenty years earlier he had done a beautiful series (in oil) of Venetian street scenes and interiors. But from about 1900 to 1913, when "swarms of smart Londoners" managed to drive him away,[6] he visited Venice almost yearly, and he painted it most often by far in watercolor (the majority of Sargent's late watercolors are Venetian). Sargent's earlier oils (fig. 3) were painted on solid ground and depicted the "Venice in Venice that...others seemed never to have perceived" that Whistler had discovered slightly earlier,[7] the Venice of back streets, small squares, and interiors that tourists seldom saw and artists seldom depicted. His later Venetian watercolors are painted from "gondola

2 *In Evan Charteris, John Sargent (London, 1927), 78.*

3 *Charteris 1927, 95.*

4 *Quoted in Charteris 1927, 155.*

5 John Singer Sargent: Paintings, Drawings, Watercolours *(London, 1970), chap. 5.*

6 *Charteris 1927, 171.*

7 *Letter to Marcus B. Huish, probably January 1880, Glasgow University Library, quoted in Richard Dorment et al.,* James McNeill Whistler *[exh. cat., Tate Gallery] (London, 1994), 179.*

FIG. 3 · John Singer Sargent, *Street in Venice,* oil on canvas, 1882. National Gallery of Art, Washington, Gift of the Avalon Foundation

8 The term is Tony Tanner's, *Venice Desired* (Cambridge, Mass., 1992), 173, apropos Henry James: "*perpetual architecture above you and perpetual fluidity beneath*" (Italian Hours [New York, 1958], 19–20). It is cited in Donna Seldin Janis, "Venice," in Sargent Abroad: Figures and Landscape (New York, 1997), 186.

9 See note 8, above.

perspective"[8] as he floated through the city's canals (they often include the prow of his gondola to make that point of view explicit), looking at its buildings and depicting its major architectural monuments and public spaces—the Grand Canal and the Riva; the Doge's Palace, Dogana, Libreria, and Scuola di San Rocco; the Salute, Gesuati, and Santa Stae; palazzi and bridges. They are painted not only with the seemingly effortless fluency that characterizes Sargent's work in every medium, but with a fluidity—a wetness both of appearance and of the process by which Sargent painted them—that befits the consistently watery perspective from which Sargent observed Venice, the "perpetual fluidity beneath"[9] him as he floated effortlessly through the city.

In depicting figures, *Gondoliers' Siesta* is something of a rarity (though hardly an exception) among Sargent's later Venetian watercolors (as is the fact, too, that it is dated, 1905). And instead of the clear blue skies and vibrantly coruscating light of most of Sargent's Venetian watercolors, *Gondoliers' Siesta* is, with its overcast sky, more subdued, more languid, shadowy, and even mysterious. In all these respects it recalls, more than most of Sargent's Venetian watercolors, the dark streets and alleys and slightly sinister occupants of his first Venetian series of the 1880s. N.C.

42
Matinee, Outdoor Stage, Paris

1902, pastel on paper,
18 x 26 (45.7 x 66)

1 Shinn Autobiographical Material,
 on deposit at the Delaware Art
 Museum, Wilmington, as quoted
 in Edith DeShazo, Everett Shinn,
 1876–1953: A Figure in His
 Time (New York, 1974), 24.

2 Linda S. Ferber, "Stagestruck:
 The Theater Subjects of Everett
 Shinn," in Doreen Bolger and
 Nicolai Cikovsky, Jr., eds., Ameri-
 can Art Around 1900: Lectures
 in Memory of Daniel Fraad (Wash-
 ington, 1990), 54.

3 See Robert L. Herbert, Impres-
 sionism: Art, Leisure, and Parisian
 Society (New Haven and London,
 1988), 76–91.

4 Herbert 1988, 88.

Everett Shinn's early experiences as a staff artist for the *Philadelphia Press,* where he began working in 1893, were of central importance in his artistic development. The art department there was, he observed, "a school that trained memory and quick perception. For in those days there was not on any newspaper the handy use of the camera. . . . The artists carried envelopes, menu cards, scraps of paper, laundry checks. . . . Rigid requirements compelled them to observe, select and get the job done."[1] Shinn moved to New York in 1897 to work as an illustrator for the *New York World,* but by the following year his works were being published in such periodicals as *Harper's New Monthly Magazine.* Pastel became his favorite medium in these years and he regularly showed pastels in exhibitions in New York and Philadelphia. In 1900 he had a one-man exhibition of more than forty pastels at the Boussod, Valadon, and Company gallery in New York. After the exhibition closed, Shinn and his wife traveled abroad, visiting both London and Paris. His "trained memory and quick perception" served him well and by the time they returned to America, in the fall of 1900, Shinn had with him numerous sketches and studies that would provide inspiration to him for years to come.[2]

Matinee, Outdoor Stage, Paris depicts a scene in one of that city's popular café-concerts, open-air entertainment spots that combined performance hall and bar. Most, like the famous Café des Ambassadeurs, were located along the Champs-Elysées and had somewhat questionable reputations. At the opera and ballet, which were generally patronized by the upper class, decorum was strict, but

the café-concerts were decidedly boisterous.[3] People came and went during performances, engaged in conversations, and, of course, drank and ate. Prostitutes circulated in the crowd, seeking clients. The singers and other performers were generally from the lower classes and were known for their use of bawdy language and gestures. The clientele, on the other hand, was primarily middle and upper class, drawn by the more relaxed and informal atmosphere and the chance to see and interact with people from outside their own social circles.[4] Mary Cassatt's friend Louisine Havemeyer, a prescient collector of French impressionist works, frowned at what she termed the "crass banality" of the café-concerts and the

FIG. 1 · Edouard Manet, *Corner in a Café-Concert,* oil on canvas, 1878–1879. National Gallery, London

42 · *Matinee, Outdoor Stage, Paris*

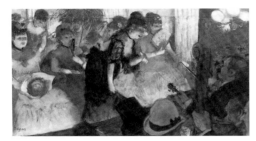

FIG. 2 · Edgar Degas, *Cabaret (Café-Chantant)*, pastel over monotype, 1876. Corcoran Gallery of Art, Washington, D.C., William A. Clark Collection 26.72

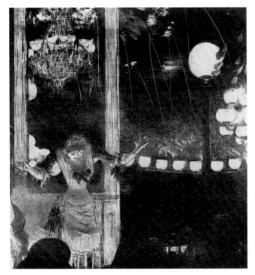

FIG. 3 · Edgar Degas, *Mlle. Bécat at the Ambassadeurs Café*, lithograph, 1877/1878. Art Institute of Chicago, William McCallin McKee Memorial Collection, 1932.1296

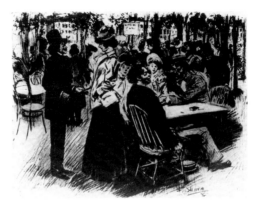

FIG. 4 · Everett Shinn, "Revenge Enough," published in *Harper's New Monthly Magazine* 97 (Sept. 1898), 661

"common type[s]" who performed there.[5] But for artists like Manet, Degas, and Shinn (see figs. 1–4), that same "crass banality" could inspire works of great beauty.

Matinee, Outdoor Stage, Paris almost certainly depicts the Café des Ambassadeurs, which was set amidst a grove of trees and lit at night by scores of gas lights. The shining white globes visible in Shinn's pastel (see also figs. 2, 3) indicate that the time is evening, when the café-concerts were at their busiest. In the background is a singer on stage, her arms open wide. In the foreground men and women, some at tables, others standing, converse, seemingly oblivious to the performance. Unlike

Degas, who generally focused on the women who sang and danced (figs. 2, 3), or Manet, who turned his attention to the waitresses (fig. 1), Shinn here made the audience his primary subject. Using his Parisian sketches, his memory, and his brilliant, vibrant handling of pastel, Shinn reshaped one of his own early illustrations (fig. 4) into a tour de force of color and light.[6] At the left a man, his head lowered, talks to a pretty woman in dark clothing and a blue hat. Perhaps there is something furtive in the way she looks at him, or perhaps not. Shinn only suggests. Two men near the center of the composition, one in a top hat, the other in a boater, seem almost conspiratorial in their conversation. Two gaily outfitted women at a table pay rapt attention to a man across from them, perhaps an artist to judge from his clothing. A standing woman, at the right, also apparently in conversation with someone, is cropped by the edge of the sheet. Clearly, Shinn indicates, this is but a glimpse of a much bigger picture, a microcosm of the myriad social interactions taking place throughout the crowd. Works such as this reveal why Shinn's contemporaries early on hailed him as a master of pastel.[7] F.K.

5 Louisine W. Havemeyer, Sixteen to Sixty: Memoirs of a Collector (New York, 1961), 245. Havemeyer was actually describing a scene at the Café des Ambassadeurs depicted in Edgar Degas' pastel The Song of the Dog (c. 1876–1877, private collection), which she once owned; see Jean Sutherland Boggs and Anne Maheux, Degas Pastels (New York, 1992), 68.

6 Barbara C. Rand, in "The Art of Everett Shinn," Ph.D. diss., University of California, Santa Barbara, 1992, 175, notes the relationship of the earlier illustration.

7 As the critic A. E. Gallatin wrote in 1906: "he knows thoroughly both the possibilities and the limitations of the medium. The material is never strained in endeavoring to get too much out of it; and if technically his pastels are great achievements, pictorially they are also. . . ." From a review in Studio Talk, November or December 1906, as quoted in DeShazo 1974, 58.

43

Sketching at the Beach

1886, watercolor on paper,
9¼ x 13 (23.5 x 33)

1 *The American Watercolor Society,
 founded in 1866, reached the
 peak of its popularity in the early
 1880s. For a history of the Society
 see Kathleen Foster, "Makers of
 the American Watercolor Move-
 ment: 1860–1890," Ph.D diss.,
 Yale University, 1982.*

2 *The watercolors Sterner exhibited
 were no. 5,* A Breezy Day—Fire
 Island; *no. 273,* A Rendezvous,
 Central Park; *no. 280,* The Sands
 —Fire Island; *no. 282,* Clearing
 Up, off Fire Island; *no. 402,*
 The Little Wader; *and no. 563,*
 A Marine Artist.

3 *Foster 1982, 2.*

4 *For an account of landscape
 painters on Long Island in the nine-
 teenth century, see Ronald G. Pisano,
 Long Island Landscape Painting:
 1820–1920 (Boston, 1985).*

In 1887 Albert Sterner contributed six works to the annual exhibition of the American Watercolor Society.[1] Three of these included "Fire Island" in their titles, and two others made reference to activities of the seashore.[2] *Sketching at the Beach* may be the watercolor that Sterner at that time called *A Marine Artist.* That year there were 656 entries, by 103 artists, in the popular exhibition. As Kathleen Foster has written: "No other exhibi-tion in New York was as diverse or as complete in its representation of native talent as the Watercolor Society, for it attracted work from well-known oil painters as well as contributions from a host of illustrators, commercial artists, and amateurs whose work had no other forum."[3] The twenty-three-year-old Sterner was among these illustrators. Having moved from Chicago to New York just a few years earlier, he had already found steady work with several major magazines. In years to come, he would become an influential force in print-making and a recognized painter in oils, as well as a popular illustrator. *Sketching at the Beach* is a youthful effort that demonstrates his consider-able talent and early accomplishment.

The near emptiness of the beach in Sterner's depiction reflects the serenity of Fire Island around 1880. A barrier island along Long Island's south shore, its relative remoteness made it a desirable location for American landscape painters such as Sanford Gifford and others.[4] In Sterner's image, the marine artist sits upon one washed-up barrel, another can be seen in the distance, and a loose stave points inward from the lower right corner, reminders of Long Island's history of commerce and of the fate of some of the ships that plied its waters.

A few light pencil strokes define Sterner's placement of the figure in her environment, and the freshness of his observation leaves no doubt that this watercolor was rendered on the spot. Sterner's model, while posing, focuses on an unseen subject. Her concentration and posture are intense and businesslike as she grasps the portfolio supporting the sheet on which she works. But her trim figure, the sunlight and shadow falling across her hat and face, and her scarf flutter-ing in the breeze also make her appear a fetching Homeresque young woman. D.C.

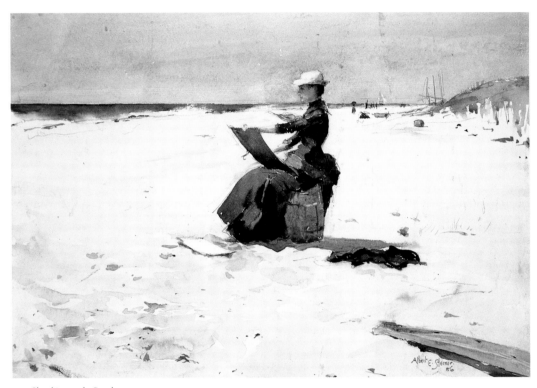

43 · *Sketching at the Beach*

44 · *Trees in a Nursery*

44

Trees in a Nursery

c. 1885–1890, pastel on
paper, 18 x 22 (45.7 x 55.9)

1 New York Times, 5 May 1890, 4.

During the period of renewed interest in pastels that occurred in America in the late 1880s and 1890s, there were two primary approaches to the medium. Some artists, such as William Merritt Chase, blended the colored chalks opaquely, treating the emerging image very much like an oil painting. Others, like John Twachtman (and Robert Blum), who more closely followed the example of Whistler, produced drawings comprising slight color notes of the utmost delicacy, placed, also following Whistler's example, on tinted papers.

In a review of the Society of Painters in Pastel exhibition in 1890, to which Twachtman contributed, a critic who applauded the artist's subtle efforts said that he "does not elaborate and insist too much on his picture."[1] He was referring chiefly, of course, to Twachtman's Whistlerian delicacy of touch and economy of means. But it is true to say also that Twachtman does not insist on his picture. For despite the strong perspective lines, which are, however, brought up short by a clump of trees, Twachtman restricts pictorial depth in favor of painterly flatness. He does so by the device, commonly used for that purpose, of a high horizon line, by the insistent surface (much of it left exposed) of the tinted paper, and by the sense, which he makes inescapable, that the colored marks that lie upon the paper's surface, despite the degree to which they refer to an illusion of space, are always felt ultimately to do exactly that.

Of the forty-three works in Twachtman's one-man exhibition at Wunderlich Galleries in New York, in March of 1891, thirty were pastels. Twachtman's style of the 1890s, therefore, can be said not only to have been announced by his pastels, but their delicacy of color and form—with which the term pastel has, of course, become virtually synonymous—of his paintings of that decade were predicted by and, it may be, in some measure derived from effects that are inherent in the pastel medium more than in oils (suggested also by Twachtman's practice in his oils of painting on colored grounds).

Many of the pastels Twachtman exhibited in 1891 seem to have been made at Branchville, Connecticut, where his friend J. Alden Weir lived and where Twachtman also worked (one was titled *On Wier's [sic] Farm*); *Trees in a Nursery,* which does not show any of the familiar views of Twachtman's Greenwich property, may be one of them.
D.C. and N.C.

45

September Sunshine

c. 1895, oil on canvas,
25 x 30 (63.5 x 76.2)

1 *Twachtman and his family proba-
bly first lived on the property as
tenants, later purchasing it in two
installments in 1890 and 1891.
For the most complete discussion
of Twachtman's relation to his
Greenwich home, see Lisa N.
Peters, "Twachtman's Greenwich
Paintings: Context and Chronol-
ogy," in Deborah Chotner, Lisa N.
Peters, and Kathleen A. Pyne,
John Twachtman: Connecticut
Landscapes [exh. cat., National
Gallery of Art] (Washington,
1989), and Lisa N. Peters, "John
Twachtman (1853–1902) and
the American Scene in the Late
Nineteenth Century: The Frontier
within the Terrain of the Familiar,"
Ph.D. diss., City University of New
York, 1995.*

2 *Diary, 11 April 1895.*

3 *"John H. Twachtman: An Esti-
mation," North American Review
176 (April 1903), 561, 554.*

In 1889 John Twachtman acquired seventeen acres of land on Round Hill Road in Greenwich, Connecticut.[1] On the property was a farmhouse, steadily enlarged over the years, in which the artist lived with his wife and seven children, and through the property ran a stream, Horseneck Brook, which fed Hemlock Pool. During the 1890s, the most productive period of Twachtman's life, house, stream, and pool would all be the subjects of many of Twachtman's best-known paintings. *September Sunshine* is one of many depictions of the house.

A sense of place, of rootedness, was deeply important for Twachtman, as it was for other of his artist friends. The closest of them, J. Alden Weir, owned a house and land near Twachtman, at Branchville, Connecticut, which, like Twachtman's, was frequently his subject. And Weir expressed what the attachment to places like his and Twachtman's meant to them when he urged their unsettled friend Theodore Robinson, as Robinson recorded, "to have a place of my own and get acquainted with it—grow up with it."[2]

Because Twachtman did not date his Connecticut paintings, and because there is otherwise little documentary evidence of when they were painted, his house has attracted particular interest in the hope that the many changes and additions he made to it over the years might, when they are seen in his paintings, hold clues to his artistic development.

Unfortunately, Twachtman was not scrupulously exact in depicting his house, so that is not reliable evidence. But there is in his refusal to be bound to precise representation (reflected also in his disinterest in titles) evidence of something almost as difficult to determine as the dates of Twachtman's paintings, namely, the nature of his style and artistic purpose and posture.

As his contemporaries understood, Twachtman was one of the most advanced, most modern artists of his generation; Weir, for instance, said, in the year after Twachtman's death, that he "had been in advance of his age," and Thomas Dewing said at the same time that he was "too modern . . . to be fully recognized or appreciated at present."[3] His modernity was expressed by his associations with such attitudes or languages of style as impressionism (his closest friends were the American impressionists Theodore Robinson and J. Alden Weir, and in 1897 he was a founding member of The Ten, a group of impressionist artists), Whistlerism, and Japanism (he collected Japanese prints), and all of which, especially in late nineteenth-century America, were signifiers of modernist affiliation that Twachtman's art bore undisguisedly. More deeply, however, his modernity operates in the abstractness and abstraction of his art—its distance from exact resemblance, on

45 · *September Sunshine*

4 Quoted in Allen Tucker, *John H. Twachtman* (New York, 1931), 8; Clarence Cook in *The Studio 43* (May 1886), 271.

5 Letter to J. Alden Weir, 2 January 1885, quoted in Kathleen A. Pyne, "John Twachtman and the Therapeutic Landscape," in Chotner, Peters, and Pyne 1989, 53. The artist was Jules Bastien-Lepage, whom Weir much admired.

6 Letter of 5 September 1880, quoted in Pyne 1989, 56.

7 Eliot Clark, *John Twachtman* (New York, 1924), 43, 68.

8 Clark 1924, 58.

9 *The Literary Works of Leonardo da Vinci*, ed. Jean Paul Richter, 3d ed. (New York, 1970), 311–312.

one hand, and its reductiveness of form, color, and space on the other. It is apparent above all, despite its beguiling beauty and delicacy of color, in the difficulty it presents to both its audience—Twachtman's friend, the painter Childe Hassam, spoke of its "evasiveness"—and to the artist himself—the elusiveness, so often inherent in modernist invention, that Twachtman described as spending "your life trying to do something that you can't," or, as a critic wrote of Twachtman's paintings, attempting to "express the inexpressible."[4]

Regardless of his many associations with impressionists and impressionism, Twachtman was not an orthodox impressionist, and perhaps not even an impressionist at all. Indeed, he was on the whole antipathetic to impressionist (scientific and realist) objectivity. He disliked the work of a contemporary, he said, because it consisted "too much in the representation of things,"[5] for, as he wrote Weir, expressing his idealist subjectivity, "Ten thousand pictures come and go every day [in his mind] and those are the only complete pictures painted, pictures that shall never be polluted by paint and canvas."[6] Twachtman's anti-naturalist, anti-materialist, anti-positivist sympathies, his preference for what his student Eliot Clark called "the elusive and fascinatingly evasive effects of nature" and his "love for nuance,"[7] were closely allied to symbolist allusiveness and indirection. Formally, his style resembles Paul Gauguin's syn-

thetism—flatness, decoration rather than depiction, painted surfaces rather than insistent pictorial illusions. In Twachtman's paintings—and they are paintings more than pictures—of the 1890s particularly, like *September Sunshine*, everything happens on the surface, and nothing is allowed to compromise its integrity. There is no irrevocable perspective distance, only vestigial references to it. Forms lie less in space than upon (or shallowly within) the painting's surface, and pigments—thinly worked and blended on it—are spread evenly, though not in unvarying thickness, over it.

The allusiveness of Twachtman's paintings and their abstract flatness, when joined to his rather singular practice of exposing his canvases to sun and rain to give them, as Clark described it, "a uniform mat or dry surface,"[8] almost like a weathered wall, call to mind a famous passage in Leonardo da Vinci's notebooks (published in English in 1883) about the suggestiveness of stained and textured walls: "[W]hen you look at a wall spotted with stains, or with a mixture of stones . . . you may discover a resemblance to various landscapes . . . an endless variety of objects. . . . And these appear on such walls confusedly, like the sound of bells in whose jangle you may find any name or word you chose to imagine."[9] N.C.

45 · *September Sunshine* (detail)

46

Waterfront Scene — Gloucester

c. 1901, oil on canvas,
16 x 22 (40.6 x 55.9)

1 For descriptions of Gloucester as
 an artists' colony see essays by
 Richard J. Boyle and William H.
 Gerdts in Twachtman in Glouces-
 ter: His Last Years, 1900–1902
 [exh. cat., Spanierman Gallery]
 (New York, 1987).

2 Obituary, New York Tribune,
 9 August 1902.

3 Lisa N. Peters, in exh. cat. New
 York, 1987, 52.

4 Eliot Clark, John Twachtman
 (New York, 1924), 28.

5 Caroline C. Mase, "John H.
 Twachtman," International Studio
 72 (January 1921), lxxvii.

By the time John Twachtman visited Gloucester, Massachusetts, in the summers of 1901 and 1902, it was already a thriving artists' colony and would remain so well into the twentieth century.[1] Twachtman's studio in Gloucester — or more properly East Gloucester — looked down upon the harbor, and there he created some of his most successful late landscapes.

Twachtman's Gloucester paintings are markedly different from the Connecticut landscapes that preceded them. Pigment is drier, brushing looser and more visible, and they are more directly and less obliquely observed and more forcefully and less indirectly expressed.

Some of that change of style, of course, is a response to the brightly dancing light of the seaside. But the intensity and edginess of the Gloucester paintings, what a contemporary critic called their "increased . . . personal force,"[2] and a more recent student of his work described as "emotional" and "fevered,"[3] suggest that his late style is at least as much Twachtman's response, perhaps unwilled, to something within himself and in his life than to effects of external nature. The last years of Twachtman's life, when he worked at Gloucester, were deeply troubled ones. His wife went with

their son to Paris, where he was a student, leaving Twachtman alone. His paintings sold poorly and he was financially distressed. He felt unappreciated and misunderstood. He drank. Altogether, as his student Eliot Clark wrote, there was "something gnawing at the soul of the man,"[4] and it found expression in the tensions and dissonant, slashing gestural energy of his late style, and even in such a thing, perhaps, as his reintroduction of black that he had banished from his palette in the sunnier times of the 1890s.

At the same time, he "talked often of Velasquez — of his mastery of planes, of his color,"[5] which suggests that his late art was not only a matter of upsurgent emotional expression but also of more meditated formal purposes. The Horowitz *Waterfront Scene — Gloucester* — one of the most beautiful and powerful of all the Gloucester paintings — is the evidence of that in its inventions of color, and in the intricately shifting play of the planes of the roofs, one that looks forward, it is tempting to say, to the cubism of Picasso and Braque that lay, after all, not too distantly in the future. N.C.

46 · *Waterfront Scene — Gloucester*

47 · *Springtime in France*

47
Springtime in France

1890, oil on canvas,
21 x 17½ (53.3 x 44.5)

1 *Art in America 16 (August 1928), 230.*

2 *Vonnoh was also able to work in more than one style at a time. In the Salon of 1890, for example, he exhibited both the prismatically colored landscape* November *(Pennsylvania Academy of the Fine Arts) and* Fais le Beau! *(private collection), a skillful, but more conventional scene of a woman in an interior, being entertained by a little dog.*

3 *The artists' colony at Grez-sur-Loing is discussed in detail in May Brawley Hill,* Grez Days: Robert Vonnoh in France *(New York, 1987).*

4 *"Vonnoh's practice by this date [1890] was to paint on an unsized canvas on which he laid a base of thinned white paint. The pigments, pure colors straight from the tube, were applied directly with brush or palette knife." Hill 1987, 17.*

5 *Hill 1987, 10.*

In 1928, the critic and biographer Eliot Clark wrote that

Robert Vonnoh must be historically one of the pioneer impressionists of America. When the low tones of the Barbizon school were in the ascendent, this innovator was experimenting in pure color. A scientific turn of mind and a receptive nature made Vonnoh doubly susceptible to the new discoveries of light and air. He was probably the first American painter to grasp the significance of the scientific color relations of the impressionists.[1]

Although his name is less well known today than many American impressionists, Vonnoh's early works do indeed suggest that he was a pioneer among his contemporaries.[2] Many of these pictures were landscapes, painted in the village of Grez-sur-Loing, on the edge of the forest of Fontaine-bleau. A two-hour train ride from Paris, Grez found favor as an artists' colony in the 1870s and 1880s and was popular not only with Americans, but also the English and Scandinavians.[3] Vonnoh appears to have first visited Grez while on his honeymoon, in 1886. He and his wife, Grace Farrell, settled into the village for the summer of 1887, and returned there, from a sojourn to Boston, the following summer. Between the fall of 1889 and spring of 1891 Vonnoh painted numerous scenes of Grez. Forty-two of these were exhibited in Boston, at the Williams and Everett Gallery, in November 1891.

One reason for the popularity of Grez was that its often overcast days provided the subdued, uniform light that many artists then preferred for their landscape paintings. By 1890, a year that he spent entirely in Grez, Vonnoh's own use of light had changed. *Springtime in France* is one of the artist's most brilliant efforts, capturing the freshness of sunlight on the newly budding, growing fields.[4] Although Vonnoh's application of pure colors to the canvas is indebted to the impressionists, this work is perhaps more reminiscent of the landscapes of certain postimpressionists. The warm-cold color contrasts of the salmon-brick red and chartreuse with deep green and purple, the flattening of space, and the layered brushwork have affinities with the landscapes of Gauguin and Cézanne. At Grez, Vonnoh felt the influence of the Irish-born artist Roderic O'Conor, whose bold and colorful paintings also made an impact on Edward Potthast. Another, more conservative, source of visual inspiration, one with which American artists were quite taken, was the work of Jules Bastien-Lepage. Among the Bastien-like qualities in *Springtime in France* are the high horizon line and "insistently horizontal organization and limited tonal range."[5]

One of the painting's more unusual horizontal elements is the vaguely oriental, blossoming branch that closes the top of the composition. Like the clever artist himself, it mediates between observable space and the strong two-dimensional design of the canvas. D.C.

48 · *Roses*

48
Roses

c. 1882–1890, oil on canvas,
9¾ x 14¾ (24.8 x 37.5)

1 Doreen Bolger Burke, J. Alden
Weir: An American Impressionist
(Newark, Del., 1983), 136.

2 Bruce Weber, American Beauty:
The Rose in American Art,
1800–1920 [exh. cat., Berry-Hill
Galleries] (New York, 1997), 21.

3 This change paralleled the grow-
ing preference for intimate tonal
landscapes, rather than grand,
detailed, dramatic vistas.

4 In eighteenth- and early nine-
teenth-century American portraits
roses served as emblems of youth,
beauty, grace, or a life cut short.
From about 1830 to 1860 Ameri-
can gift books on the language of
flowers often ascribed a different
meaning to each color or type
of rose. By the time Weir and his
contemporaries were painting the
flowers, this symbolism was no
longer employed.

Beginning about 1880, J. Alden Weir produced a variety of handsome, well-received still lifes. Some, in emulation of works he had seen at the Paris Salon, were large-scale exhibition pieces that depicted complex arrangements of flowers and decorative objects. The New York office of the decorating firm Cottier and Company purchased several such images from the artist.[1] But many more of Weir's still lifes had an affinity with the quieter, elegant flower paintings by the eminent French portraitist and still life painter Henri Fantin-Latour.

Floral still lifes were becoming increasingly popular in the United States during the 1870s and 1880s, replacing fruit and other subjects. Among American flowers, the clear favorite was the rose, depictions of which increased threefold between 1875 and 1885.[2] At mid-nineteenth century, American still life painters had usually described their subjects with botanical precision. In later decades this interpretation gave way to more emotive images.[3] The leading practitioner of the romantic approach to still life was John La Farge, whose less structurally intricate, but more expressive arrangements offered a kind of poetic interpretation of objects. While La Farge, Weir, and a number of other American artists successfully conveyed the distinct characteristics of the rose, with its delicate, creamy petals and sturdy, wiry stems, they surrounded these blooms in evocative, rather than clinical, lighting and atmosphere.

Roses is one of Weir's more intimate still lifes, of the smaller scale that he sometimes presented to his friends as gifts. The cool, gray-green background is of the same restful, neutral tonality employed by many of his colleagues, such as Abbott Thayer and Dennis Miller Bunker, not only for still lifes, but for the backdrops of portraits as well. In *Roses* Weir has rendered indistinguishable the shelf on which the flowers sit and the wall behind them. Although the roses seem to form a fairly neat pyramid, the composition is informal, with the blooms laid casually on the ledge rather than carefully arranged. The largest blossom is shown from the back, allowing the viewer to see the connection between the calyx and the fully open, curving petals. Other blossoms are shown in bud or beginning to open, so that the painting presents a kind of "life of the rose." The choice of flowers of the most delicate pale pink and yellow hues adds to the subtlety and harmony of the image.[4] The roses appear to be just snipped, neither wilting nor fading, and their fragile, evanescent beauty is sensitively conveyed. D.C.

49

U.S. Thread Company Mills, Willimantic, Connecticut

c. 1893–1897, oil on canvas,
20 x 24 (50.8 x 60.9)

National Gallery of Art,
Washington, Gift (Partial
and Promised) of Margaret
and Raymond Horowitz,
in Honor of the 50th An-
niversary of the National
Gallery of Art, 1990.74.1

1 *A year and a half after the death
of his first wife, Anna Dwight
Baker, Weir married her sister Ella.*

The family of Ella Baker, J. Alden Weir's wife, had a summer home in Windham, Connecticut, next to the industrial town of Willimantic.[1] During his visits to the Baker farm, the artist painted the nearby factory village about a half dozen times between 1893 and 1897.[2] Although American impressionists were generally inclined to choose as their subjects more conventionally picturesque views than those which interested their European counterparts, images of contemporary life had begun to interest some American artists. Weir's friend Theodore Robinson, for example, painted several views of canal locks in 1893, and in his 1894

Drawbridge—Long Branch R.R. depicted an un-prepossessing iron railway bridge. In his Willimantic pictures, Weir embraced the visual aspects of industrialization, finding the pale, gray stone mill structures aesthetically enriching additions to the landscape.

The site depicted in *U.S. Thread Company Mills* is actually the Willimantic Linen Company (founded in 1854), which was bought by the American Thread Company in 1898. This mill produced the finest spool cotton thread outside of England, a product for which it received recognition at the Philadelphia Centennial Exposition in 1876. By 1882, it was Connecticut's largest manufacturing company.[3] The Jillson Hill Bridge, shown at lower right, was one of two arched stone structures that crossed the Willimantic River at the mill sites.[4] The other, the Bridge Street Bridge, had been built one year earlier, in 1868.

Weir featured a bridge as his subject in at least one other painting about this time: his striking *The Red Bridge* (fig. 1) was also painted near Windham and shows the newly painted iron struc-ture (a modern bridge that had recently replaced a historic one) that crossed the Shetucket River. Elements of both of these compositions, with the

FIG. 1 · J. Alden Weir, *The Red Bridge*, oil on canvas, c. 1895. The Metropolitan Museum of Art, Gift of Mrs. John A. Rutherford, 1914

49 · *U.S. Thread Company Mills, Willimantic, Connecticut*

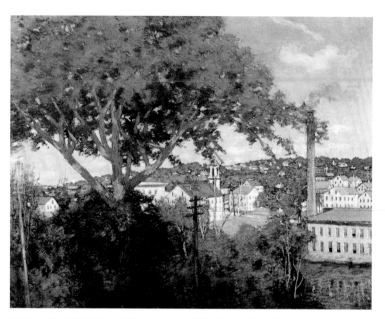

FIG. 2 · J. Alden Weir, *The Factory Village*, oil on canvas, 1897. Jointly owned by the Metropolitan Museum of Art and Cora Weir Burlington

bridges cropped at the picture's edges and trees placed against the front of the picture plane, recall Japanese prints, particularly those by Utagawa Hiroshige, whose works Weir collected.[5]

Closer still in design to *U.S. Thread Company Mills* is another of Weir's Willimantic images, *The Factory Village* (fig. 2). The two share a similar horizon that bisects the canvas, and a similar, somewhat elevated vantage point that looks down slightly over the distant hills. Both compositions are anchored by a tree at left (though of differing masses), and each has a pole jutting from the direct center of the lower edge of the canvas. Although *Factory Village* appears to be somewhat more polished and less open and experimental than the earlier work, both Willimantic paintings, and indeed all of Weir's views of this site, display the confident, lighter, more energetic brushwork and close observation of light that characterizes these, the most impressionist of the artist's efforts. D.C.

2 Weir's other known Willimantic subjects are Willimantic Thread Mills *(1893, Brooklyn Museum),* Willimantic Landscape *(c. 1893, private collection),* Willimantic *(c. 1893–1897, private collection),* The Factory Village *(1897, Metropolitan Museum of Art), and* Willimantic, Connecticut *(1903, Arizona State University).*

3 Thomas R. Beardsley, Willimantic Industry and Community: The Rise and Decline of a Connecticut Textile City *(Willimantic, Conn., 1993), 4.*

4 The identification of the bridge was provided by Beverly L. York, director, Windham Textile and History Museum, Willimantic, Connecticut (National Gallery curatorial files).

5 The influence of Japanese art on Weir, and on this painting in particular, is discussed in Doreen Bolger Burke, J. Alden Weir: American Impressionist *(Newark, Del., 1983), 209.*

Biographies of the Artists

BIBLIOGRAPHY

Thomas Anshutz: Paintings, Watercolors and Pastels [exh. cat., Graham Gallery] (New York, 1979).

Griffin, Randall C. Thomas Anshutz: Artist and Teacher [exh. cat., Heckscher Museum] (New York and Seattle, 1994).

Thomas Pollock Anshutz was born in Newport, Kentucky, in 1851. In his early teens, the family moved to Wheeling, West Virginia, along the Ohio River. There he developed his fondness for boats, water, and outdoor pursuits, themes that would inform his work as an artist. At the age of twenty, Anshutz moved to New York and joined the Brooklyn Art Club. In 1873 he enrolled at the National Academy of Design to learn the rudiments of traditional draftsmanship. Two years later he moved to Philadelphia and attended the life class of the Philadelphia Sketch Club, taught by Thomas Eakins, who was to become the dominant influence on Anshutz's early art and teaching.

In 1876, Anshutz enrolled at the Pennsylvania Academy of the Fine Arts, the same year Eakins was appointed the academy's chief demonstrator of anatomy. From 1878 to 1879, he served as assistant to Eakins, whose emphasis on the live model, together with anatomical instruction and dissection, inspired him. In 1880, Anshutz himself was promoted to chief demonstrator of anatomy. A year later, he completed what is probably his most famous work, *The Ironworker's Noontime,* a striking representation of modern industrial life.

The 1880s saw Anshutz's rise as an esteemed instructor at the Pennsylvania Academy, where he taught, among others, Robert Henri, William Glackens, George Luks, and John Sloan, all members of The Eight.

By the early 1890s, Anshutz had absorbed all that he was to learn from Eakins and was seeking inspiration in the newly advanced aesthetic principles of postimpressionism, art-for-art's sake, and symbolism. In 1892, feeling the need to study abroad, he resigned his post, married Effie Shriver Russell, and left for Paris in December. He enrolled at the Académie Julian, but left after three months and spent the spring of 1893 visiting museums, exhibitions, and galleries in Paris. He also began experimenting with watercolor, in a style of loose, spontaneous brushwork and bright color.

In the fall of 1893 Anshutz returned to Philadelphia and resumed teaching at the Pennsylvania Academy. He purchased a summer home in Holly Beach, New Jersey, where he painted a series of watercolors depicting coastal scenes. During this period he also perfected his portraiture, in a style highly indebted to Eakins, as well as his landscape painting, deriving inspiration from the Barbizon school, French impressionism, and the tonalist landscapes of Thomas Dewing and John Twachtman.

In the final years of his career Anshutz began to acquire national and international recognition. In addition to receiving a silver medal at the 1904 Saint Louis World's Fair and a gold medal in 1910 at the Buenos Aires International Exposition, he became the head instructor of the Pennsylvania Academy of the Fine Arts in 1909 and president of the Philadelphia Sketch Club a year later. By the end of 1910, however, Anshutz's failing health forced him to resign from teaching. He died in 1912, at the age of sixty-one.

BIBLIOGRAPHY

Beaux, Cecilia. Background with Figures: Autobiography of Cecilia Beaux. Boston and New York, 1930.

Drinker, Henry, et al. The Paintings and Drawings of Cecilia Beaux. Philadelphia, 1955.

Tappert, Tara L. Cecilia Beaux and the Art of Portraiture [exh. cat., National Portrait Gallery] (Washington, 1995).

Tappert, Tara L. "Choices— The Life and Career of Cecilia Beaux: A Professional Biography." Ph.D. diss., George Washington University, 1990.

Born in Philadelphia in 1855, Cecilia Beaux attributed much of her success to the support she received from her family; early on they had recognized her talent and arranged for her to train in the studio of a distant cousin, Catherine Ann Drinker, a successful artist, writer, and teacher. At eighteen, Beaux took over Drinker's drawing lessons at Mrs. Sanford's School in Philadelphia and embarked on a career in the decorative arts, painting porcelain, making portrait sketches from photographs, and experimenting with lithography.

Beaux also attended classes at the Pennsylvania Academy of the Fine Arts, and studied privately with William Sartain. Influenced by her teacher, as well as by the work of Thomas Eakins and James McNeill Whistler, she developed an early portrait style characterized by strong textural effects, a preference for deep, rich colors, and an appreciation of the strength and simplicity of the human form.

In 1883–1884 Beaux executed her first major portrait, *Les Derniers Jours d'Enfance,* a Whistler-influenced image of her sister and nephew that won the Mary Smith Prize in 1885 at the Pennsylvania Academy's annual exhibition. Two years later, the portrait's entry in the 1887 Salon exhibition in Paris inspired Beaux to continue her training in France.

In January of 1888 Beaux arrived in Paris and spent the next year and a half studying at the Académies Julian and Colorossi and copying old masters at the Louvre. While summering along the Brittany coast, she became fascinated with memory studies and plein-air painting and began experimenting with pastel.

Returning to Philadelphia in 1889, Beaux resumed her portrait career. In the 1890s she progressed toward a more colorful and painterly style, and her ability to capture what she called the "measure of the individual" found a ready clientele among upper-class Philadelphians. Around 1898, Beaux commenced the first of an important series of double portraits, in a style reminiscent of John Singer Sargent's full-length society portraits. They brought her tremendous critical acclaim: one of them, *Mother and Daughter,* received more honors than any other single work by Beaux, including first prize at the 1899 Carnegie Institute annual exhibition, and the gold medal at the Pan-American Exposition in 1901.

By the turn of the century, Beaux was a leader in her profession, and to keep up with demand she moved to New York. She continued to teach at the Pennsylvania Academy, however, where she was the first woman instructor of portraiture, a post she held from 1895 to 1916. In 1919 Beaux was selected by the National Art Committee as one of a number of artists to paint leading figures of World War I.

Following a hip injury in 1924, Beaux found it increasingly difficult to paint and devoted most of her attention to writing her autobiography, *Background with Figures,* published in 1930. In 1935, she was honored by the American Academy of Arts and Letters, which had elected her as a member two years earlier, with her first retrospective exhibition. In 1942 the National Institute of Arts and Letters awarded her a gold medal for her lifetime achievements. She died in 1942 at the age of eighty-seven.

BIBLIOGRAPHY

Burke, Doreen Bolger. "J. Carroll Beckwith 1852–1917." In American Paintings in the Metropolitan Museum of Art. New York, 1980, 3: 135–136.

Rood, Beverly. "James Carroll Beckwith." In Ronald G. Pisano, The Art Students League [exh. cat., Heckscher Museum] (Hamilton, N.Y., 1987), 23.

Wickenden, Robert J. "James Carroll Beckwith." In Dictionary of American Biography. New York, 1943, 1: 120–122.

Carroll Beckwith, as he preferred to be known, was born in Hannibal, Missouri, in 1852, but grew up in Chicago, the son of a prominent wholesale grocer. His interest in art came at an early age, and at sixteen he entered the Chicago Academy of Design, where he studied with Walter Shirlaw. Following the Chicago fire of 1871, which significantly altered his family's fortunes, Beckwith received his father's consent to pursue a career in art and moved to New York to study at the National Academy of Design.

In 1873, Beckwith left for Paris, where he remained for five years, taking drawing courses from Adolphe Yvon at the Ecole des Beaux-Arts, but studying primarily under the noted portraitist Emile-Auguste Carolus-Duran. He also visited museums and galleries to study Raphael, Tintoretto, Veronese, Tiepolo, and Velázquez. In 1877, together with his friend and fellow student John Singer Sargent, Beckwith assisted Carolus-Duran with the ceiling decorations for the Palais du Luxembourg. By this time, he had also achieved success at the Paris Salon and a year later exhibited his idealized portrait, *The Falconer,* at the Paris Exposition Universelle.

In 1878 Beckwith returned to New York, and his talents as a draftsman secured him a professorship at the Art Students League, where he taught from 1878 to 1882 and from 1886 to 1887. As an artist, he concentrated mostly on portraits, figure studies, and detailed renderings of historical monuments, but he never lost his interest in decorative design. In 1893 he executed murals for the Liberal Arts Building at the World's Columbian Exposition in Chicago. Refusing to follow artistic fashion, he remained faithful to his conviction that art should embody the technical refinement of form, color, and expression. The honors he received for his portraiture included awards at the 1887 Paris Salon, and at the Exposition Universelle in 1899 for what is probably his most celebrated work, *William Walton* (1886), which, according to Carolus-Duran was "the strongest portrait" he had ever seen issued from a New York studio. Beckwith went on to earn medals at the Atlanta and Saint Louis expositions, and a gold medal at Charleston in 1902.

Throughout his career, Beckwith was committed to furthering the progress of American artists. He was among the earliest promoters of the Art Guild of New York and served as president of the Free Art League, which sought to educate artists and the public by bringing in original works of art from abroad. As a member of the Artists Fund Society of New York, he worked for the benefit of needy artists and their families. In the spring of 1889, he joined the effort to raise money for the construction of a new building to house the Art Students League, the Society of American Artists, the Architectural League, and the Art Guild. After three years of tireless fundraising, the American Fine Arts Society opened its doors in the fall of 1892; the Art Students League is still housed there today. For the remainder of his career, Beckwith worked unceasingly in his New York studio and spent four years in Italy from 1910 to 1914. He died of a heart attack at the age of sixty-six.

BIBLIOGRAPHY

Ayers, Linda, and Jane Myers. George Bellows: The Artist and His Lithographs *[exh. cat., Amon Carter Museum] (Fort Worth, 1988).*

Braider, Donald. George Bellows and the Ashcan School of Painting. Garden City, N.Y., 1971.

Doezema, Marianne. George Bellows and Urban America. *New Haven, 1992.*

Mason, Lauris, and Joan Ludman. The Lithographs of George Bellows: A Catalogue Raisonné. Millwood, N.Y., 1977.

Morgan, Charles H. George Bellows, Painter of America. *New York, 1965.*

Quick, Michael, et al. The Paintings of George Bellows *[exh. cat., Amon Carter Museum] (Fort Worth, 1992).*

Born and raised in Columbus, Ohio, George Bellows attended public schools and entered Ohio State University in 1901, where he played baseball and made drawings for college publications. In 1904, Bellows moved to New York, where he studied under the influential teacher Robert Henri. They would remain lifelong friends.

Like Henri, Bellows took inspiration from New York urban life for his early work, exploring such subjects as scenes of the Lower East Side, the rivers surrounding Manhattan, and prizefights at Sharkey's saloon. Success was soon forthcoming. By 1908, his New York pictures were represented in several noteworthy public collections, including the Metropolitan Museum of Art and Pennsylvania Academy of the Fine Arts, and that same year he received the National Academy of Design's Second Hallgarten Prize for *North River.* In 1909 Bellows was elected an associate member of the National Academy; he was made a full member in 1913. In 1910 he married Emma Story, following his appointment as life-class instructor at the Art Students League.

Active in the cause of promoting progressive art, Bellows was a founding member of the Society of Independent Artists and a charter member of the Association of American Painters and Sculptors. He helped to organize the Armory Show in 1913, in which five of his paintings and a number of drawings were included. He contributed illustrations to the socialist publication *The Masses* between 1912 and 1917. Bellows began to make lithographs in 1916, and his exceptional talent engendered a revival of interest in that medium.

Throughout the decade he worked at a number of places in Maine, Carmel, California, and Middletown, near Newport, Rhode Island. In 1919 he taught at the Art Institute of Chicago. In 1920 he painted at Woodstock, New York, where he bought a house the following year. He never traveled abroad.

After 1910 Bellows gradually abandoned urban realism and a dark palette and turned increasingly to landscapes and portraiture in a style reflecting the color theories of Hardesty Maratta and Denman Ross, and Jay Hambidge's compositional system of dynamic symmetry. He died in 1925, at the age of forty-two.

BIBLIOGRAPHY

Bedford, Faith Andrews, et al.
Frank W. Benson: A Retrospective
[exh. cat., Berry-Hill Galleries]
(New York, 1989).

Bedford, Faith Andrews. Frank
W. Benson: American Impres-
sionist. New York, 1994.

Frank W. Benson; Edmund C.
Tarbell: Exhibition of Paintings,
Drawings and Prints [exh. cat.,
Museum of Fine Arts] (Boston,
1938).

Salaman, Malcolm C. Modern
Masters of Etching: Frank W.
Benson. London, 1925.

Wilmerding, John, Sheila Dugan,
and William Gerdts. Frank W.
Benson: The Impressionist Year
[exh. cat., Ira Spanierman
Gallery] (New York, 1988).

Frank Weston Benson was born in Salem, Massa-
chusetts, in 1862, the second of six children of a
prosperous Boston cotton merchant. His grandfa-
ther was Captain Samuel Benson, who sailed
around the world and brought back many exotic
treasures, objects that would appear later in his
grandson's paintings. In 1880, Benson enrolled
in the newly founded Boston Museum school,
where he studied for three years. Among his fellow
students was Edmund C. Tarbell, who became
Benson's lifelong friend as well as a fellow member
of The Ten. The two men also studied together
in Paris, at the Académie Julian, under Gustave
Boulanger and Jules-Joseph Lefebvre. Benson
spent the summer of 1884 at the artists' colony of
Concarneau, Brittany, and traveled with Tarbell
through Germany, Italy, and England.

Upon returning to the United States in 1886,
Benson worked briefly in Salem, where he would
eventually settle. During 1886 and 1887 he taught
drawing and painting at the Portland Society of
Art, and in 1889 he began to teach at the Boston
Museum school. He also received wide recogni-
tion for his own work, which received numerous
awards, including the National Academy of
Design's Hallgarten Prize in 1889 and an 1893
World's Columbian Exposition medal in Chicago.
In 1896 he decorated a series of ceiling and wall
panels in the Library of Congress. Benson became
an associate member of the National Academy in
1897 and a full academician in 1905, and was a
founding member of the Guild of Boston Artists
in 1914.

Benson had his first solo exhibition of etchings
and drypoints in 1915. The prints, primarily of
sporting subjects, combined Benson's love of the
outdoors with his free and open draftsmanship.
This turn to sporting subjects changed the direc-
tion of his work, and he created fewer of the
serene paintings of women and children for which
he had become so well known. In the last years
of his career his watercolor landscapes were much
in demand.

Retrospective exhibitions of his work were
held at the Corcoran Gallery of Art, Washington,
in 1921 and, jointly with Tarbell, at the Museum
of Fine Arts, Boston, in 1938. Benson, who had a
studio in Boston and, at various times, summer
houses in Maine and Cape Cod, eventually retired
to Salem, where he died in 1951.

BIBLIOGRAPHY

Birnbaum, Martin. Catalogue
of a Memorial Loan Exhibition of
the Works of Robert Frederick
Blum. New York, 1913.

Blum, Robert. "An Artist in
Japan (with illustrations by the
author)." Scribner's Magazine
13 (April–June 1893), 399–414,
624–636, 729–749.

Boyle, Richard J. A Retrospective
Exhibition: Robert F. Blum [exh.
cat., Cincinnati Art Museum]
(Cincinnati, 1966).

Weber, Bruce. "Robert Frederick
Blum (1857–1903) and His
Milieu." Ph.D. diss., 2 vols., City
University of New York, 1985.

Robert Frederick Blum was born in Cincinnati in 1857, the son of German immigrants. At seventeen he apprenticed with a local lithography firm and attended evening drawing classes at the Mechanics' Institute under Frank Duveneck. In 1875 he trained at the McMicken School of Design, and a year later enrolled at the Pennsylvania Academy of the Fine Arts in Philadelphia. Dissatisfied with his teacher, Blum sought inspiration elsewhere and found it in the Japanese art, architecture, and craft displays at the Centennial exhibitions in Fairmont Park.

In 1879, Blum moved to New York, where he worked as an illustrator at Charles Scribner's Sons and became involved with William Merritt Chase and others associated with the Society of American Artists. In 1880 he was sent to Europe on assignment, traveling to Paris, Rome, Geneva, Naples, and Venice. There he met James McNeill Whistler, who not only inspired him to take up etching and pastel, but also taught him the principles of Japanese design. After his return to New York, Blum became president of the Society of Painters in Pastel.

In 1881, Blum returned to Europe, accompanied by Chase and J. Carroll Beckwith. While in Venice he completed a series of illustrations that were later published in *The Century* to accompany an article on the city by Henry James. The next year Blum and Chase were in Madrid, studying Velázquez and Ribera at the Prado, and in 1884 they spent the summer in Zandvoort, Holland, producing landscapes in watercolor and pastel.

Back in New York in 1885, Blum turned his attention to painting. Two years later, he completed his first important canvas, *Venetian Lace Makers,* which won him a gold medal and an associate membership at the National Academy of Design, and a bronze medal at the 1889 Exposition Universelle in Paris.

In 1890 *Scribner's* commissioned Blum to illustrate Sir Edwin Arnold's *Japonica.* The commission entailed a two-year trip to Japan, where Blum created numerous ink sketches, drawings, pastels, watercolors, and oils of genre subjects. On his return to New York in 1893 he exhibited *The Ameya* at the National Academy of Design, and was immediately elected a full academician. That same year he began work on two large mural decorations, *Mood to Music* and *The Vintage Festival,* for New York's Mendelssohn Hall, which he completed in 1898. Blum was then commissioned to paint another set of murals for the New Amsterdam Theater in New York. He was still working on the project when he died in 1903 at the age of forty-six.

BIBLIOGRAPHY

Edwards, Jared I. "Dennis Miller Bunker (1861–1890) Rediscovered." Nineteenth Century 4, 1 (Spring 1978), 70–75.

Hirshler, Erica E. Dennis Miller Bunker: American Impressionist [exh. cat., Museum of Fine Arts] (Boston, 1995).

Born in New York City in 1861, Dennis Miller Bunker received his earliest training at the National Academy of Design and the Art Students League, between 1876 and 1882.

In the fall of 1882 Bunker traveled to Paris, where he spent his first few months at the Académie Julian before entering the studio of Jean-Léon Gérôme at the Ecole des Beaux-Arts. Under Gérôme, he became a masterful draftsman and absorbed the tenets of French academic painting.

In the summer of 1883, Bunker set out on a sketching tour of France to capture picturesque landscape views, which he later worked up into finished pictures in his studio on his return to Paris. With their soft atmospheric effects and subtle color contrasts, these early French landscapes reflect Bunker's admiration for Corot and his desire to emulate the contemporary landscapes of Salon artists such as P. A. J. Dagnan-Bouveret and Jean-Charles Cazin.

Bunker completed his training at the Ecole in the spring of 1884 and spent the summer in Larmor, along the southern coast of Brittany. There he painted at least six landscapes of the town and the surrounding countryside, in which he abandoned the moody soft atmosphere and subtle contrasts of his earlier work to create images of greater clarity with an emphasis on shapes and surfaces.

In 1885 Bunker returned to New York, but then moved to Boston to teach at the Cowles Art School, where he soon became chief instructor of figure and cast drawing, painting, artistic anatomy, and composition. He also began to actively exhibit, with his first solo show at Noyes and Blackslee Gallery in the fall of 1885. For the next three years, Bunker continued to teach and exhibit his work while carrying on an active social life with the prominent Bostonians that would become his most important patrons, including two of the city's richest art collectors, J. Montgomery Sears and Isabella Stewart Gardner.

By 1889, Bunker had grown tired of Boston and was eager to prove himself in New York. Before moving, he became engaged to Eleanor Hardy, whom he married in October of the following year. Once in New York, Bunker struggled to make ends meet, finding portrait commissions difficult to secure. In 1890, however, he received two teaching offers, a fall course at the Metropolitan Museum of Art and William Merritt Chase's winter class at the Brooklyn Art Association. He also received generous assistance from such friends as Chase, Charles Adams Platt, Thomas Dewing, Augustus Saint-Gaudens, and Stanford White, who commissioned him to paint ceiling decorations in the Whitelaw Reid house in New York. In addition he won the first gold medal at the 1890 Second Special Exhibition of the Art Club of Philadelphia for his figure study, *The Mirror.* In December of that year, Bunker died of a sudden illness at the age of twenty-nine.

BIBLIOGRAPHY

Atkinson, D. Scott, and Nicolai Cikovsky, Jr. William Merritt Chase: Summers at Shinnecock 1891–1902 [exh. cat., National Gallery of Art] (Washington, 1987).

Bryant, Jr., Keith L. William Merritt Chase: A Genteel Bohemian. Columbia, Mo., 1991.

Cikovsky, Jr., Nicolai. "William Merritt Chase's Tenth Street Studio." Archives of American Art Journal 16 (1976), 2–14.

Gallati, Barbara Dayer. William Merritt Chase. New York, 1995.

Pisano, Ronald G. A Leading Spirit in American Art: William Merritt Chase, 1849–1916. Seattle, 1983.

Pisano, Ronald G. William Merritt Chase. New York, 1979.

William Merritt Chase was born in Williamsburg (later Ninevah), Indiana, in 1849, the oldest of six children. When he was twelve, the family moved to Indianapolis. His father hoped that he would follow him into the women's shoe business, but Chase, who said "the desire to draw was born in me," resisted his father's commercial ambitions for his own artistic ones. In 1867 he began his training with Barton S. Hays, followed two years later with study at the National Academy of Design in New York under Lemuel P. Wilmarth.

In 1871 Chase moved to Saint Louis, where he painted still lifes professionally. He attracted the attention of local patrons, who, in the fall of 1872, offered to send him abroad. At the Royal Academy of Fine Arts in Munich, where he received his most decisive training, Chase was one of the many Americans, including Frank Duveneck and later John Twachtman, studying there. After an extended visit to Venice with Duveneck and Twachtman in 1878, Chase returned to New York, where he began teaching at the Art Students League. He devoted much of his time and energy to teaching, not only at the League, but also the Brooklyn Art Association, the Pennsylvania Academy of the Fine Arts, the Shinnecock Summer School of Art, and the New York School of Art— the last two of which he founded—and was the most celebrated teacher of his time. As a leader of the insurgent younger painters who challenged the authority of the National Academy of Design,

he was a founding member of the Society of American Artists and, in 1880, was elected its president. His large, sumptuously decorated studio in the Tenth Street Studio Building, which he took soon after his return to New York, was the most famous artist's studio in America and a virtual manifesto of his and his generation's artistic practices and beliefs, and of the dignity of the artist's calling.

In 1886 he married Alice Gerson, who was frequently his model, as were their many children. Chase painted a wide range of subjects, including figures, landscapes and cityscapes, studio interiors, still lifes, and, increasingly later in life, portraits, and he worked with equal brilliance in oil and pastel. Chase died in New York City in 1916.

BIBLIOGRAPHY

An American Art Student in Paris: The Letters of Kenyon Cox, 1877–1882. Ed. H. Wayne Morgan. Kent, Ohio, and London, c. 1986.

An Artist of the American Renaissance: The Letters of Kenyon Cox, 1883–1919. Ed. H. Wayne Morgan. Kent, Ohio, and London, c. 1995.

Coffin, William A. "Kenyon Cox." Century 4 (Jan. 1891), 333–337.

Morgan, H. Wayne. Kenyon Cox, 1856–1919: A Life in American Art. Kent, Ohio, and London, 1994.

Kenyon Cox was born in Warren, Ohio, the son of Jacob D. Cox, who later became governor of Ohio. Bedridden with illness from the age of nine to thirteen, Cox received his earliest education from his mother, devoting most of his time to reading and drawing. At fifteen, he was well enough to enter the McMicken School of Design in Cincinnati. In 1876 he traveled to the Centennial Exposition in Philadelphia, and stayed on in the city to study at the Pennsylvania Academy of the Fine Arts. A year later, at age twenty-one, he was in Paris, where he entered the studio of Emile-Auguste Carolus-Duran. Soon thereafter he enrolled at the Ecole des Beaux-Arts, studying drawing and painting with Alexandre Cabanel and Jean-Léon Gérôme; he also took additional courses at the Académie Julian. Between 1879 and 1882, he exhibited his work regularly at the Paris Salon.

In 1883, Cox settled in New York and became a member of the Society of American Artists. That same year he joined the faculty of the Art Students League, where he taught until 1909. During the 1880s he focused primarily on landscape painting, figure studies, and portraiture. In 1886 he received a commission to illustrate Dante Gabriel Rossetti's "The Blessed Damozel," and thereafter worked as a freelance illustrator for *Harper's Weekly* and *Scribner's.* In 1892, he married his pupil Louise Howland King, who specialized in children's portraiture.

In the 1890s Cox's love of traditional academic art and his interest in allegorical and classical themes led him to mural painting, and he completed a number of important mural commissions, among them decorations for the Manufactures and Liberal Arts Buildings at the 1893 World's Columbian Exposition in Chicago, a lunette beneath the dome of the Sculpture Hall of the Walker Art Building at Bowdoin College in Maine, two murals at the Library of Congress in Washington, and a frieze of figures for the Appellate Court Building in New York.

Although his art was well received, his reputation rested chiefly on his art criticism, which he began writing in the early 1880s during his student years in Paris. For twenty-five years he contributed exhibition reviews and essays to a number of newspapers and periodicals including *Nation, Scribner's, American Art News, Art World, The Century, Harper's Weekly, North American Review, Scrip,* and *Studio.* Dealing with a wide range of historical and contemporary art, many of his articles and lectures were subsequently published as books, advocating the classical academic tradition over the encroachment of modernism. In 1913 he wrote a scathing review of the Armory Show, in which he characterized cubist and futurist art as "the total destruction of the art of painting." His death in 1919 was termed "The Passing of Classicism."

BIBLIOGRAPHY

Gerdts, William H. William Glackens. New York, 1996.

Glackens, Ira. William Glackens and the Ashcan Group: The Emergence of Realism in American Art. New York, 1957.

Shinn, Everett. "William Glackens as an Illustrator." American Artist 9 (November 1945), 22–27, 37.

Wattenmaker, Richard J. "The Art of William Glackens." Ph.D. diss., New York University, 1972.

William James Glackens was born in Philadelphia in 1870. A talented draftsman, in 1891 he landed his first job as an artist-reporter for the *Philadelphia Record.* The following year he joined the staff of the *Philadelphia Press,* where he befriended John Sloan, George Luks, and Everett Shinn. The four soon began attending evening classes at the Pennsylvania Academy of the Fine Arts. There they were inspired by Robert Henri, who helped them make the transition from reportorial sketching to oil painting.

By 1894 Glackens was sharing Henri's studio, and the following year he accompanied his friend and mentor on a year-long trip to Europe. In France, Belgium, and Holland, he studied the old masters and contemporary French art, particularly the seventeenth-century Dutch painter Frans Hals and the modern artist Edouard Manet. Glackens returned to Philadelphia briefly in 1896, before settling in New York later that year. Through his friend Luks, he secured a position with the *New York World* and was soon reporting for several newspapers and magazines, including *McClure's,* which sent him to Cuba, in 1897, to cover the Spanish-American War.

Glackens continued to work as a freelance illustrator until 1915, working primarily for such periodicals as *Ainslee's, The Century, Collier's Weekly, Harper's Bazar, Harper's Weekly, McClure's, Munsey's,* the *Saturday Evening Post,* and *Scribner's.* Painting also became a preoccupation for him at this time, as he began to draw inspiration from the streets, parks, restaurants, and parlors of New York. Often depicting the more genteel side of city life and urban recreation, his earliest painted works reflect the vitality and immediacy advocated by Henri.

Following a second trip to Europe in 1906, Glackens, together with Henri, Sloan, Luks, Shinn, and three others, mounted the landmark 1908 independent exhibition of The Eight, a nonjuried show promoting the nonacademic and predominantly realist approach of Henri's circle. Shortly thereafter, Glackens adopted an impressionistic style more in keeping with contemporary French art than the teachings of Henri. By 1913, when he served as chairman of the selection committee for American entries to the Armory Show, he had shifted to a bright, colorful approach strongly reminiscent of Pierre-Auguste Renoir.

In 1912 Glackens returned to Europe to purchase contemporary French art for his high-school classmate, Dr. Albert C. Barnes. The works he acquired, which included those by Degas, Renoir, and Matisse, form the core of the Barnes Foundation's collection in Merion, Pennsylvania. During his final years, Glackens continued to enjoy success and traveled often to France. In 1938, he was preparing work for the Carnegie International when he died at the age of sixty-eight.

BIBLIOGRAPHY

Hirshler, Erica E. "Lilian Westcott Hale (1880–1963): A Woman Painter of the Boston School." Ph.D. diss., Boston University, 1992.

Lilian Westcott Hale was born in Hartford, Connecticut, in 1880 and at age seventeen entered the Hartford Art School. William Merritt Chase, who taught there from 1899 to 1900, invited her to attend his renowned summer art school in Shinnecock, Long Island, where she experimented in plein-air painting.

In 1900 Hale continued her training at the school of the Museum of Fine Arts in Boston, where she was placed in Edward Tarbell's advanced painting class. Soon she was working from the live model in charcoal and developing an interest in Japanese design. In 1902, she married Philip Hale, an established landscape and figure painter who also taught at the school. Two years later, the Hales toured Europe, visiting museums in London and Paris and copying old master paintings. She also developed a passion for impressionism, which she studied at the Paris galleries of Durand-Ruel, and in Giverny.

Around 1905, the Hales, along with other influential artists of the Boston school, established studios in the Fenway Studio Building. Focusing on portraits and interior scenes with figures, she soon began exhibiting her paintings and charcoal drawings in Boston and Philadelphia. A series of drawings of her favorite model, Rose Zeffler, executed from late 1906 through 1907, brought Hale considerable recognition and early success.

The drawings in her first solo exhibition, which opened at the Rowlands Galleries in Boston, in January of 1908, were praised for their "remarkable sense of form and movement" and "distinct elegance of style." Many of these same works were exhibited at the twenty-first annual exhibition of the Boston Water Color Club, and their enthu-siastic reception resulted not only in her election to full membership but in a number of portrait commissions, marking the beginning of Hale's long career as a portraitist.

With the birth of her daughter, in 1908, domestic responsibilities curbed her painting output, but she continued to draw. Over the next several years, her reputation grew steadily, as did her range of subject matter, which included landscape and still life in addition to her signature portraits and figure studies in interiors. In 1915 she was awarded a gold medal and a medal of honor at the Panama-Pacific International Exposition in San Francisco, and four years later received the Potter Palmer Gold Medal at the Art Institute of Chicago.

During the 1920s, Hale continued to enjoy widespread success. In 1927 she painted a full-length portrait of Taylor Scott Hardin, her future son-in-law, which won the first Altman Prize at the 1927 winter exhibition of the National Academy of Design, the association's most prestigious award. She was the first woman to ever win the prize and it led to her election to the academy.

The sudden death of her husband in 1931 was a devastating blow, both personally and professionally. Her career was seriously curtailed thereafter, but she never ceased working entirely, spending most of her time in her home studio in Dedham, Massachusetts. Hale died in 1963 at the age of eighty-two.

BIBLIOGRAPHY

Buckley, Charles E. Childe Hassam: A Retrospective Exhibition *[exh. cat., Corcoran Gallery of Art] (Washington, 1965).*

Curry, David Park. Childe Hassam: An Island Garden Revisited. *[exh. cat., Denver Art Museum] (Denver and New York, 1990).*

Hiesinger, Ulrich H. Childe Hassam: American Impressionist. *Munich and New York, 1994.*

Hoopes, Donelson F. Childe Hassam. *New York, 1979.*

Frederick Childe Hassam was born in 1859 in Dorchester, Massachusetts. In 1876 he was apprenticed to a local wood engraver and soon thereafter became a freelance illustrator. In the evenings he attended the life class at the Boston Art Club, then briefly studied anatomy with William Rimmer at the Lowell Institute, and took private lessons from the German-born painter Ignaz Gaugengigl.

In 1883 Hassam traveled to Great Britain, Holland, Spain, and Italy, where he produced a large number of watercolors that were exhibited at the Williams and Everett Gallery in Boston later that year. Once home, in 1884, Hassam married Kathleen Maude Doane and lived in Boston until the spring of 1886, when the couple left for Europe. In Paris, Hassam studied figure painting with Lucien Dorcet, Gustave Boulanger, and Jules-Joseph Lefebvre at the Académie Julian, and exhibited his work at the Salons of 1887 and 1888. In 1889 the Hassams returned to the United States and settled in New York. Hassam subsequently assisted in founding the New York Watercolor Club and joined the Pastel Society of New York. He also began to exhibit with the Society of American Artists. In 1897 he was a founder of The Ten.

During the 1890s and the following two decades, Hassam spent his summers painting throughout New England. His favorite sites were Old Lyme, Connecticut, and Appledore, on the Isles of Shoals, off the coast of New Hampshire, where he produced some of his best known works.

A prolific and industrious artist, Hassam painted numerous scenes of both the city and the countryside. Many of his early street scenes of Boston, Paris, and New York, with their reflections of wet pavement or of gaslight on the snow, evidenced a talent for capturing the effects of light and atmosphere.

Throughout his career Hassam garnered numerous awards and prizes and earned the attention of the collectors George A. Hearn, John Gellatly, and Charles Freer. His work was widely exhibited throughout the country, and in the 1913 Armory Show Hassam was represented by six paintings, five pastels, and a drawing. About 1915 he turned to printmaking, producing etchings and drypoints first, and lithographs about two years later. By 1933 a catalogue raisonné of his intaglio prints listed 376 different plates. Toward the end of his life Hassam most often exhibited graphic works. The quality of his paintings, in the meantime, became increasingly uneven.

Shortly before his death, in East Hampton in August 1935, he arranged to bequeath all the paintings remaining in his studio to the American Academy of Arts and Letters. According to his wish they were sold to establish a fund for the purchase of American works to be donated to museums.

BIBLIOGRAPHY

Homer, William Innes. Robert Henri and His Circle. Ithaca, 1969.

Kwiat, Joseph J. "Robert Henri's Good Theory and Earnest Practice: The Humanistic Values of an American Painter." Prospects 4 (1979), 389–401.

Perlman, Bennard B. Robert Henri: His Life and Art. New York, 1991.

Robert Henri was born Robert Henry Cozad in Cincinnati, in 1865, the son of a professional gambler and businessman. In 1881 he accompanied his family to Denver. When his father was indicted for manslaughter a year later the Cozads changed their name and fled to Atlantic City, New Jersey. In 1886 Henri enrolled at the Pennsylvania Academy of the Fine Arts, where he studied under Thomas Anshutz, Thomas Hovenden, and James B. Kelly. In 1888 he went to Paris and enrolled at the Académie Julian under Adolphe-William Bouguereau and Tony Robert-Fleury. During the summers he painted in Brittany and Barbizon, and visited Italy prior to being admitted to the Ecole des Beaux-Arts in 1891. He returned to Philadelphia late that year, and in 1892 resumed studying at the academy. He also began his long and influential career as an art teacher at the School of Design for Women, where he taught until 1895. During this period he met the young newspaper illustrators who would later achieve fame as members of The Eight: John Sloan, William Glackens, George Luks, and Everett Shinn. He made regular trips to Paris where he was particularly influenced by Edouard Manet, Frans Hals, and Diego Velázquez. In 1899, one year after his marriage to Linda Craige, one of his paintings was purchased for the Musée National du Luxembourg.

In 1900 Henri settled in New York and taught at the New York School of Art from 1902 to 1908. He gradually began to reject the genteel traditions of academic painting and impressionism, and turned his attention to urban realist subjects executed in a bold, painterly style. In 1906 he was elected to the National Academy of Design, and that summer he taught in Spain. When the academy refused to exhibit works by Henri's circle in its 1907 annual show, he resolved to organize an independent exhibition. The result was the famous show of The Eight held at the Macbeth Gallery in February 1908. That year he married his second wife, the illustrator Marjorie Organ. In 1910 he organized the first "Exhibition of Independent Artists," between 1911 and 1919 he arranged jury-free exhibitions at the MacDowell Club, and in 1913 he helped the Association of American Painters and Sculptors organize the Armory Show. Henri's influence began to wane after the ascent of European modernism, although he continued to win numerous awards. He taught at the Art Students League from 1915 until 1927.

Although Henri was an important portraitist and figure painter, he is best remembered as a progressive and influential teacher. His ideas on art were collected by former pupil Margery Ryerson and published as *The Art Spirit* (Philadelphia, 1923). He died in 1929 at the age of sixty-four.

BIBLIOGRAPHY

Adams, Henry, et al. John La Farge *[exh. cat., National Museum of American Art; Carnegie Museum of Art] (New York, 1987).*

Cortissoz, Royal. John La Farge: A Memoir and a Study. *Boston, 1911.*

Weinberg, H. Barbara. The Decorative Work of John La Farge. *New York, 1977.*

Yarnall, James L. John La Farge: Watercolors and Drawings *[exh. cat., Hudson River Museum] (Yonkers, N.Y., 1990).*

Yarnall, James L. Nature Vivante: The Still Lifes of John La Farge. *New York, 1995.*

John La Farge was born in 1835, the eldest child in a family of urbane, affluent French immigrants who had settled in New York City. He received drawing lessons from his grandfather and training in watercolor technique from an unknown English artist. Initially, he saw his artistic practice only as an avocation, experimenting with oil painting while studying law in New York. By 1856, however, La Farge had left for Paris, where his family connections helped to secure his introduction to that city's elite literary and artistic circles. Indeed, his later career would be marked by its preoccupation with sometimes esoteric intellectual and aesthetic matters.

While abroad, La Farge traveled in northern Europe, copied the old masters, and spent a few weeks in the studio of Thomas Couture. The illness of his father, however, necessitated his return to the United States. After briefly studying law again, in 1857, he rented space in New York's Tenth Street Studio Building, where he met the building's architect Richard Morris Hunt. This was the likely impetus for La Farge's decision in 1859 to travel to Newport, Rhode Island, and study painting with the architect's brother, William Morris Hunt.

In 1860 La Farge married Margaret Perry, and for most of the rest of his career his family life was centered in Rhode Island. In this seminal period of the late 1860s he cultivated an interest in Japanese art and explored a highly personal style of still life and plein-air landscape painting. His wide interests eventually led him to innovations in other media as well. By 1875, for example, he was working in stained glass, and a year later he directed the decorative program for Trinity Church, Boston, designed by the architect H. H. Richardson.

La Farge became a leader in the mural movement, and his commissions for churches, government buildings, and private homes were his chief source of income in later years. This work usually kept him in Boston or New York, separated from his family. As an easel painter, he was a member of both the Society of American Artists and the National Academy of Design.

An inveterate traveler, La Farge made several trips to Europe and two highly publicized Pacific voyages: to Japan in 1886, and to the South Sea Islands in 1890–1891, with Henry Adams. He documented his trips with extensive series of watercolors and with a succession of articles and books. Nearly always in need of money to pay the many employees required for his glass and mural projects, he found that his writing and lecturing helped cover these mounting costs. He continued to take on large commissions, however, even as his fragile health and financial insolvency became critical. He died in Providence, Rhode Island, in 1910.

BIBLIOGRAPHY

Berry-Hill, Henry and Sidney. Ernest Lawson—American Impressionist, 1873–1939. Leigh-on-Sea, England, 1968.

Born in Halifax, Nova Scotia, in 1873, Ernest Lawson spent his early years in Kingston, Ontario, and Kansas City, Missouri. He began his artistic training at the Kansas City Art Institute, studying painting for a year with Ella Holman, whom he would eventually marry. In 1889, his family moved to Mexico City, where Lawson worked as a draftsman and attended evening classes at the San Carlos Art School. The following year Lawson moved to New York and began studying with John Twachtman and J. Alden Weir, first at the Art Students League and then at their school in Cos Cob, Connecticut. Their impressionistic approach to landscape remained an influence on Lawson throughout his career.

In 1893 Lawson traveled to France to study the art of the impressionists. In Paris he enrolled at the Académie Julian and shared a studio with the author Somerset Maugham. Later that year he moved to Moret-sur-Loing, near Fontainebleau, deriving inspiration from the impressionist painter Alfred Sisley, who was working there at the time. In 1894 Lawson exhibited two of his impressionist paintings at the Paris Salon, before returning briefly to the United States to marry Holman.

After three years in France, Lawson and his family moved to Washington Heights, on the northern tip of Manhattan between the Harlem and Hudson Rivers. The location inspired Lawson to paint the extensive series of river scenes for which he is best known. In 1904, Lawson exhibited his work at the Universal Exposition in Saint Louis, winning a silver medal, but a year later was refused admission to the National Academy of Design. Soon thereafter, Lawson joined the group of artists later known as The Eight, who protested the academy's conservatism with their landmark exhibition at the Macbeth Gallery in 1908. Later that year, in response to the show's critical acclaim, the National Academy presented the group's work in its spring exhibition, awarding Lawson the First Hallgarten Prize and electing him as an associate member. In 1910, he participated with other members of The Eight in the Exhibition of Independent Artists, the first nonrestricted and nonjuried show in America. Three years later he served on the foreign exhibitions committee for the New York Armory Show. In 1917 he was promoted to full membership at the National Academy and won the Inness Gold Medal.

During the 1920s, Lawson taught in Kansas City and Colorado Springs, while his work continued to win honors, including the Temple Gold Medal at the Pennsylvania Academy of the Fine Arts and the National Academy's First Altman Prize in 1920, first prize at the Pittsburgh International Exposition and the Carnegie Gold Medal in 1921, and another Altman Prize from the National Academy in 1928.

By the 1930s, however, Lawson was living alone in New York and struggling to keep his career afloat. Several setbacks, including a lack of funds, a decrease in sales, and deteriorating health, curtailed his output considerably. Eventually he moved to Florida, where he died in 1939 at the age of sixty-six.

BIBLIOGRAPHY

Goodman, Jonathan. "Re-seeing Alfred H. Maurer." Arts Magazine 64 (Nov. 1989), 64–67.

Alfred H. Maurer, 1868–1932 [exh. cat., National Collection of Fine Arts] (Washington, 1973).

McCausland, Elizabeth. A. H. Maurer [exh. cat., Walker Art Center] (Minneapolis, 1949).

Pollack, Peter. Alfred Maurer and the Fauves: The Lost Years Rediscovered [exh. cat., Bernard Danenberg Galleries] (New York, 1973).

Alfred Henry Maurer was born in New York City in 1868, the son of a German-born lithographer. Taken out of school at sixteen, Maurer spent the next thirteen years working for a lithographic firm. Aside from his practical printing experience and sporadic study at the National Academy of Design, he was essentially self-taught.

In 1897 Maurer went to Paris. He studied briefly at the Académie Julian, but preferred instead to sketch at the Louvre and work in his studio painting young women he met in cafes. By the turn of the century, Maurer was producing figure studies that bore the influence of James McNeill Whistler. This series brought him critical as well as financial success. In 1901, his Whistler-inspired figure composition, *An Arrangement,* won first prize and a gold medal at the Carnegie International, and over the next four years Maurer won other prestigious awards, including a silver medal at the Saint Louis Exposition of 1904 and a gold medal at the International Art Exhibition in Munich in 1905.

After 1904, Maurer was increasingly influenced by postimpressionism and fauvism, developing a richly eclectic style that exhibited the palette of Matisse and the perspectival distortion of Cézanne. Critics berated Maurer for abandoning his earlier style and for his uncompromising modernism, and rejection and ridicule continued to plague Maurer in 1909 when he had his first New York one-man exhibition, together with John Marin, at Alfred Stieglitz's Photo-Secessionist Gallery. In 1913 he exhibited four paintings at the New York Armory Show, which were noticeably more avant-garde than other American entries.

With the outbreak of World War I, Maurer returned to New York and settled at his parents' home, where he stayed for eighteen years.

During the last years of his life, Maurer's increasingly troubled state of mind led to the creation of an even more eclectic body of avant-garde paintings. Comprised mostly of still lifes and nudes, as well as a series of psychologically haunting portrait heads, Maurer's late work was suffused with a cubist-influenced technique and an expressionist anxiety. In 1928 he received his first important acclaim as a modernist following the annual exhibition of his work by the veteran New York bookseller and art dealer E. Wehye, who had discovered Maurer's talent four years earlier. Maurer's financial struggles and mental anguish finally proved too daunting and painful, and the artist committed suicide in 1932 at the age of sixty-four.

BIBLIOGRAPHY

Brown, E. Edward Henry Potthast. *Saint Petersburg, 1991.*

Holman, T. Edward Henry Potthast: An American Impressionist. *Atlanta, 1992.*

Edward Henry Potthast: American Impressionist *[exh. cat., Gerald Peters Gallery] (New York, 1998).*

Smith-Hurde, Diane. Edward Henry Potthast (1857–1927): An American Painter *[exh. cat., Chidlaw Gallery, Art Academy of Cincinnati] (Cincinnati, 1994).*

Edward Henry Potthast was born and raised in Cincinnati, the son of German immigrants. At thirteen he began his training at the McMicken School of Design. Practical and hardworking, Potthast devoted the early years of his career to illustration, while continuing to attend night courses at the McMicken School from 1874 to 1882.

In the fall of 1882, Potthast traveled to Antwerp and Munich, where he became captivated by seventeenth-century Dutch genre painting and the bravura style of paint handling favored by the Munich school. Returning to Cincinnati in 1885, Potthast resumed his work as a commercial lithographer and enrolled in evening classes at the Cincinnati Association Art School. In 1887 he left for three years in France, settling in the art colony of Grez-sur-Loing to devote himself to landscape painting. It was there, with the American painter Robert Vonnoh, that Potthast became influenced by French impressionism, drawn especially to the primary role of color in defining light and form, and to spontaneous and loosely applied brushwork. Before his departure in 1890, Potthast exhibited his work at the Paris Salon and in Munich, where he was awarded a bronze medal.

Once back in Cincinnati, Potthast returned to commercial lithography while continuing to participate in the annual exhibitions held at the Cincinnati Art Museum. In the spring of 1894, the museum purchased his *Dutch Interior* for its permanent collection. Prompted by this success, he moved to New York in 1896. There he worked as a freelance lithographer for several popular magazines, including *Scribner's* and *The Century.* It was not until after the turn of the century that he felt financially secure enough to pursue his painting full time.

From 1889 onward, Potthast took seasonal excursions to the crowded, sun-filled beaches and resorts along the East Coast painting the idyllic seaside scenes of women and children for which he is best known.

Potthast won a number of prizes, including the Clarke Prize of the National Academy of Design in 1899, the Evans and Hudnut Prizes of the American Watercolor Society in 1901 and 1914, and silver medals at the Saint Louis Exposition in 1904 and the Panama-Pacific Exposition in San Francisco in 1915. Through the 1920s, Potthast continued to participate in juried exhibitions and was awarded several more honors. Painting until the end of his life, Potthast reportedly died at his easel in March of 1927.

BIBLIOGRAPHY

Clark, Carol, Nancy Mowll Matthews, and Gwendolyn Owens. Maurice Brazil Prendergast and Charles Prendergast: A Catalogue Raisonné. Williamstown, Mass., 1990.

Glavin, Ellen Marie. "Maurice Prendergast: The Development of an American Post-Impressionist, 1900–1915." Ph.D. diss., Boston University, 1988.

Matthews, Nancy Mowll. Maurice Prendergast [exh. cat., Williams College Museum of Art] (Munich, 1990).

Wattenmaker, Richard J. Maurice Prendergast. New York, 1994.

Maurice Brazil Prendergast was born in Saint John, Newfoundland, to a shopkeeper who moved the family to Boston in 1868. He left school after only eight or nine years and went to work for a commercial art firm. He never married and throughout his life was accompanied and supported by his brother Charles, a gifted craftsman and artist in his own right.

According to Charles, Maurice always wanted to be an artist and spent every available moment sketching. In 1892, Maurice traveled to Paris, where he spent three years. Studying first under Gustave Courtois at the Atelier Colorossi, he eventually moved on to the Académie Julian. There he met the Canadian painter James Wilson Morris, under whose influence he began executing *pochades,* small sketches on wood panels depicting elegantly dressed women and playful children at the seaside resorts of Dieppe and Saint-Malo. Back in Paris, he developed a sophisticated modern style inspired in large part by the postimpressionists, particularly Pierre Bonnard and Edouard Vuillard.

In 1895, home from abroad, Prendergast joined his brother in Winchester, Massachusetts. Working in watercolor, oil, and monotype, he continued to focus on men, women, and children at leisure, strolling in parks, on the beach, or traveling the city streets. In 1898 he went to Venice and returned a year later with a series of watercolors of the city. In 1900 the Macbeth Galleries in New York mounted an exhibition of his work.

In 1907 he returned to France, where he was profoundly influenced by Cézanne and the fauves. Integrating these new influences into his work, Prendergast painted more forceful works of art, with startling bright colors and staccato brushstrokes. As one of The Eight, Prendergast was sharply criticized for his more abstract and brightly colored style.

Following another trip to Venice, in 1911–1912, Prendergast returned to New York to select works for and participate in the Armory Show of 1913. A year later, he and Charles moved to New York. In 1915, he was given an exhibition at the Carroll Galleries. Although the critical reception of his work remained mixed, he was able to attract a number of important patrons, among them John Quinn, Lillie B. Bliss, and Dr. Albert Barnes.

During the final years of his career, Prendergast spent his summers sketching in New England and his winters painting in New York. In 1921, the Brummer Gallery in New York held a small retrospective exhibition of his work. By 1923, Prendergast was in frail health, and he died a year later at age sixty-five.

BIBLIOGRAPHY

Baur, John I. H. Theodore Robinson [exh. cat., Brooklyn Museum] (New York, 1946).

Clark, Elliot C. Theodore Robinson: His Life and Art. Chicago, 1979.

Johnston, Sona. Theodore Robinson, 1852–1896. Baltimore, 1973.

Theodore Robinson, American Impressionist (1852–1896) [exh. cat., Kennedy Galleries] (New York, 1966).

Theodore Robinson was born in Irasburg, Vermont, and grew up in Evansville, Wisconsin. Drawn to art at an early age, he entered the Art Institute of Chicago in 1869, but the following year he moved to Denver, seeking relief from his chronic asthma.

In 1874, his health much improved, Robinson moved to New York and enrolled at the National Academy of Design. In 1876 he left for two years in France, where he studied with Emile-Auguste Carolus-Duran and Jean-Léon Gerôme in Paris, and spent the summer of 1877 at Grez-sur-Loing. After trips to Venice and Bologna, he returned to the United States in 1879.

By 1881, Robinson was firmly established in New York, having secured both a studio and teaching position. That same year he joined the Society of American Artists and was soon working with John La Farge on mural decorations. In 1884 he returned to France, and after 1888 spent most of his time in Giverny working with Claude Monet.

On his return to New York in 1892, Robinson obtained a teaching position with the Brooklyn Art School and conducted summer classes in Napanoch, New York, and at Evelyn College in Princeton. He later taught at the Pennsylvania Academy of the Fine Arts in Philadelphia. He spent his last years applying his Monet-inspired impressionism to the American scenery of Vermont and Connecticut. These late American works, favorably received by critics at his first one-man exhibition, at the Macbeth Gallery in 1895, unleashed in Robinson a new and deeply felt emotional bond with his native land. A year later, Robinson died at the age of forty-six, succumbing to the asthma that had plagued him all his life.

BIBLIOGRAPHY

Charteris, Evan. John Sargent. New York, 1927.

Downes, William Howe. John S. Sargent: His Life and Work. Boston, 1925.

Fairbrother, Trevor J. John Singer Sargent. New York, 1994.

Hills, Patricia, et al. John Singer Sargent [exh. cat., Whitney Museum of American Art] (New York, 1986).

Kilmurray, Elaine, and Richard Ormond, eds. John Singer Sargent [exh. cat., Tate Gallery; National Gallery of Art; Museum of Fine Arts, Boston] (London, 1998).

Mount, Charles Merrill. John Singer Sargent: A Biography. Rev. ed. New York, 1969.

Ratcliff, Carter. John Singer Sargent. New York, 1982.

Born in Florence in 1856 to expatriate American parents, John Singer Sargent received his first formal art instruction in Rome in 1868, and sporadically attended the Accademia delle Belle Arti in Florence between 1870 and 1873. In 1874 he was accepted at the Paris studio of the portraitist Emile-Auguste Carolus-Duran, and the next fall entered the Ecole des Beaux-Arts to study drawing. He began to exhibit at the Salon in 1877. Over the next few years several experiences had a significant impact on Sargent's artistic development: during a trip to Spain in 1879 he copied paintings by Velázquez at the Prado; in 1880 he visited Belgium and Holland, where he copied works by Frans Hals; and in 1881 he met James McNeill Whistler in Venice.

During the 1870s and 1880s, Sargent painted genre scenes, based in part on his travels to Spain and Venice, but it was his remarkable skills as a portraitist upon which his reputation rested. The scandal caused by Sargent's daring portrait of Madame Gautreau at the Salon of 1884 precipitated his departure to London the following year. In England, Sargent's style of working was seen as peculiarly French. In 1885 he joined Francis David Millet in the Worcestershire village of Broadway, where he began his masterpiece of English impressionism, *Carnation, Lily, Lily, Rose.* By 1886, he had made London his permanent home. A year later, Sargent visited and worked with Monet at Giverny, and made his first professional trip to America, where the demand for his portraiture brought him considerable fame.

In 1897 he was elected an academician at the National Academy of Design, New York, and the Royal Academy of Art, London, and he was made a member of the Legion of Honor in France.

By the turn of the century Sargent was recognized as the most acclaimed international society portraitist of the Edwardian era, and his clientele included the most affluent, aristocratic, and fashionable people of his time. Sargent chafed in later life at the limitations of portraiture, and around the turn of the century he worked increasingly at other subjects and in other mediums, particularly watercolor, in which he was extraordinarily gifted.

Although an expatriate who lived in London, Sargent was committed to America's cultural development and executed important mural decorations for the Boston Public Library (1890–1919), the Museum of Fine Arts, Boston (1916–1925), and Harvard University's Widener Library (1921–1922). He died in London in 1925.

BIBLIOGRAPHY

Clamp, Brian Paul. "Everett Shinn: Lights of the City and Stage." In Everett Shinn: Important Paintings and Pastels [exh. cat., Owen Gallery] (New York, 1996).

DeShazo, Edith. Everett Shinn 1876–1953: A Figure in His Time. New York, 1974.

Rand, Barbara C. "The Art of Everett Shinn." Ph.D. diss., 2 vols., University of California, Santa Barbara, 1992.

Born in Woodstone, New Jersey, in 1876, Everett Shinn developed an early aptitude for drawing and entered Spring Garden Institute in Pennsylvania at age fifteen. In the fall of 1893 he enrolled at the Pennsylvania Academy of the Fine Arts and took a job as an artist-reporter for the *Philadelphia Press,* a newspaper dedicated to public welfare and human interest stories. He later described this experience as a "school that trained memory and quick perception."

In Philadelphia Shinn befriended fellow *Press* reporter George Luks, and together they attended evening art discussions held by Robert Henri, then an instructor at the Philadelphia School of Design for Women, who shared their fascination with the dramatic spectacle of modern urban life. Through their newspaper work and Henri's meetings, Shinn and Luks became acquainted with two other Philadelphia reporters, William Glackens and John Sloan. The four men became friends and took inspiration from Henri in making the transition from reportorial sketching to painting. Later on, as The Eight, they banded together with Henri, Ernest Lawson, Arthur B. Davies, and Maurice Prendergast to exhibit their work independently of New York's National Academy of Design.

In 1897 Shinn moved to New York, where he joined Luks and Glackens in the art department of *The World.* He soon abandoned newspaper work for the more lucrative field of magazine illustration, and by 1900 had landed the prestigious center-page spread of *Harper's Magazine,* providing its first full-color illustrations. Painting was also a preoccupation for him at this time and his choice of subjects ranged from scenes of urban violence and poverty to vaudeville theater and city crowds. In 1889, Shinn began exhibiting his work in New York and Philadelphia, and a year later he was sent to Europe by his New York dealer, Boussod, Valadon, and Company, to record scenes of London and Paris.

While abroad, Shinn concentrated on oil painting and pastel, drawing much inspiration from the French painter Edgar Degas. On returning to New York in the winter of 1900–1901, he mounted an exhibition of his Paris pictures that brought him much critical acclaim and financial success. With his painting career established, Shinn became increasingly fascinated with theater, taking part in every creative aspect of its production, including writing, directing, producing, casting, and set design; by 1908, Shinn's subjects were almost exclusively devoted to the stage.

Beginning in 1907, Shinn pursued work as an interior decorator, painting murals, decorative panels, and furniture for private homes and public buildings, such as New York's Stuyvesant Theater and City Hall in Trenton. He spent a good portion of his late career as a theatrical set designer and later on as an art director for the newly emerging motion picture industry. Shinn was seventy-seven when he died in 1953.

BIBLIOGRAPHY

Brinton, Christian. "Apropos of Albert Sterner." International Studio 52, 207 (May 1914), LXXI–LXXVIII.

Broadd, Harry A. "Albert Sterner: Printmaker with Ideas." Print Review (1981), 27–40.

Flint, Ralph. Albert Sterner: His Life and His Art. New York, 1927.

Born in London in 1863, Alfred Sterner began studying art at King Edward's School in Birmingham. At seventeen, he moved to Chicago to join his family, who had settled there in 1878. Shortly after his arrival, on the strength of his drawing skills, he secured a position with a lithography firm. Soon thereafter he was painting scenery for the Grand Opera House and making the commercial illustrations for which he would become famous. He would later help to organize the Art Institute of Chicago.

By 1885, Sterner had moved to New York, where he quickly established himself as a popular illustrator. In 1889, he left for six months in Paris, where he studied at the Académie Julian with Gustave Boulanger and Jules-Joseph Lefebvre, and attended Jean-Léon Gérôme's classes at the Ecole des Beaux-Arts. He also continued to supply his New York publishers with sketches and pen and ink drawings. Sterner returned to New York in 1890, but within a year was back in Paris. In 1891, he received an honorable mention at the Paris Salon for his first submission, *Le Célibataire.*

After his return to New York around 1892, Sterner won a competition to illustrate *Prue and I* by George William Curtis, editor of *Harper's*. The project, which comprised one hundred pen, ink, and wash drawings, was an unqualified success, earning Sterner much critical acclaim. In 1894, Sterner held his first public exhibition at the Frederick Keppel Gallery in New York. The following year, he again set out for Europe, where he spent two and a half years. He studied lithography in Paris, and in Munich a number of his lithographs were purchased by the director of the Kupferstich Kabinet. Upon returning to New York, he pioneered the revival of lithography in the United States and helped to train other artists in the genre, most notably George Bellows and Rockwell Kent.

At the turn of the century Sterner began to devote more time to his painting, exhibiting at the New York Water Color Society, as well as the National Academy of Design and the American Fine Arts Society. His skills as a portraitist, moreover, earned him commissions from a number of prominent families. At the same time, he taught courses at the Art Students League and played a leading role in establishing in 1915 the Painter-Gravers of America, a group of graphic artists dedicated to improving the overall quality of American prints.

Over the years Sterner received a number of awards, including a bronze medal at the Paris Exposition in 1900, a silver medal at the Buffalo Exposition in 1901, and in 1905, his first gold medal at the International Exhibition at the Glass Palace in Munich. As an associate member of the National Academy of Design, he would later earn the academy's Clara Obrig Prize in 1935 and the Carnegie Prize in 1941. At the time of his death in 1946, Sterner had distinguished himself as a lecturer on art, a writer of articles and plays, and a prodigiously creative painter, etcher, and lithographer.

BIBLIOGRAPHY

Boyle, Richard J. John Twachtman. New York, 1979.

Chotner, Deborah, Lisa N. Peters, and Kathleen Pyne. John Twachtman: Connecticut Landscapes [exh. cat., National Gallery of Art] (Washington, 1989).

Clark, Eliot. John Twachtman. New York, 1924.

Hale, John Douglass. "The Life and Creative Development of John H. Twachtman." Ph.D. diss., 2 vols., Ohio State University, 1957.

Hale, John Douglass, Richard J. Boyle, and William H. Gerdts. Twachtman in Gloucester: His Last Years, 1900–1902 [exh. cat., Ira Spanierman Gallery] (New York, 1987).

Peters, Lisa N., William H. Gerdts, John Douglass Hale, and Richard J. Boyle. In the Sunlight: The Floral and Figurative Art of J. H. Twachtman [exh. cat., Ira Spanierman Gallery] (New York, 1989).

Peters, Lisa. "John Twachtman (1853–1902) and the American Scene in the Late Nineteenth Century: The Frontier Within the Terrain of the Familiar." Ph.D. diss., City University of New York, 1995.

John Henry Twachtman was born in Cincinnati, in 1853, to German immigrants. Among the various jobs that Frederick Twachtman took to support his family was that of window shade decorator, work that young Twachtman also assumed when he was fourteen years old. Concurrently, John Twachtman attended classes at the Ohio Mechanics Institute. After 1871 he was enrolled part-time in the McMicken School of Design, where he met Frank Duveneck.

Although only five years Twachtman's senior, Duveneck, who had studied in Munich, had already achieved some success in the United States. The older artist invited Twachtman to share his studio in Cincinnati and eventually to return to Europe with him. In 1875 Twachtman began to study under Ludwig von Loefftz at the Royal Academy of Fine Arts, Munich, where he learned the broad, vigorous brushwork and somber tones typical of that school. A trip to Venice with Duveneck and William Merritt Chase in 1877 did not lighten his palette appreciably.

Returning to the United States in 1878, Twachtman taught briefly at the Women's Art Association of Cincinnati, but spent much of his time in the east. He became a member of the Society of American Artists in 1879, and the next year he returned to Europe, assisting as a teacher in Duveneck's school in Florence. In 1881 he married Martha Scudder and the couple went abroad, where they remained until 1882. During this visit Twachtman spent time in Holland, painting and etching with his friend J. Alden Weir.

From 1883 to 1885 Twachtman studied at the Académie Julian in Paris and spent the summers painting in Normandy and at Arques-la-Bataille, near Dieppe. During this period his brushwork became more subdued and his palette lightened considerably, a change to which his familiarity with the work of James McNeill Whistler may have contributed.

By 1886 Twachtman and his family had returned to the United States, probably spending much of their time in New York. During the winter of 1886–1887, the artist supported them by painting Civil War battle scenes on a cyclorama constructed in Chicago. In 1889 he began to teach at the Art Students League in New York and to produce illustrations for *Scribner's*. About this time he purchased a farm in Greenwich, Connecticut, which became the subject of many of his best-known landscapes.

While living in the country, Twachtman exhibited in New York throughout the 1890s. In 1893, his work was included in an American Art Galleries exhibition with that of J. Alden Weir, and he also won a medal at the World's Columbian Exposition in Chicago. About a year later he received commissions for a landscape series of Niagara Falls and Yellowstone National Park. In 1897 Twachtman was a founding member of The Ten and exhibited with them until his death in 1902.

BIBLIOGRAPHY

Clark, Eliot. "The Art of Robert Vonnoh." Art in America 16 (August 1928), 223–232.

Hill, May Brawley. "The Early Career of Robert William Vonnoh." Antiques (November 1986), 1014–1023.

Hill, May Brawley. Grez Days: Robert Vonnoh in France. New York, 1987.

Robert Vonnoh was born in Hartford, Connecticut, in 1858, but later moved with his widowed mother to Roxbury, Massachusetts. He attended grammar school until age fourteen, then went to work for a lithographic firm in Boston while attending classes at the Free Evening Drawing Schools. From 1875 to 1879, he studied at the Massachusetts Normal Art School, and after graduation taught at the Evening Drawing Schools and at the Thayer Academy in South Braintree, Massachusetts.

In 1881, Vonnoh went to Paris to study at the Académie Julian. There he became a pupil of Gustave Boulanger and Jules-Joseph Lefebvre. By the end of his stay, Vonnoh had advanced considerably as a portraitist as evidenced by his academic portrait of fellow art student *John Severinus Conway*, which he exhibited at the 1883 Paris Salon.

Returning to Boston in 1883, Vonnoh resumed teaching at the Free Evening Drawing Schools and the Cowles Art School. The *Conway* portrait proved instrumental in establishing his career, hailed by one critic for its fluency of technique and uncompromising realism. Following its American debut at the Boston Arts Club early in 1884, the portrait won a gold medal at the Massachusetts Charitable Mechanics Association later that year.

In the fall of 1885, Vonnoh was appointed instructor of painting at the Boston Museum of Fine Arts schools, where he instituted academic principles for painting the human figure learned at the Académie Julian. With his career firmly established, he married Grace D. Farrell of Boston in July of 1886. A year later, Vonnoh and his wife went to France, settling in Grez-sur-Loing, where he turned his attention to plein-air painting. By 1891 he had become a devoted proponent of impressionism. His landscapes and garden scenes of this period exhibit its vibrant palette, spontaneous brushwork, and unconventional format.

By the spring of 1891, Vonnoh was back in Boston. Later that fall he was given a solo exhibition at the Williams and Everett Gallery. Intent on resuming his teaching career, Vonnoh then accepted a post at the Pennsylvania Academy of the Fine Arts in Philadelphia. His method of instruction encouraged experimentation, especially with impressionistic technique, making his courses immensely popular with his students, who included Robert Henri, William Glackens, and Maxfield Parrish.

During the 1890s Vonnoh worked mostly on portraiture in an academic style tempered by his impressionistic leanings, yet his landscapes continued to be well represented in exhibitions of his work. In 1899, following the death of his wife, Vonnoh married the sculptor Bessie Potter. Three years later they moved to New York and began spending their summers in Old Lyme, Connecticut, where he devoted himself to plein-air painting. His awards during these years included bronze medals at the Paris Expositions of 1889 and 1900, and the Proctor Portrait Prize at the National Academy of Design in 1904.

In 1907, Vonnoh returned to Grez, where he created a series of landscapes that revealed a new-found interest in the changing effects of weather, time of day, and season. In 1911 he returned to New York, where he continued to teach and paint. Prior to his death in 1933, Vonnoh was honored with two retrospective exhibitions of his work in New York—at the Ainslie Galleries in 1923 and the Durand-Ruel Galleries in 1926.

BIBLIOGRAPHY

Burke, Doreen Bolger. J. Alden Weir: An American Impressionist. *Newark, Del., 1983.*

Century Association. Julien Alden Weir: An Appreciation of His Life and Work. *New York, 1921.*

Cummings, Hildegard, Helen Fusscas, and Susan G. Larkin. J. Alden Weir: A Place of His Own *[exh. cat., The William Benton Museum of Art, University of Connecticut] (Storrs, 1991).*

Young, Dorothy Weir. The Life and Letters of J. Alden Weir. *New Haven, 1960.*

Born Julian Alden Weir in 1852, the artist received his earliest training from his father Robert Weir, a drawing instructor at the U.S. Military Academy at West Point. Weir's older half-brother, John Ferguson Weir, also an artist, was dean of the School of Fine Arts at Yale University for forty years. Under his father's tutelage, Julian began to study the old masters, developing an admiration for the Italian Renaissance and seventeenth-century Dutch painters. His earliest works were portraits, but he also painted landscape views of the Hudson River and the occasional interior scene. He trained at the National Academy of Design in New York, where he studied drawing for three years.

In 1873 Weir traveled to France and entered Jean-Léon Gérôme's studio at the Ecole des Beaux-Arts. A year later he enrolled at the Ecole as a full-time student and spent the next four years completing its rigorous program. (It was about this time, partly in gratitude to Mrs. Bradford Alden, the family friend who sponsored his trip, that he began to call himself J. Alden Weir.) While in Europe, Weir traveled to Holland and Spain, where he studied the paintings of Frans Hals and Velázquez. Among the French painters he met in Paris, the most influential was Jules Bastien-Lepage, who later became his close friend.

Weir returned to the United States late in 1877. After settling in New York, he became a member of the newly established Society of American Artists, but continued to exhibit at the National Academy of Design. Teaching, portrait commissions, and still life subjects provided his income. He maintained his ties in Europe, making several trips there and exhibiting at the Paris Salons of 1881, 1882, and 1883. In the spring of 1883 he mar- ried Anna Dwight Baker and the couple honeymooned in Europe until September. Upon their return they divided their time between New York City and two Connecticut towns, Branchville and Windham.

At Branchville, Weir was host to scores of artists, among them his closest friend John Twachtman, as well as Childe Hassam, Theodore Robinson, and Albert Pinkham Ryder. In the late 1880s Weir developed an interest in pastels and etchings, often working alongside Twachtman and reflecting that artist's lightness of touch. Weir, whose work had become increasingly daring after his initial stay in Europe, absorbed many aspects of impressionism from his American colleagues and eventually exhibited with The Ten. When he had his first important one-man show in 1891, Weir was described by one critic as "the first among Americans to use impressionistic methods and licenses successfully." Two years later, when he and Twachtman held their joint exhibition at the American Art Association, their works were shown adjacent to and compared with those of French impressionists.

By 1900 Weir was widely known and respected. That year he won a bronze medal at the Exposition Universelle in Paris. Four years later he won medals for both painting and engraving at the Saint Louis Exposition. A retrospective exhibition of his work circulated to Boston, New York, Buffalo, and Cincinnati in 1911–1912, and he was elected president of the National Academy of Design in 1915. Weir died in 1919 at the age of sixty-seven.

Provenance, Exhibitions, and References

THOMAS ANSHUTZ

1

Two Boys by a Boat

c. 1894, watercolor and graphite on paper;
6 x 8½ (15.2 x 21.6). Verso: *Boy in a Sailor Suit*
Unsigned

PROVENANCE

Estate of the artist. James Graham and Sons, New
York, 1963.

EXHIBITIONS

Thomas Anshutz, Graham Gallery, New York, 1963
(not in catalogue); New York 1973, no. 36.

REFERENCES

Pilgrim 1973, 120–121, ill.; Monneret 1979, I: 45.

2

Woman Drawing

c. 1895, charcoal on paper; 24½ x 18¾ (62.2 x 47.6)
Unsigned

PROVENANCE

Son of the artist. James Graham and Sons, New York, 1963.

EXHIBITIONS

Thomas Anshutz, Graham Gallery, New York, 1963, no. 96;
Six Early American Portraits, Graham Gallery, New York,
1964, no. 26; *Major 19th and 20th Century Watercolors and
Drawings,* Gallery of Modern Art, New York, 1965; New
York 1973, no. 35; New York 1976–1977; New York 1980.

REFERENCES

Pilgrim 1973, 118–119, ill.; Randall C. Griffin, *Thomas
Anshutz Artist and Teacher* [exh. cat., Heckscher Museum]
(New York and Seattle, 1994), 60, 62, fig. 22.

CECILIA BEAUX

3

Ethel Page (Mrs. James Large)

1890, pastel on paper; 16⅛ x 12 (41 x 30.5)
Signed and dated, lower left: Cecilia Beaux / 90

PROVENANCE

Ethel Page (Mrs. James) Large to Miss Pauline Bowie.
Hirschl & Adler Galleries, New York, 1987.

EXHIBITIONS

New York 1987, no. 56.

REFERENCES

Henry S. Drinker et al., *The Paintings and Drawings
of Cecilia Beaux* (Philadelphia, 1955), 85.

J. CARROLL BECKWITH

4

Portrait of John Leslie Breck

1891, oil on canvas; 13¼ x 17¼ (33.7 x 43.8)
Signed and dated, upper left: Carroll Beckwith / '91;
upper right: Breck

PROVENANCE

Private collection, Giverny. Ira Spanierman Gallery,
New York, 1996.

EXHIBITIONS

Americans in Brittany and Normandy, 1860–1910, Phoenix
Art Museum, 1982–1983, no. 93; *Les artistes américains à
Giverny,* Musée Municipal A. G. Pulain, Vernon, 1984, no. 3.

REFERENCES

Exh. cat. Phoenix 1982–1983, 208, ill.; William H. Gerdts,
Monet's Giverny: An Impressionist Colony (New York, 1993),
63, fig. 29.

GEORGE BELLOWS

5

Swans in Central Park

1906, oil on canvas; 18¾ x 21¾ (47.6 x 55.3)
Signed, lower right: Geo. Bellows

PROVENANCE

Edward R. Keefe. Hirschl & Adler Galleries, New York, 1967.

EXHIBITIONS

American Paintings from Public and Private Collections,
Hirschl & Adler Galleries, New York, 1968, no. 92; New
York 1968, no. 3; New York 1973, no. 49.

REFERENCES

George Bellows, "Private Book of Paintings," unpublished
ms., A, 19; Charles H. Morgan, *George Bellows, Painter
of America* (New York, 1965), 57; Gordon Brown, "Notes on
Things American," *Arts Magazine* 42, 3 (Dec. 1967–Jan.
1968), 39, ill.; Pilgrim 1973, 162–163, ill.

6

Emma in the Purple Dress

1919, oil on panel; 40 x 32 (101.6 x 81.3)
Signed, lower right: Geo. Bellows; inscribed and dated,
verso: Emma in the Purple Dress / painted in Middletown,
Rhode Island / June 1919

PROVENANCE

Emma S. Bellows estate. H. V. Allison and Co.,
New York, 1971.

EXHIBITIONS

32nd Annual Exhibition of American Oil Paintings, Art
Institute of Chicago, 1919, no. 13; *7th Annual Exhibition
of Oil Paintings by Contemporary Artists,* Corcoran Gallery
of Art, Washington, 1919–1920, no. 150 (as *Portrait of
Emma*); *14th Annual Exhibition of Selected Paintings by
American Artists* (as *Emma in Purple*), Buffalo Fine Arts
Academy, Albright Art Gallery, 1920, no. 7; New York 1973,
no. 50; *20th Century American Masterworks,* Whitney
Museum of American Art, New York, 1977; *19th- and 20th-
Century Masterpieces in New York Private Collections,* ACA
Galleries, New York, 1978, no. 2; *Homage to George Bellows,*
Metropolitan Museum of Art, New York, 1982.

REFERENCES

George Bellows, "Private Book of Paintings," unpublished
ms., 165; *Index of Twentieth-Century Artists* 1, 6 (March
1934), 88; Charles H. Morgan, *George Bellows, Painter of
America* (New York, 1965), 225; Pilgrim 1973, 164–165,
ill.; Michael Quick et al., *The Paintings of George Bellows*
[exh. cat., Amon Carter Museum; Los Angeles County
Museum] (Fort Worth, 1992), 206–207, ill.

FRANK W. BENSON

7

A Summer Day

1911, oil on canvas; 36⅛ x 32⅛ (91.8 x 81.6)
Signed, lower right: F.W. Benson

PROVENANCE

Ira Spanierman Gallery, New York, 1968.

EXHIBITIONS

107th Annual Exhibition, Pennsylvania Academy of the
Fine Arts, Philadelphia, 1912, no. 55; *19th Annual Exhibition
of American Art,* Cincinnati Art Museum, 1912, no. 2;
New York 1968, no. 4; New York 1973, no. 28; *Frank W.
Benson: The Impressionist Years,* Ira Spanierman Gallery,
New York, 1988.

REFERENCES

Pilgrim 1973, 96–97, ill.; Pierce 1976, 50, ill.; Monneret
1979, 1: 69; Julie Schimmel, *The Art and Life of W. Herbert
Dunton, 1878–1936* (Austin, Texas, 1984), 141, fig. V-16;
Ronald G. Pisano, *Idle Hours: Americans at Leisure* (Boston,
1988), 90, 97, ill.; Faith Andrews Bedford et al., *Frank W.
Benson: A Retrospective* [exh. cat., Berry-Hill Galleries, Inc.]
(New York, 1989), 75, fig. 78; Faith Andrews Bedford,
Frank W. Benson: American Impressionist (New York, 1994),
10, 106, 135, pl. 85 (det., cover).

ROBERT BLUM

8

The Lace Makers

c. 1885–1887, oil on canvas; 16⅛ x 12¼ (41 x 31.1)
Stamped, top center: Blum

PROVENANCE

Victor Spark. Mrs. Joan Patterson, 1960–1972. Hirschl &
Adler Galleries, New York, 1972.

EXHIBITIONS

Important Recent Acquisitions, Hirschl & Adler Galleries,
New York, 1972, no. 7; New York 1973, no. 7; *Americans in
Venice, 1879–1913,* Coe Kerr Gallery, New York, and Boston
Athenaeum, 1983, no. 25; *The Lure of Italy: American Artists
and the Italian Experience, 1760–1914,* Museum of Fine
Arts, Boston, and Cleveland Museum of Art, 1992–1993,
no. 119.

REFERENCES

Pilgrim 1973, 34–35, ill.; Bruce Weber, "Robert Frederick
Blum (1857–1903) and His Milieu," Ph.D. diss., 2 vols.,
City University of New York, 1985, 1: 284–285, 2: 663, fig.
225; exh. cat. Boston and Cleveland 1992–1993, 410–413, ill.

9

The Blue Obi

c. 1890–1893, pastel on canvas; 18 x 13 (45.7 x 33)
Stamped, lower right: Blum

PROVENANCE

Alfred Corning Clark, by descent to Jane Clark until 1982.
Hirschl & Adler Galleries, New York, 1982.

EXHIBITIONS

The Art of Collecting, Hirschl & Adler Galleries, New York,
1984, no. 35.

10
Low Tide

c. 1880–1882, oil on canvas; 14½ x 20½ (36.8 x 52.1)
Signed, lower right: D.B.

PROVENANCE

Mrs. William G. Thayer. Adelson Galleries, Inc., Boston, 1969. Hirschl & Adler Galleries, New York, 1969.

EXHIBITIONS

Exhibition of the Pictures of Dennis Bunker, Saint Botolph Club, Boston, 1891, no. 52; *Dennis Miller Bunker: Exhibition of Paintings and Drawings,* Museum of Fine Arts, Boston, 1943, no. 22; *The American Impressionists,* Hirschl & Adler Galleries, New York, 1978, no. 8; New York 1973, no. 12; *Dennis Miller Bunker Rediscovered,* New Britain Museum of American Art, New Britain, Conn., and Davis and Long Co., New York, 1978, no. 6; *Dennis Miller Bunker: American Impressionist,* Museum of Fine Arts, Boston, Terra Museum of American Art, Chicago, Denver Art Museum, 1995, no. 5 (Boston only).

REFERENCES

John Canaday in *New York Times,* 15 Nov. 1968, 30, ill.; Pilgrim 1973, 48–49, ill.; Jared I. Edwards, "Dennis Miller Bunker (1861–90) Rediscovered," *Nineteenth Century* 4, 1 (Spring, 1978), 73, fig. 7; Monneret 1979, 1: 97; exh. cat. Boston, Chicago, and Denver 1995, 14, 18 (det.), 22, 123, 181, ill.

11
Roadside Cottage

1889, oil on canvas; 25¹/₁₆ x 30 (63.7 x 76.2)
Signed and dated, lower right: D.M. Bunker / 1889

PROVENANCE

Perry Rathbone, 1972.

EXHIBITIONS

New York 1973, no. 13; temporary loan, The White House, Washington, 1977; temporary loan for display with permanent collection, National Gallery of Art, Washington, 1985; *The Bostonians: Painters of an Elegant Age, 1870–1930,* Museum of Fine Arts, Boston, Denver Art Museum, and Terra Museum of American Art, Evanston, Ill., 1986–1987, no. 26; temporary loan, Metropolitan Museum of Art, New York, 1988–1992; *Dennis Miller Bunker: American Impressionist,* Museum of Fine Arts, Boston, Terra Museum of American Art, Chicago, and Denver Art Museum, 1995, no. 37 (Boston only).

REFERENCES

Pilgrim 1973, 50–51, ill.; Barbaralee Diamonstein, "Jimmy, Jody, Zbig and Ham and the Art at the Office," *Art News* 77, 3 (March 1978), 38; Jared I. Edwards, "Dennis Miller Bunker (1861–90) Rediscovered," *Nineteenth Century,* 4, 1 (Spring 1978), 73, fig. 6; exh. cat. Boston, Chicago, and Denver 1995, 14–15, 65–66, 94, 96, 155, 175, 182, ill.

WILLIAM MERRITT CHASE

12
Portrait Study

c. 1880, watercolor on paper; 14¾ x 10⅜ (37.5 x 26.4)
Signed, right center: Chase

PROVENANCE

Moses Van Brink, Mount Vernon, N.Y. M. R. Schweitzer Gallery, New York, 1963.

EXHIBITIONS

14th Annual Exhibition of the American Watercolor Society, National Academy of Design, New York, 1881, no. 243; *William Merritt Chase (1849–1916),* Art Gallery, University of California, Santa Barbara, La Jolla Museum of Art, California Palace of the Legion of Honor, San Francisco, and the Gallery of Modern Art, New York, 1964–1965, no. 23; *200 Years of Watercolor Painting in America,* Metropolitan Museum of Art, New York, 1966–1967, no. 99; New York 1973, no. 2; *William Merritt Chase,* M. Knoedler and Co., New York, 1976; Seattle and New York, 1983–1984 (New York only); New York 1994–1995, no. 2.

REFERENCES

Pilgrim 1973, 22–23, ill.; Ronald G. Pisano, "The Teaching Career of William Merritt Chase," *American Artist* 40, 404 (March 1976), 31, ill.; Donelson F. Hoopes, *American Watercolor Painting* (New York, 1977), 62, 80, ill.; exh. cat. Seattle and New York, 1983–1984, 45, ill.; Christopher Finch, *American Watercolors* (New York, 1986), 136, pl. 172.

13
Self-Portrait

c. 1884, pastel on paper; 17¼ x 13½ (43.8 x 34.3)
Signed, upper right: WM Chase.; stamped, upper right: PP [Society of Painters in Pastel]

PROVENANCE

18th–20th Century American Paintings, Drawings, Sculpture, lot 70, Parke-Bernet Galleries, Inc., New York, 19–20 March 1969.

EXHIBITIONS

New York 1973, no. 3; *William Merritt Chase,* M. Knoedler
and Co., New York, 1976; New York 1976–1977; New York
1980; Seattle and New York, 1983–1984 (New York only;
not in catalogue); New York 1987, no. 7.

REFERENCES

Pilgrim 1973, 24–25, ill.; Pierce 1976, 53, ill.; Stebbins 1976,
231, 428, fig. 187; Pilgrim 1978, 49, fig. 13; Pisano 1979, 32,
pl. 7; Ronald G. Pisano, "Prince of Pastels," *Portfolio* 5,
3 (May–June 1983), 66, ill.; Ronald G. Pisano, "William
Merritt Chase: Innovator and Reformer," *In Support of
Liberty: European Paintings at the 1883 Pedestal Fund Art
Loan Exhibition* (Southampton, N.Y., 1986), 60, fig. 3;
Bryant 1991, 85; Gallati 1995, 34, ill.

14
Back of a Nude

c. 1888, pastel on paper; 18 x 13 (45.7 x 33)
Signed, lower right: Wm M. Chase.

PROVENANCE

Potter Palmer by 1897. Florence Davis Watson, Jacksonville,
Fla. Kennedy Galleries, New York. Hirschl & Adler Gal-
leries, New York, 1965.

EXHIBITIONS

William Merritt Chase, Art Institute of Chicago, 1897, no.
67 (as *Study of Flesh Color and Gold*); *William Merritt
Chase Exhibition,* Gallery of Modern Art, New York, 1965
(not in catalogue); New York 1973, no. 5; *Three Centuries
of the American Nude,* New York Cultural Center, 1975;
New York 1980; temporary loan, The White House,
Washington, 1977–1978; Seattle and New York, 1983–1984
(New York only); New York 1987, no. 9.

REFERENCES

"Art Notes," *Art Interchange* 22 (16 March 1889), 83;
Chicago Chronicle, 28 Nov. 1897; *Chicago Times Herald,* 28
Nov. 1897; William H. Gerdts, *The Great American Nude*
(New York, 1973), 110, color pl. 9; Pilgrim 1973, 28–29,
ill.; Pierce 1976, 63, ill.; Barbaralee Diamonstein, "Jimmy,
Jody, Zbig, and Ham and the Art at the Office," *Art News*
77, 3 (March 1978), 37–38, ill.; Pilgrim 1978, 49, fig. 14;
Pisano 1979, 46–47, pl. 14; Ronald G. Pisano, "Prince of
Pastels," *Portfolio* 5, 3 (May–June 1983), 70–71, ill.; exh. cat.
Seattle and New York 1983–1984, 69, ill.; Bryant 1991, 121;
Lisa N. Peters, *American Impressionist Masterpieces* (New
York, 1991), 46–47, ill.

15
Roses

c. 1888, pastel on paper; 13 x 11⅜ (33 x 28.9)
Signed, lower left: Wm. M. Chase.; stamped, lower left: PP
[Society of Painters in Pastel]

PROVENANCE

M. Knoedler and Co., New York. Dr. and Mrs. Irving
Levitt. Kennedy Galleries, New York, 1966.

EXHIBITIONS

*American Flowers: Loan Exhibition of Oils, Pastels, and
Watercolors,* Wickersham Gallery, New York, 1967, no. 5;
150 Years of American Still-Life Painting, Coe Kerr Gallery,
New York, 1979, no. 35; New York 1973, no. 4; *William
Merritt Chase,* M. Knoedler and Co., New York, 1976; New
York 1978; Seattle and New York, 1983–1984 (New York
only; not in catalogue) New York 1987, no. 9; New York
1994–1995, no. 16; *American Beauty: The Rose in American
Art 1800–1920,* Berry-Hill Galleries, Inc., New York, 1997.

REFERENCES

William H. Gerdts and Russell Burke, *American Still-Life
Painting* (New York, 1971), 201, pl. xxiv; Pilgrim 1973,
26–27, ill.; Pilgrim 1978, 49, fig. 16; Pisano 1979, 34, pl. 8;
Dennis R. Anderson, *American Flower Paintings* (New
York, 1980), 42, pl. 13; exh. cat. New York 1997, 25, pl. 25.

16
The Fairy Tale

1892, oil on canvas; 16½ x 24 (41.9 x 61)
Signed, lower right: Wm M. Chase.

PROVENANCE

Macbeth Gallery, to William T. Evans, 1898. American Art
Galleries, 1900, William T. Evans collection sale, no. 182
(as *A Fairy Tale*). To W. R. Beal. Coe Kerr Galleries, New
York, 1969.

EXHIBITIONS

16th Annual Exhibition of American Paintings, Gill's Art
Gallery, Springfield, Mass., 1893, no. 41 (as *A Sunny Day*);
11th Annual Exhibition, Saint Louis Exposition and Music
Hall Association, 1894, no. 97; *15th Exhibition,* Society of
American Artists, New York, 1893, no. 60 (as *The Fairy
Tale*); New York 1973, no. 6; *The Impressionist Epoch,* Met-
ropolitan Museum of Art, New York, 1974–1975; *William
Merritt Chase,* M. Knoedler and Co., New York, 1976; *A
New World: Masterpieces of American Painting, 1760–1910,*
Museum of Fine Arts, Boston, Corcoran Gallery of Art,
Washington, and Grand Palais, Paris, 1983–1984, no. 92;
William Merritt Chase: Summers at Shinnecock, 1891–1902,
National Gallery of Art, Washington, 1987, no. 1; *Master-*

works of American Impressionism, Fondazione Thyssen-Bornemisza, Lugano-Castagnola, Switzerland, 1990, no. 38; temporary loan, Metropolitan Museum of Art, New York, 1991; New York and Fort Worth 1994 no. 19.

REFERENCES

New York Herald, 15 Apr. 1893, 4; John Gilmer Speed, "An Artist's Summer Vacation," *Harper's New Monthly Magazine* 87 (June 1893), 11–12, 13, ill. (as *A Fairy Tale*); *Index of Twentieth -Century Artists* 2, 2 (Nov. 1934), 25 (as *Fairy Tale*); William H. Truettner, "William T. Evans, Collector of American Paintings," *American Art Journal* 3, 2 (Fall 1971), 73; Pilgrim 1973, 30–31, ill.; Richard J. Boyle, *American Impressionism* (Boston, 1974), 13, ill.; Pierce 1976, 60, ill.; Pilgrim 1978, 43, fig. 9; Pisano 1979, 56–57, pl. 19; exh. cat. Boston, Washington, and Paris 1983, 161, 167, 314–315, ill.; Gerdts 1984, 135, pl. 145 (det., dust jacket); Pisano 1985, 114, 119, ill.; exh. cat. Washington 1987, 22, 28, pl. 1; Nicolai Cikovsky, Jr., "William Merritt Chase at Shinnecock Hills," *The Magazine Antiques* 132, 2 (August 1987), 294, pl. II; Sarah Lyall in *New York Times,* 6 Sept. 1987, 25; exh. cat. Lugano-Castagnola 1990, 98–99, 158, pl. 38; Bryant 1991, 167; Ronald G. Pisano, *Summer Afternoons: Landscape Paintings of William Merritt Chase* (Boston, 1993), 91, ill.; Weinberg, Bolger, and Curry 1994, 35, 109, 113, fig. 98; Gallati 1995, 78, 80–82, ill.

17
Reflections

1893, oil on canvas; 25 x 18 (63.5 x 45.7)
Signed, lower right: Wm M. Chase.

PROVENANCE

The artist. American Art Galleries, New York, 1894, *The Collection of William Merritt Chase,* no. 1170. Franklyn S. Gesner Fine Paintings, Largo, Fla., 1983.

EXHIBITIONS

16th Annual Exhibition, Society of American Artists, New York, 1884, no. 68; Seattle and New York 1983–1984 (New York only); *William Merritt Chase: Summers at Shinnecock, 1891– 1902,* National Gallery of Art, Washington, 1987, no. 20; New York 1994–1995, no. 25.

REFERENCES

"The Exhibition of the Society of American Artists," *Art Amateur* (April 1884), 127; William Baer, "Reformer and Iconoclast," *Monthly Illustrator* 1 (1893), 137, ill.; exh. cat. Seattle and New York 1983–1984, 154–155, ill.; exh. cat. Washington 1987, 48–49, 61–62, pl. 20; Nicolai Cikovsky, Jr., "William Merritt Chase at Shinnecock Hills," *The Magazine Antiques* 132, 2 (August 1987), 295, 298, pl. XIV; Gallati 1995, 59–61, 65, ill.; F. Hopkinson Smith et al., *Discussions on American Art and Artists* (Boston, n.d.), 238, ill.

KENYON COX

18
Theodore Robinson

1878, pencil on paper; 11 x 8½ (27.9 x 21.6)
Signed and dated, upper right: Cox / 1878

PROVENANCE

The artist to Hamline Robinson. Mrs. C. F. Terhune, Kansas City, Missouri. Kennedy Galleries, New York, 1966.

REFERENCES

Baur 1946, 4, ill. cover.

WILLIAM GLACKENS

19
Seated Woman

c. 1902, black chalk, ink, and pastel on paper; 18⅝ x 14¾ (47.3 x 37.5)
Signed, lower right: Glackens; inscribed, verso: Drawn by W. J. Glackens / size 11½ x 15½ date—possibly 1887 / Price $. . . / Possibly drawn from a model in the sketch class at the Philadelphia [sic] Academy of Fine Arts / Given to E. Shinn later. Not signed but authentic / the above attested by Everett Shinn

PROVENANCE

The artist to Everett Shinn. Joseph Katz, 1959 to Babcock Galleries, New York. Paul Magriel. Kennedy Galleries, New York, 1968.

EXHIBITIONS

100 American Drawings from the Collection of Paul Magriel, Currier Gallery of Art, Manchester, N.H., 1962, no. 41; *Robert Henri (1865–1929) and His Circle,* American Academy of Arts and Letters, New York, 1964, no. 94; Saint Louis, Washington, and New York 1966, no. 96; New York 1968, no. 66; New York 1973, no. 43; New York 1976–1977; New York 1980.

REFERENCES

Ira Moskowitz, ed., *Great Drawings of All Time* (New York, 1962), 4, no. 1020; Pilgrim 1973, 142–143, ill.; Stebbins 1976, 279, fig. 239; Marjorie Welish, "Magriel's Way," *Connoisseur* 213, 7 (July 1983), 47, ill.

20
The Ermine Muff

c. 1903, oil on canvas; 15 x 18 (38.1 x 45.7)
Unsigned

PROVENANCE

Mr. and Mrs. Ira Glackens. Kraushaar Galleries, New York,
1967.

EXHIBITIONS

4th Annual Exhibition of the Paintings of William Glackens,
10 West 9th Street, New York, 1942, no. 4; Saint Louis,
Washington, and New York 1966, no. 10; New York 1968,
no. 67; New York 1973, no. 44.

REFERENCES

Pilgrim 1973, 144–145, ill.; William H. Gerdts, *William
Glackens* (New York, 1996), 43, pl. 36.

21
Study of a Young Man
(Portrait of Everett Shinn)

c. 1903, red chalk on tracing paper, mounted on board;
10 x 8⅛ (25.4 x 20.6)
Signed, lower right: W Glackens

PROVENANCE

Mr. and Mrs. Ira Glackens. Kraushaar Galleries,
New York, 1967.

EXHIBITIONS

Saint Louis, Washington, and New York 1966, no. 96;
New York 1973, no. 45.

REFERENCES

Pilgrim 1973, 146–147, ill.; Stebbins 1976, 278–279.

LILIAN WESTCOTT HALE

22
Japonoiserie

c. 1907, charcoal on paper; 22¼ x 14 (56.5 x 35.6)
Signed, upper left: Lilian Westcott Hale

PROVENANCE

Museum of Fine Arts, Boston, to 1969. Private collection
to 1989. Richard York Gallery to 1990.

EXHIBITIONS

Fifth Annual Philadelphia Water Color Exhibition, The
Pennsylvania Academy of the Fine Arts and the Philadelphia
Water Color Club, 1907, no. 245; Rowlands Galleries,
Boston, 1908, no. 4.

CHILDE HASSAM

23
Nurses in the Park

c. 1889, oil on panel; 9¾ x 13¼ (24.8 x 33.7)
Signed, lower left: Childe Hassam

PROVENANCE

John Fox, Boston. Dwight W. Collins, Washington.
Babcock Galleries, New York. Davis Galleries, New York
(on consignment from Babcock Galleries), 1961.

EXHIBITIONS

Childe Hassam: A Retrospective Exhibition, Corcoran
Gallery of Art, Washington, Museum of Fine Arts, Boston,
the Currier Gallery of Art, Manchester, N.H., and the
Gallery of Modern Art, New York, 1965, no. 11; New York
1968, no. 74; *Childe Hassam, 1859–1935,* University of Ari-
zona Museum of Art, Tucson, 1972, no. 30; New York 1973,
no. 24; *Childe Hassam,* Guild Hall, East Hampton, N.Y.,
1981, no. 6.

REFERENCES

*American Paintings and Historical Prints from the Midden-
dorf Collection* (New York, 1967), 62; *Los Angeles Times,* 23
April 1972, 54, ill.; Pilgrim 1973, 82–83, ill.; Monneret
1979, 1: 268.

24
Poppies, Isles of Shoals

1890, pastel on brown paper; 7¼ x 13¾ (18.4 x 34.9)
Signed and dated, lower left: Childe Hassam 1890.

PROVENANCE

Milch Gallery, New York. John Fox, Boston. Babcock
Galleries, New York, 1962.

EXHIBITIONS

New York 1973, no. 25; *Childe Hassam: Printmaker,* Metro-
politan Museum of Art, New York, 1977; New York 1980;
*Down Garden Paths: The Floral Environment in American
Art,* Montclair Art Museum, N.J., 1983; New York 1987,
no. 26; *Childe Hassam: An Island Garden Revisited,* Yale
University Art Gallery, New Haven, Conn., 1990.

REFERENCES

Pilgrim 1973, 84–85, ill.; Stebbins 1976, 227; exh. cat.
Montclair 1983, 53, 64, 135, ill.; Gerdts 1984, fig. 107; exh.
cat. New Haven 1990, 84, pl. 31.

25
Poppies

1891, oil on canvas; 19 ¾ x 24 (50.2 x 61)
Signed and dated, lower left: Childe Hassam 1891

PROVENANCE

John Stringer Tilney, Orange, N.J., 1900–1925. To Mrs. Mary Garner Tilney, 1925–1957. To Marie Tilney Inge, Mobile, Ala., 1957–1965. Hirschl & Adler Galleries, New York, 1965. Mrs. Ralph Ritter to 1987. Hirschl & Adler Galleries, New York, 1987. Partial and promised gift to the National Gallery of Art, Washington, since December, 1997.

EXHIBITIONS

Collectors, Arizona State Museum, Tucson, 1977; Childe Hassam: An Island Garden Revisited, Yale University Art Gallery, New Haven, Conn., 1990; New York and Fort Worth, 1994, no. 37.

REFERENCES

William H. Gerdts, "'Like Dreams of Flowers,'" In the Sunlight: The Floral and Figurative Art of J. H. Twachtman (New York, 1989), 29–30, fig. 20; exh. cat. New Haven 1990, 104, pl. 45; Stephen May, "Childe Hassam in the Isles of Shoals," Smithsonian 21, 9 (Dec. 1990), 75, ill.; Ulrich W. Hiesinger, Impressionism in America: The Ten American Painters (Munich, 1991), 101, pl. 45; Ulrich W. Hiesinger, Childe Hassam: American Impressionist (Munich and New York, 1994), 85, fig. 89; Weinberg, Bolger, and Curry 1994, 100, fig. 87.

ROBERT HENRI

26
Girl Seated by the Sea

1893, oil on canvas; 18 x 24 (45.7 x 61)
Signed and dated, lower left: Robert Henri '93

PROVENANCE

Estate of the artist. Hirschl & Adler Galleries, New York, 1961.

EXHIBITIONS

63rd Annual Exhibition, Pennsylvania Academy of the Fine Arts, Philadelphia, 1893–1894, no. 359 (as Landscape with Figure, Jersey Coast); American Painting, 1740 to 1920, Main Street Gallery, Chicago, 1961, no. 44; Robert Henri (1865–1929) and His Circle, American Academy of Arts and Letters, New York, 1964, no. 12; Robert Henri, 1865–1929–1965, Sheldon Memorial Art Gallery, Lincoln, Nebr., 1965, no. 2; New York 1966, no. 73; Robert Henri: Painter-Teacher-Prophet, New York Cultural Center, 1969, no. 4; New York 1973, no. 37; Seascape and the American Imagination, Whitney Museum of American Art, New York, 1975; American

Impressionism, Henry Art Gallery, Seattle, Frederick S. Wight Gallery, University of California, Los Angeles, Terra Museum of American Art, Evanston, Ill., and the Institute of Contemporary Art, Boston, 1980; American Masters, Guild Hall Museum, East Hampton, N.Y., 1987.

REFERENCES

William Inness Homer, Robert Henri and His Circle (Ithaca and London, 1969), 213, pl. 1; Norman Geske, "Review of Robert Henri and His Circle," Art Bulletin 53, 4 (Dec. 1971), 549–550; Pilgrim 1973, 124–125, ill.; exh. cat. New York 1975, 127, 130, fig. 135; Monneret 1979, 1: 274; Judith K. Zilczer, "Anti-Realism in the Ashcan School," Artforum 17, 7 (March 1979), 44–45, ill.; exh. cat. Seattle et al. 1980, 120, 133, ill.; Gerdts 1984, pl. 135; Bennard B. Perlman, Robert Henri: His Life and Art (New York, 1991), 26–27, ill.; H. Barbara Weinberg, The Lure of Paris: Nineteenth-Century American Painters and Their French Teachers (New York, 1991), 258, pl. 269; Weinberg, Bolger, and Curry 1994, 35, 117, fig. 107.

JOHN LA FARGE

27
Wild Roses and Water Lily—Study of Sunlight

c. 1883, watercolor on paper; 10 ⅝ x 8 ⅞ (27 x 22.5)
Unsigned

PROVENANCE

Moore's Art Gallery, New York, 26–27 March 1885, lot 32. Moritz Bernard Philipp, New York, 1885 to 1929. Mrs. Moritz Bernard Philipp, New York, 1929 to 1965. Private collection, 1965 to 1968. Kennedy Galleries, New York, 1968 to 1971.

EXHIBITIONS

The Century Association, New York, 1884, no. 92; Catalogue of a Collection of Oil and Water Color Paintings, by John La Farge, Moore's Art Gallery, New York, 1885, no. 32; Catalogue of the Third Annual Exhibition of the Architectural League of New York at the Fifth Avenue Art Galleries, Architectural League of New York, December 1887–January 1888, no. 353 (as Water Color Study for Embroidery); Paintings, Studies, Sketches and Drawings, Mostly Records of Travel, 1886 and 1890–91 by John La Farge, Durand-Ruel Galleries, New York, 1895, no. 221; Loan Exhibition of Paintings by John La Farge and His Descendants, Wildenstein and Co., New York, 1931, no. 30; An Exhibition of the Work of John La Farge, Metropolitan Museum of Art, New York, 1936, no. 38; Exhibition of American Painting from 1860 until Today at the Cleveland Museum of Art, Cleveland Museum of Art, 1937, no. 122; American Masters,

18th to 20th Centuries, Kennedy Galleries, New York, 1971, no. 39; New York 1973, no. 1; New York 1978; New York 1980; *Reflections of Nature: Flowers in American Art,* Whitney Museum of American Art, New York, 1984; *John La Farge,* National Museum of American Art, Washington, Carnegie Museum of Art, Pittsburgh, and Museum of Fine Arts, Boston, 1987–1988, no. 61 (Washington only); *Nature Vivante: The Still Lifes of John La Farge,* Jordan-Volpe Gallery, New York, 1995, no. 77.

REFERENCES

New York Daily Tribune, 27 March 1885, 2; Cecilia Waern, *John La Farge, Artist and Writer* (London, 1896), ill. opp. 26; Royal Cortissoz, "John La Farge," *Outlook* 84, 9 (27 Oct. 1906), 487, ill.; *New York Daily Tribune,* 20 Nov. 1910, 2, ill.; Royal Cortissoz, *John La Farge: A Memoir and a Study* (Boston, 1911), ill. opp., 56; Arthur E. Bye, *Pots and Pans, or Studies in Still-Life* (Princeton, N.J., 1921), 194–195; Frank J. Mather et al., *The Pageant of America: The American Spirit in Art* (New Haven, 1927), ill., 27; Edythe Helen Browne, "Wizard of Windows," *Columbia* 14 (March 1935), 8, 19; Royal Cortissoz in *New York Herald Tribune,* 23 March 1936, 19, ill.; Ann Hamilton Sayre, "The Complete Work of John La Farge at the Metropolitan," *Art News* (28 March 1936), 10; Pilgrim 1973, 18–20, ill.; Stebbins 1976, 238; Ella M. Foshay, "Charles Darwin and the Development of American Flower Imagery," *Winterthur Portfolio* 15, 4 (Winter 1980), 306–307, 309, ill.; exh. cat. New York 1984, 59, fig. 44; Henry Mitchell, "Gorgeous Flowers as They Burgeoned in American Art," *Smithsonian* 14 (March 1984), 98, ill.; Christopher Finch, *American Watercolors* (New York, 1986), 102, 105, pl. 136; exh. cat. Washington, Pittsburgh, and Boston 1987–1988, 45, 139, 140, 264, ill.; Barbara Dayer Gallati, "The Watercolors of John La Farge," *The Magazine Antiques* 132 (Dec. 1987), 1293, ill.; exh. cat. New York 1995, 50–51, 142, pl. 42.

ERNEST LAWSON

28
Upper Harlem River

c. 1915, oil on canvas; 16 x 20 (40.6 x 50.8)
Signed, lower left: E. Lawson

PROVENANCE

Robert Rockmore. Zabriskie Gallery, 1962.

EXHIBITIONS

Ernest Lawson, Zabriskie Gallery, New York, 1962, no. 9 (as *Winter Scene*); New York 1966, no. 78; New York 1973, no. 33.

REFERENCES

Henry and Sidney Berry-Hill, *Ernest Lawson—American Impressionist, 1873–1939* (Leigh-on-Sea, England, 1968), no. 71, ill.; Pilgrim 1973, 110–111, ill.

ALFRED MAURER

29
At the Shore

1901, oil on cardboard; 23½ x 19¼ (59.7 x 48.9)
Unsigned

PROVENANCE

Hudson D. Walker to Curt Valentin to Curt Valentin estate. Richard Sisson. Babcock Galleries, New York, 1963.

EXHIBITIONS

A. H. Maurer, 1868–1932, Walker Art Center, Minneapolis, Whitney Museum of American Art, New York, and the Boston Institute of Modern Art, 1949, no. 4; *The Friends Collect,* Whitney Museum of American Art, New York, 1964, no. 104; New York 1966, no. 97; *Summer Loan Exhibition: Paintings from Private Collections,* Metropolitan Museum of Art, New York, 1967, no. 59; New York 1973, no. 40.

REFERENCES

Exh. cat. Minneapolis, New York, and Boston 1949, 31; Elizabeth McCausland, *A. H. Maurer* (New York, 1951), 69–70; Milton W. Brown, *American Paintings from the Armory Show to the Depression* (Princeton, N.J., 1955), 32, ill.; Pilgrim 1973, 132–133, ill.; Pisano 1985, 150–151, ill.

30
Cafe Scene

c. 1904, oil on canvas; 36 x 34 (91.4 x 86.4)
Signed, lower right: Alfred H. Maurer

PROVENANCE

Ione and Hudson Walker Collection, University of Minnesota, Minneapolis. Babcock Galleries, New York, 1968.

EXHIBITIONS

A. H. Maurer, 1868–1932, Walker Art Center, Minneapolis, Whitney Museum of American Art, New York, and the Boston Institute of Modern Art, 1949, no. 11; New York 1973, no. 41; temporary loan, Metropolitan Museum of Art, New York, 1980–1982.

REFERENCES

Exh. cat. Minneapolis, New York, and Boston 1949, 31; Elizabeth McCausland, *A. H. Maurer* (New York, 1951), 77–78; Pilgrim 1973, 134–135, ill.; Nick Madormo, "The Early Career of Alfred Maurer: Paintings of Popular Entertainments," *American Art Journal* 15, 1 (Winter 1983), 27, fig. 26.

EDWARD POTTHAST

31
Beach Scene

c. 1915, oil on panel; 11 x 15⅞ (27.9 x 40.3)
Signed, lower right: E Potthast

PROVENANCE

Mr. and Mrs. Merrill J. Gross. Hirschl & Adler Galleries, New York. M. Knoedler and Co., New York, 1964.

EXHIBITIONS

Edward Henry Potthast, 1857–1927, Hirschl & Adler Galleries, New York, 1962, no. 19; *Light and Atmosphere: American Impressionist Painters,* Newark Museum, 1969; *18th- and 19th-Century American Art from Private Collections,* Whitney Museum of American Art, New York, 1972, no. 55; New York 1973, no. 34.

REFERENCES

Pilgrim 1973, 114–115, ill.

MAURICE PRENDERGAST

32
Revere Beach

1896, watercolor on paper; 14 x 10 (35.6 x 25.4)
Signed and dated, lower right: Prendergast 1896; inscribed, verso (in different hand): Revere Beach, Revere, Massachusetts; A midsummer day at the beach (erased); Charles Prendergast (written over part of the erased inscription)

PROVENANCE

Edgar W. Hodgson to Carolyn Holdtman, by 1949. Sotheby, Parke-Bernet (*Traditional and Western American Paintings, Drawings, Watercolors, Sculpture and Illustrations of the 18th, 19th and 20th Centuries*), New York, 1972, lot 10.

EXHIBITIONS

University of Connecticut, Museum of Art, Storrs, 1969; New York 1973, no. 29; *Ten Americans, Masters of Watercolor,* Andrew Crispo Gallery, New York, 1974, no. 17; *The Remembered Image: Prendergast Watercolors, 1896–1906,* Coe Kerr Gallery, no. 4; *Maurice Prendergast,* Whitney Museum of American Art, New York, 1990, no. 8.

REFERENCES

Pilgrim 1973, 100–101, ill.; Ellen M. Galvin, "Maurice Prendergast: The Boston Experience," *Art and Antiques* 5 (July–Aug. 1982), 70–71; Bennard B. Perlman in *Daily Record* (Baltimore), 19 Nov. 1986, 14; Clark, Matthews, and Owens 1990, 359, no. 630, ill.

33
Picnicking Children—Central Park

c. 1900–1903, watercolor and pencil on paper;
8¾ x 16⅝ (22.2 x 42.2)
Signed, lower right: Prendergast; inscribed and dated, verso (in different hand): Picnic 1895–97 (Boston Garden)

PROVENANCE

The artist. To Charles Prendergast, 1924. To Mrs. Charles Prendergast, 1948. To Davis Galleries, New York, 1962 (owned jointly with Mr. and Mrs. Daniel Fraad, Jr., 1962–1986).

EXHIBITIONS

American Paintings: Selections from the Collection of Daniel and Rita Fraad, Brooklyn Museum, New York, and Addison Gallery of American Art, Phillips Academy, Andover, Mass., 1964, no. 34; New York 1973, no. 30; New York 1976–1977; *American Paintings, Watercolors, and Drawings from the Collection of Rita and Daniel Fraad,* Amon Carter Museum, Fort Worth, 1985, no. 28; *The Remembered Image: Prendergast Watercolors 1896–1906,* Coe Kerr Gallery, New York, 1986, no. 5.

REFERENCES

Pilgrim 1973, 106–107, ill.; Stebbins 1976, 246, 248, fig. 206; Clark, Matthews, and Owens 1990, 415, no. 803, ill.

34
The Breezy Common

c. 1895–1897, monotype; 10⅜ x 8¼ (26.4 x 21)
Signed, lower right: Prendergast; lower left: The Breezy Common; inscribed and dated, verso (in different hand): The Breezy Common—1901 / M. Prendergast (in pencil), DG-150 (in blue ballpoint) with a stamp of an eagle

PROVENANCE

The artist. To Charles Prendergast, 1924. To Mrs. Charles Prendergast, 1948. To Davis Galleries, New York, 1962.

EXHIBITIONS

Drawings by Maurice B. Prendergast, Davis Galleries, New York, 1963, no. 40; *Maurice Prendergast: The Monotypes,* William Cooper Procter Art Center, Bard College, Annandale-on-Hudson, New York, 1967, no. 29; New York 1973, no. 31; *Maurice Prendergast: Art of Impulse and Color,* University of Maryland Art Gallery, College Park, and Davis and Long Co., New York, 1976–1977, no. 10; *Maurice Prendergast Monotypes,* Davis and Long Co., New York, 1979, no. 59.

REFERENCES

Pilgrim 1973, 104–105, ill.; David W. Kiehl, "Monotypes in America in the Nineteenth and the Twentieth Centuries," *The Painterly Print: Monotypes from the Seventeenth to the Twentieth Century* (New York, 1980), 45, ill.; Cecily Langdale, *Monotypes by Maurice Prendergast in the Terra Museum of American Art* (Chicago, 1984), 25, 102; Clark, Matthews, and Owens 1990, 660–661, no. 1659, ill.

35
Picnic by the Inlet

c. 1918–1923, oil on canvas; 28¼ x 24⅝ (71.8 x 62.6)
Signed, lower left: Prendergast

PROVENANCE

The artist. To Charles Prendergast, 1924. To Mrs. Charles Prendergast, 1948. Babcock Galleries, New York, 1963–1965. Partial and promised gift to the Metropolitan Museum of Art, New York, 1996.

EXHIBITIONS

New York 1966, no. 140; *Summer Loan Exhibition: Paintings from Private Collections,* Metropolitan Museum of Art, New York, 1967, no. 82; New York 1973, no. 32; *Maurice Prendergast: Art of Impulse and Color,* University of Maryland Art Gallery, College Park, and Davis and Long Co., New York, 1976–1977, no. 103.

REFERENCES

Pilgrim 1973, 106–107, ill.; Cecily Langdale, "Maurice Prendergast: An American Post-Impressionist," *Connoisseur* 202 (Dec. 1979), 253; Gerdts 1984, fig. 388; Clark, Matthews, and Owens 1990, 321, no. 481, color pl. 85; *The Metropolitan Museum of Art Bulletin* 55, 2 (Fall 1997), 67, ill.

THEODORE ROBINSON

36
Self-Portrait

c. 1884–1887, oil on canvas; 13¼ x 10¼ (33.7 x 26)
Signed and inscribed, lower center: "Robinson peint par lui même"

PROVENANCE

A. Conger Goodyear to Babcock Galleries, 1928–1930. M. Knoedler and Co., New York. William T. Cresmer to Cresmer estate. Hanzel Galleries, Chicago. Babcock Galleries, New York, 1961.

EXHIBITIONS

Exhibition by American Artists, Babcock Galleries, New York, 1928, no. 16; *Selected Small Paintings by Prominent American Artists,* Babcock Galleries, New York, 1928, no. 3; *Theodore Robinson, 1852–96,* Macbeth Gallery, New York, 1943, no. 21; *Theodore Robinson, 1852–1896,* Brooklyn Museum, New York, 1946; New York 1973, no. 14.

REFERENCES

Art Digest 17, 14 (15 April 1943), 5, ill.; Baur 1946, 75, no. 206; *Claude Monet and the Giverny Artists* (New York, 1960), n.p., ill.; Florence Lewison, "Theodore Robinson, America's First Impressionist," *American Artist* 27, 2 (Feb. 1963), 40, ill.; Pilgrim 1973, 54–55, ill.

37
Young Woman Reading

1887, watercolor on paper; 19⅜ x 13¾ (49.2 x 34.9)
Signed and dated, lower right: T H Robinson / Paris 1887

PROVENANCE

Mrs. Charles Kelsey; M. Knoedler and Co., New York. Kende Galleries, New York, 1942, John F. Braun sale, no. 15. Florence Lewison Gallery, 1962.

EXHIBITIONS

Theodore Robinson, 1852–1896, Brooklyn Museum, New York, 1946; *Theodore Robinson,* Florence Lewison Gallery, New York, 1962, no. 18; New York 1973, no. 15.

REFERENCES

Baur 1946, 86, no. 335; *Theodore Robinson, American Impressionist (1852–1896)* [exh. cat., Kennedy Galleries] (New York, 1966), 11; Pilgrim 1973, 56–57, ill.

38
A Normandy Mill

1892, watercolor on gray academy board; 9⅞ x 15 (25.1 x 38.1)
Signed and dated, lower left: Th. Robinson / 1892

PROVENANCE

An English collection. Bernard Black Gallery, New York, 1968.

EXHIBITIONS

New York 1973, no. 16; *Turn-of-the-Century America: Paintings, Graphics, Photographs, 1890–1910,* Whitney Museum of American Art, New York, Saint Louis Art Museum, Seattle Art Museum, and the Oakland Museum, 1977–1978; New York 1980.

REFERENCES

Pilgrim 1973, 60–61, ill.; Stebbins 1976, 236; Donelson Hoopes, *American Watercolor Painting* (New York, 1977), 64, 89, ill.

39
Low Tide, Riverside Yacht Club

1894, oil on canvas; 18 x 24 (45.7 x 61)
Unsigned

PROVENANCE

American Art Association, New York, 1898. Theodore Robinson sale, no. 86 to C. Armstrong. Ferargil Galleries, New York, 1926, to Macbeth Gallery. D. A. Schmitz. Parke-Bernet Galleries, Inc., *American Paintings and Drawings,* 29 Jan. 1964, lot 53.
Litigation pending regarding validity of title

EXHIBITIONS

Theodore Robinson, Macbeth Gallery, New York, 1895, no.
3; *Cotton States and International Exposition,* Atlanta, 1895,
no. 514; *Exhibition of Paintings by American Impressionists
and Other Artists of the Period 1880– 1900,* Brooklyn Museum,
New York, 1934, no. 79; *Theodore Robinson, 1852– 1896,*
Brooklyn Museum, New York, 1946; New York 1966, no.
161; New York 1973, no. 18; *The Impressionist Epoch,* Metro-
politan Museum of Art, New York, 1974–1975; *Masters of
American Impressionism,* Coe Kerr Gallery, New York, 1976;
New York and Fort Worth, 1994, no. 61.

REFERENCES

Art Notes 85 (New York, 1927), n.p. ill.; *Art Portfolio* (New
York, 1927), n.p.; Baur 1946, 86, no. 138, pl. xxxiv; *Theodore
Robinson, American Impressionist (1852– 1896)* [exh. cat.,
Kennedy Galleries] (New York, 1966), 15; Pilgrim 1973,
62–63, ill.; Elliot C. Clark, *Theodore Robinson: His Life
and Art* (Chicago, 1979), 48, ill.; Monneret 1979, 2: 189;
Gerdts 1984, 152, fig. 164; Bolger 1990, 22–23, fig. 17; Hilde-
gard Cummings, Helen K. Fusscas, and Susan G. Larkin,
J. Alden Weir: A Place of His Own (Storrs, Conn., 1991), 69,
fig. 24; Susan G. Larkin, "Light, Time, and Tide: Theodore
Robinson at Cos Cob," *American Art Journal* 23, 2 (1991),
75, 88, 93–95, 100, fig. 1; Weinberg, Bolger, and Curry 1994,
72, 75, fig. 60.

JOHN SINGER SARGENT

40
Under the Willows

1888, watercolor and pencil on paper; 14 x 9 ⅜ (35.6 x 23.8)
Unsigned; inscribed and dated, verso: "Under the Willows
1888 / Flora Priestly and Viol . . . / Given to Violet Sargent
by her. . . ."

PROVENANCE

Mrs. Hugo Pitman (Sargent's niece). James Coates,
New York, 1962.

EXHIBITIONS

The Private World of John Singer Sargent, Corcoran Gallery
of Art, Washington, 1964, no. 96; New York 1973, no. 9;
John Singer Sargent: His Own Work, Coe Kerr Gallery, New
York, 1980, no. 20; *Sargent at Broadway: The Impressionist
Years,* Coe Kerr Gallery, New York, 1986, no. 30.

REFERENCES

Richard Ormond, *John Singer Sargent: Paintings, Drawings,
Watercolors* (New York, 1970), 69 (as *Two Figures in a
Landscape*); Pilgrim 1973, 40–41, ill.; exh. cat. New York
1986, 50, pl. xxx.

41
Gondoliers' Siesta

1905, watercolor on paper; 14 x 20 (35.6 x 50.8)
Signed, dated, and inscribed, lower right: To Mrs. Gorham
Sargent from her affectionate nephew John S. Sargent 1905.

PROVENANCE

Mrs. Gorham Sargent. Ferargil Galleries, New York.
Mrs. Irving Telling, New Haven, Conn. Vose Galleries,
Boston, 1963.

EXHIBITIONS

103rd Annual Philadelphia Water Color Exhibition, Pennsyl-
vania Academy of the Fine Arts, Philadelphia, 1906, no.
389 (as *Venice*); *Major 19th and 20th Century Drawings,*
Gallery of Modern Art, New York, 1965; *200 Years of Water-
color Painting in America,* Metropolitan Museum of Art,
New York, 1966–1967, no. 105; New York 1973, no. 10; *Ten
Americans: Masters of Watercolor,* Andrew Crispo Gallery,
New York, 1974; *Americans in Venice, 1879– 1913,* Coe Kerr
Gallery, New York, and Boston Athenaeum, 1983, no. 45;
The Italian Presence in American Art, 1860– 1920, Richard
York Gallery, New York, 1989, no. 35; *Sargent Abroad,*
Adelson Galleries, Inc., New York, 1997, no. 13; *John Singer
Sargent,* Tate Gallery, London, National Gallery of Art,
Washington, and Museum of Fine Arts, Boston, 1998–1999,
no. 106 (London and Boston only).

REFERENCES

Collector and Critic 14 (June 1906), 241 (as *Venice*), ill.; Leila
Mechlin, "The Philadelphia Water Color Exhibition," *In-
ternational Studio* 28 (June 1906), cxi (as *Venice*), ill.; *Amer-
ican Magazine of Art* 10 (Feb. 1919), 143 (as *Venetian Street
Scene*); *American Magazine of Art* 16 (June 1925), 287 (as
Venice), ill.; William Howe Downes, *John S. Sargent: His
Life and Work* (Boston, 1925), 282 (as *Venetian Street Scene*);
Ferargil 2, 2 (Oct. 1926), n.p., ill.; Pilgrim 1973, 42–43, ill.;
exh. cat. New York 1989, 22–23, ill.; Margaretta M. Lovell,
A Visitable Past: Views of Venice by American Artists
(Chicago, 1989), 84, pl. 8; Hugh Honour and John Flem-
ing, *The Venetian Hours of Henry James, Whistler and Sargent*
(Boston, 1991), 126, ill.; Warren Adelson et al., *Sargent Abroad:
Figures and Landscapes* (New York, 1997), 195, pl. 192; exh.
cat. London, Washington, and Boston 1998–1999, 216.

EVERETT SHINN

42
Matinee, Outdoor Stage, Paris

1902, pastel on paper; 18 x 26 (45.7 x 66)
Signed and dated, lower right: E. Shinn / 1902

PROVENANCE

The artist to Mr. Lindeberg to Barbara Lindeberg.
Hanover Arts Associates. Stanley Moss, Ltd. Schoelkopf
Gallery, New York, 1972.

EXHIBITIONS

Paintings by Everett Shinn of Paris and New York, 1902–1945, James Vigeveno Galleries, Los Angeles, 1945, no. 1 (as *Matinee Music Hall, Paris*); *Artists of the Philadelphia Press,* Philadelphia Museum of Art, 1945, no. 36 (as *Matinee Music Hall, Paris*); *Circus and Theatre by Everett Shinn,* James Vigeveno Galleries, Los Angeles, 1947, no. 10; New York 1973, no. 42.

REFERENCES

Pilgrim 1973, 138–139, ill.; Edith DeShazo, *Everett Shinn 1876–1953: A Figure in His Time* (New York, 1974), color insert; Monneret 1979, 2: 250; Linda S. Ferber, "Stagestruck: The Theatre Subjects of Everett Shinn," *Studies in the History of Art* 37 (1990), 54, 56, fig. 2 (as *Paris Theatre*).

ALBERT E. STERNER

43
Sketching at the Beach

1886, watercolor on paper; 9 ¼ x 13 (23.5 x 33)
Signed and dated, lower right: Albert E. Sterner / 86

PROVENANCE

Sotheby, Parke-Bernet, New York, 1976.

EXHIBITIONS

Painter's Paradise: The Long Island Landscapes, The Museums at Stony Brook, New York, 1985–1986.

REFERENCES

Pisano 1985, 7, 110–111, ill.

JOHN TWACHTMAN

44
Trees in a Nursery

c. 1885–1890, pastel on paper; 18 x 22 (45.7 x 55.9)
Inscribed, verso: Twachtman #3

PROVENANCE

Martha Scudder Twachtman, Greenwich, Conn. Mr. and Mrs. Godfrey Twachtman, Independence, Mo. Milch Gallery, New York, 1967.

EXHIBITIONS

John Henry Twachtman, 1853–1902: An Exhibition of Paintings and Pastels, Ira Spanierman Gallery, New York, 1968, no. 33; New York 1973, no. 19; New York 1978; New York 1980; New York 1987, no. 25; *In the Sunlight: The Floral and Figurative Art of J. H. Twachtman,* Ira Spanierman Gallery, New York, 1989, no. 18.

REFERENCES

Hale 1957, 592, no. 1031; Pilgrim 1973, 66–67, ill.; Stebbins 1976, 227; Pilgrim 1978, 59, ill.; Burke 1983, 168–171, fig. 4.24.

45
September Sunshine

c. 1895, oil on canvas; 25 x 30 (63.5 x 76.2)
Signed, lower right: J. H. Twachtman

PROVENANCE

The artist. E. T. Stotesbury, Philadelphia, 1906. Freeman Auction Rooms, Philadelphia. John F. Braum. Private collection, Houston, Texas, c. 1965–1996. Adelson Galleries, Inc., New York, 1996.

EXHIBITIONS

101st Annual Exhibition, Pennsylvania Academy of the Fine Arts, Philadelphia, 1906, no. 27; Milch Galleries, New York, 1906.

REFERENCES

Hale 1957, 498, no. 618, fig. 138.

46
Waterfront Scene—Gloucester

c. 1901, oil on canvas; 16 x 22 (40.6 x 55.9)
Signed, lower left: JH Twachtman

PROVENANCE

Son of W. A. Putnam. Mr. and Mrs. Allen T. Clark. Ira Spanierman Gallery, New York, 1966.

EXHIBITIONS

New York 1966, no. 188; *John Henry Twachtman, 1853–1902: An Exhibition of Paintings and Pastels,* Ira Spanierman Gallery, New York, 1968, no. 23 (as *Gloucester*); New York 1973, no. 21; *Twachtman in Gloucester: His Last Years, 1900–1902,* Ira Spanierman Gallery, New York, 1987, no. 2.

REFERENCES

Hale 1957, 577, no. 688, fig. 142; Hilton Kramer in *New York Times,* 29 April 1973, 21, ill.; Pilgrim 1973, 70–71, ill.; Monneret 1979, 2: 329; Gerdts 1984, 190–191, fig. 212; Bolger 1990, 17, fig. 3.

47
Springtime in France

1890, oil on canvas; 21 x 17½ (53.3 x 44.5)
Signed and dated, lower right: Vonnoh 1890

PROVENANCE

James Graham and Sons, 1962.

EXHIBITIONS

Transitions in American Impressionism, Cummer Gallery
of Art, Jacksonville, Fla., 1986–1987; *Grez Days: Robert
Vonnoh in France,* Berry-Hill Galleries, Inc., New York,
1987, no. 15.

REFERENCES

Gerdts 1984, 121, fig. 133; May Brawley Hill, "The Early
Career of Robert William Vonnoh," *The Magazine
Antiques* 130, 5 (Nov. 1986), 1020, pl. ix; exh. cat. New
York 1987, 25–27, pl. x.

J. ALDEN WEIR

48
Roses

c. 1882–1890, oil on canvas; 9¾ x 14¾ (24.8 x 37.5)
Unsigned

PROVENANCE

Frank K. M. Rehn, New York. Paul Magriel, New York.
Mrs. Norman B. Woolworth, Winthrop, Maine. Coe Kerr
Gallery, New York, 1981.

EXHIBITIONS

Weir Memorial Exhibition, The Century Association, New
York, 1920; *Weir Memorial Exhibition,* Metropolitan
Museum of Art, New York, 1924; *Garden Pieces: 19th-Century
American Still Life,* The American Federation of Arts,
New York, and Corcoran Gallery of Art, Washington, 1956
–1957, no. 23; *The American Painting Collection of Mrs.
Norman B. Woolworth: An Exhibition for the Benefit of the
Girl Scout Council of Greater New York,* Coe Kerr Gallery,
New York, 1970, no. 114; *J. Alden Weir: An American Impres-
sionist,* Metropolitan Museum of Art, New York, 1983–1984;
American Beauty: The Rose in American Art, 1800–1920,
Berry-Hill Galleries, Inc., New York, 1997.

REFERENCES

Paul Magriel, "American Flower Paintings," *The Antiques
Journal* 10, 12 (Dec. 1955), 9–10, ill.; William H. Gerdts
and Russell Burke, *American Still-Life Painting* (New York,
1971), 210, fig. 15.5; Burke 1983, 141, 192, fig. 3.64; exh. cat.
New York 1997, 24–25, 111, pl. 21.

49
U.S. Thread Company Mills, Willimantic, Connecticut

c. 1893–1897, oil on canvas; 20 x 24 (50.8 x 60.9)
Signed, lower left: J. Alden Weir

PROVENANCE

June Wickersham, to Robert Carlen to Schoelkopf Gallery,
New York, 1968. Partial and promised gift to the National
Gallery of Art, Washington, since 1990.

EXHIBITIONS

Blakeslee Galleries, New York, 1891; Saint Botolph Club,
Boston, 1891; American Art Galleries, New York, 1893;
American Paintings, Wickersham Gallery, New York, 1965,
no. 7; New York 1973, no. 22; *Masters of American Impres-
sionism,* Coe Kerr Gallery, New York, 1976; *Paris—New
York: A Continuing Romance,* Wildenstein and Co., New
York, 1977, no. 82; *J. Alden Weir: An American Impressionist,*
Metropolitan Museum of Art, New York, Los Angeles
County Museum of Art, and the Denver Art Museum,
1983–1984; temporary loan for display with permanent
collection, National Gallery of Art, Washington, 1986;
temporary loan for display with permanent collection, Na-
tional Gallery of Art, Washington, 1990; *Art for the Nation:
Gifts in Honor of the 50th Anniversary of the National
Gallery of Art,* National Gallery of Art, Washington, 1991.

REFERENCES

Pilgrim 1973, 74–75, ill.; Richard J. Boyle, *American Im-
pressionism* (Boston, 1974), 96, ill.; Mahonri Sharp Young,
"The Last Time I Saw Paris," *Apollo,* n.s. 189 (Nov. 1977),
415–416, ill.; Gerrit Henry, "Paris—New York: A Continu-
ing Romance," *Art News* 76, 10 (Dec. 1977), 60, ill.; Burke
1983, 208–209, 218, fig. 5.21; Bolger 1990, 17, 21, 25–26, fig.
2; William H. Gerdts, *Art Across America: Two Centuries
of Regional Art, 1710–1920* (New York, 1990), 1: 118, fig. 1.119;
Ulrich W. Hiesinger, *Impressionism in America: The Ten
American Painters* (Munich, 1991), pl. 48; Lisa N. Peters,
American Impressionist Masterpieces (New York, 1991), 68–69,
ill.; exh. cat. Washington 1991, 244, ill.; Robert Wilson
Torchia, *American Paintings of the Nineteenth Century,*
Part II (Washington, New York, and Oxford, 1998), 228, ill.

FREQUENTLY CITED SOURCES

BAUR 1946

Baur, John I. H. *Theodore Robinson, 1852–1896.*
Brooklyn, 1946.

BOLGER 1990

Bolger, Doreen. "American Artists and the Japanese
Print: J. Alden Weir, Theodore Robinson, and John H.
Twachtman." *Studies in the History of Art* 37 (1990),
14–27.

BRYANT 1991

Bryant, Jr., Keith L. *William Merritt Chase: A Genteel
Bohemian.* Columbia, Mo., 1991.

BURKE 1983

Burke, Doreen Bolger. *J. Alden Weir: An American
Impressionist* [exh. cat., Metropolitan Museum of Art]
(Newark, 1983).

CLARK, MATTHEWS, AND OWENS 1990

Clark, Carol, Nancy Mowll Matthews, and Gwen-
dolyn Owens. *Maurice Brazil Prendergast and Charles
Prendergast: A Catalogue Raisonné.* Munich, 1990.

GALLATI 1995

Gallati, Barbara Dayer. *William Merritt Chase.*
New York, 1995.

GERDTS 1984

Gerdts, William H. *American Impressionism.*
New York, 1984.

HALE 1957

Hale, John Douglas. "The Life and Creative Develop-
ment of John H. Twachtman." Ph. D. diss., Ohio State
University, 1957.

MONNERET 1979

Monneret, Sophie. *L'impressionnisme et son epoque:
dictionnaire international illustré.* Paris, 1979.

PIERCE 1976

Pierce, Patricia Jobe. *The Ten.* North Abington,
Mass., 1976.

PILGRIM 1973

Pilgrim, Dianne H. *American Impressionist and Realist
Paintings and Drawings from the Collection of Mr.
and Mrs. Raymond J. Horowitz* [exh. cat., Metropolitan
Museum of Art] (New York, 1973).

PILGRIM 1978

Pilgrim, Dianne H. "The Revival of Pastels in Nine-
teenth-Century America: The Society of Painters
in Pastel." *The American Art Journal* 10, 2 (Nov. 1978),
43–62.

PISANO 1979

Pisano, Ronald G. *William Merritt Chase.*
New York, 1979.

PISANO 1985

Pisano, Ronald G. *Long Island Landscape Painting,
1820–1890.* Boston, 1985.

STEBBINS 1976

Stebbins, Theodore E., Jr. *American Master Drawings
and Watercolors.* New York, 1976.

WEINBERG, BOLGER, AND CURRY 1994

Weinberg, H. Barbara, Doreen Bolger, and David
Park Curry. *American Impressionism and Realism:
The Painting of Modern Life, 1885–1915* [exh. cat.,
Metropolitan Museum of Art; Amon Carter Museum]
(New York, 1994).

FREQUENTLY CITED EXHIBITIONS

NEW YORK 1966

Summer Loan Exhibition: Paintings, Drawings, and Sculpture from Private Collections. Metropolitan Museum of Art, New York, 1966.

NEW YORK 1968

New York Collects: Paintings, Watercolors, and Sculpture from Private Collections. Metropolitan Museum of Art, New York, 1968.

NEW YORK 1973

American Impressionist and Realist Paintings and Drawings from the Collection of Mr. and Mrs. Raymond J. Horowitz. Metropolitan Museum of Art, New York, 1973.

NEW YORK 1976 – 1977

American Master Drawings and Watercolors: Works on Paper from Colonial Times to the Present. Whitney Museum of American Art, New York, 1976–1977.

NEW YORK 1978

American Flower Paintings, 1850–1950. ACA Galleries, New York, 1978.

NEW YORK 1980

American Drawings, Watercolors, and Prints. Metropolitan Museum of Art, New York, 1980.

NEW YORK 1987

Painters in Pastel: A Survey of American Works. Hirschl & Adler Galleries, New York, 1987.

NEW YORK AND FORT WORTH 1994

American Impressionism and Realism: The Painting of Modern Life, 1885–1915. Metropolitan Museum of Art, New York, and Amon Carter Museum, Fort Worth, 1994.

NEW YORK 1994 – 1995

William Merritt Chase: Master of American Impressionism. Ira Spanierman Gallery, New York, 1994–1995.

SAINT LOUIS, WASHINGTON, NEW YORK 1966

William Glackens in Retrospect. City Art Museum of Saint Louis; National Collection of Fine Arts, Washington; and the Whitney Museum of American Art, New York, 1966.

SEATTLE AND NEW YORK 1983 – 1984

A Leading Spirit in American Art: William Merritt Chase, 1849–1916. Henry Art Gallery, Seattle, and Metropolitan Museum of Art, New York, 1983–1984.

PHOTO CREDITS FOR BIOGRAPHIES

Thomas Anshutz: Anshutz Papers, Archives of American Art, Smithsonian Institution. *Cecilia Beaux, Dennis Miller Bunker:* Photographs of Artists Collection II, Archives of American Art, Smithsonian Institution. *J. Carroll Beckwith, George Bellows, Kenyon Cox, William Glackens, Childe Hassam, Robert Henri, John La Farge, Ernest Lawson, John Singer Sargent, Everett Shinn, Albert Sterner, John Twachtman, J. Alden Weir:* Peter A. Juley & Son Collection, National Museum of American Art, Smithsonian Institution. *Frank W. Benson, Robert Blum, Alfred Maurer, Maurice Prendergast, Theodore Robinson:* Photographs of Artists Collection I, Archives of American Art, Smithsonian Institution. *William Merritt Chase:* albumen print, c. 1878, William Merritt Chase Archives, Gift of Mrs. Virginia Brumenschenkel, 78.Brl.8, The Parrish Art Museum, Southampton, N.Y. *Lilian Westcott Hale:* published in *The American Magazine of Art* 18, no. 2 (February 1927), 61. *Edward Potthast:* published in *The Cincinnati Enquirer,* 15 February 1922. *Robert Vonnoh:* Bessie Potter Vonnoh Papers, Archives of American Art, Smithsonian Institution.

ISBN 0-89468-239-3

90000

9 780894 682391

T2-CYY-349